Historic England

Durham

Derek Dodds

AMBERLEY

First published 2018

Amberley Publishing
The Hill, Stroud, Gloucestershire, GL5 4EP
www.amberley-books.com

Copyright © Derek Dodds, 2018

The right of Derek Dodds to be identified as the Author
of this work has been asserted in accordance with the
Copyright, Designs and Patents Act 1988.

ISBN 978 1 4456 7302 8 (print)
ISBN 978 1 4456 7303 5 (ebook)

British Library Cataloguing in Publication Data.
A catalogue record for this book is available from the
British Library.

Origination by Amberley Publishing.
Printed in Great Britain.

Contents

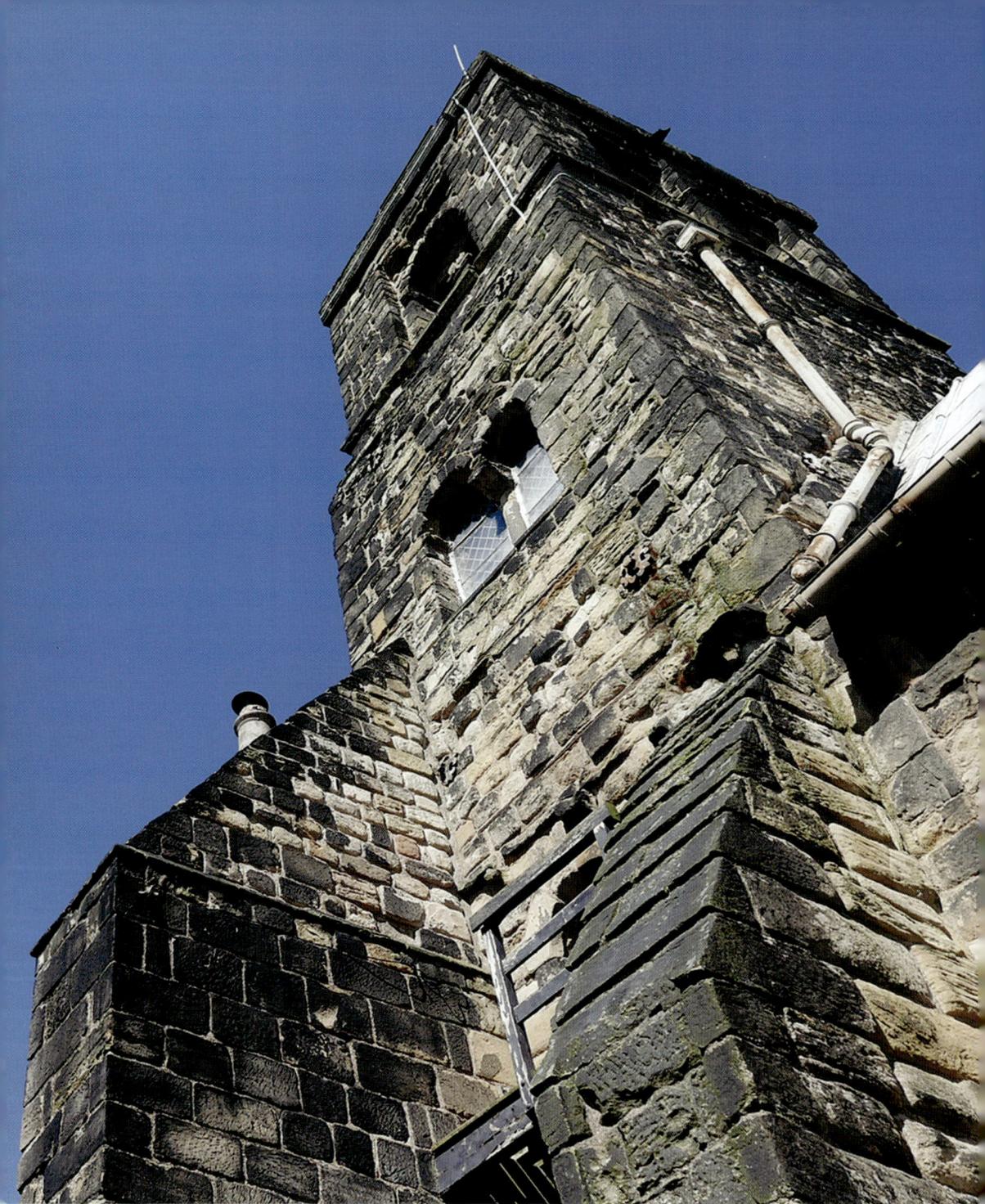

St Paul's, Jarrow.

Introduction

County Durham deserves its place in what has been called Historic England's 'treasure trove' of images (Mike Evans, Gary Winter and Ann Woodward, *Picturing England: The Photographic Collections of Historic England* (2015)). Since Victorian times photographers have ranged across the county, weighed down in the early days with heavy plate cameras and even processing equipment, portraying streets and landscapes, ancient monuments and stately homes as well as a wide array of Durham's commercial, domestic and industrial buildings.

It is well served in the latter of course. Cameras have been on hand to record not only the region's industrial growth and decline (particularly coal mining and shipbuilding) but also more recent signs of economic regeneration, all of which is hopefully reflected in this book's selection of photographs.

Everyone who has taken the images within these pages deserve acknowledgment. Among the better-known photographers are Eric de Mare and John Gay, vivid illustrators of everyday life and industrial landscapes in post-war Britain. Perceived as more workmanlike perhaps but just as relevant is the work of photographic company Bedford Lemere, established in the 1860s, who showcase Durham's shops and houses, inside and out. Other contributors may be unknown but all of their talents, professional or amateur, enhance an extraordinary and invaluable collection.

As many of the images were taken before governmental boundary changes in 1974, traditional county lines have been retained in this publication. Its photographs are of the old County Durham, the historic stretch of land between the rivers Tyne and Tees, still recognised and embraced by many inhabitants as their one true home.

Holy Trinity Sunderland and High Street flats.

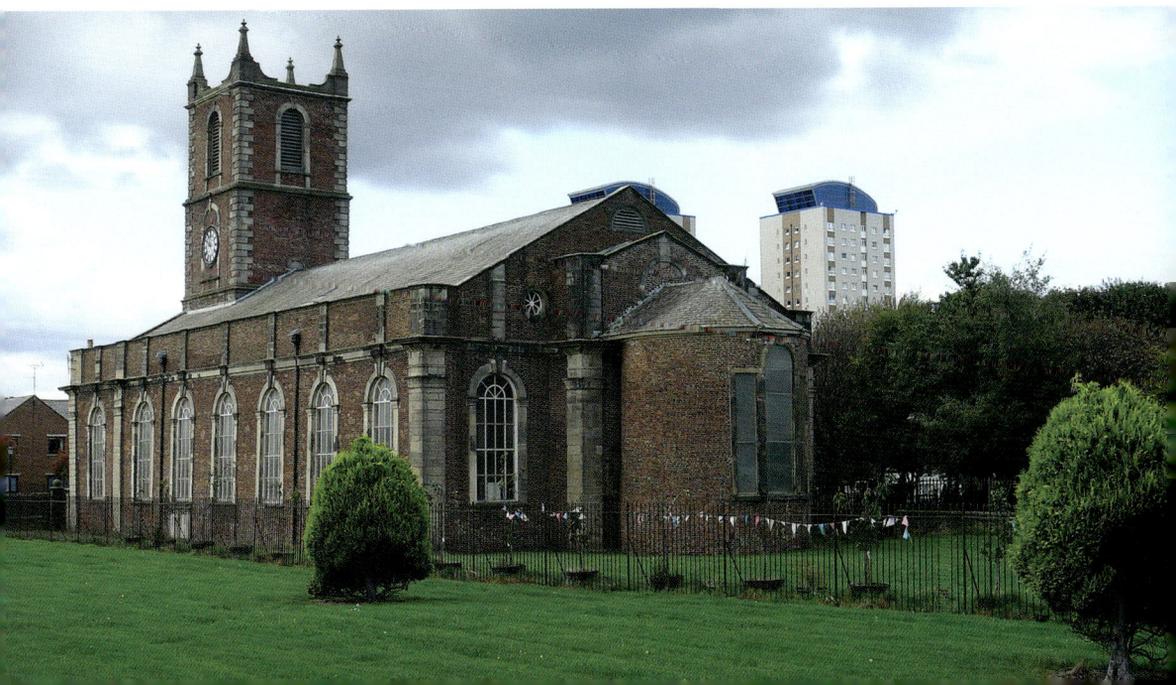

Durham City

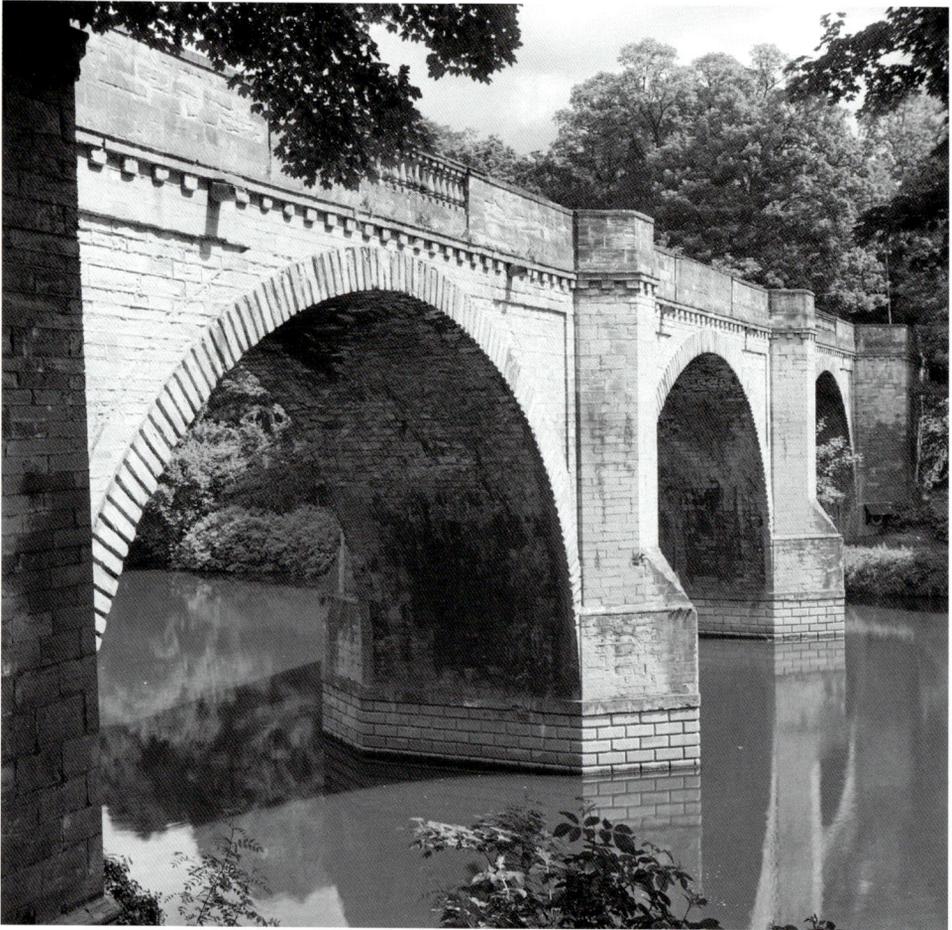

Above: Prebends' Bridge

Prebends' Bridge is seen from the River Wear's west bank in this 1950s image. Widely regarded as the most elegant of Durham City's River Wear bridges, it was begun in 1772, largely in response to a disastrous flood in the previous year. Many of County Durham's bridges were destroyed, including one slightly downstream from the present structure. Completed in 1778, Prebends' Bridge was designed and built by George Nicholson in collaboration with Robert Mylne. (Historic England Archive)

Opposite above: Durham Castle

Photographed in the summer of 1966, Durham Castle rises above the city and a richly wooded riverbank. High on a rocky peninsula, it was begun by the Normans around 1072, probably replacing an earlier fortress. Over the centuries it was a stronghold and palatial residence for Durham's prince-bishops and since 1836 has been the spectacular home of Durham University. Underpinning in the 1930s saved the ancient building from collapse. (Historic England Archive)

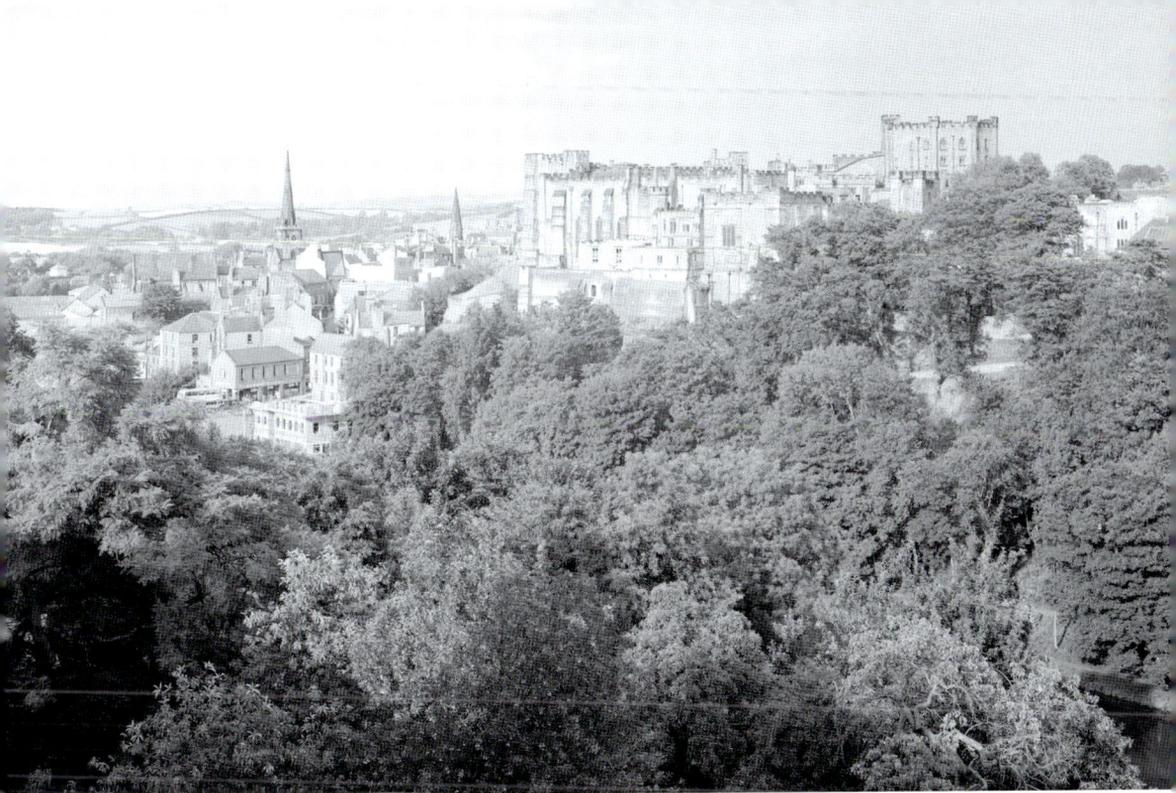

Below: Durham Castle

The castle's keep overlooks the rooftops in this recent photograph taken from the north near Elvet Bridge. Originally built in the fourteenth century, the keep replaced a timber fort. A ruin in 1840, the octagonal building was then reconstructed by Anthony Salvin, who retained much of its 'shell keep' form. High on an earth mound and today part of the university, it now provides the most secure student lodgings imaginable.

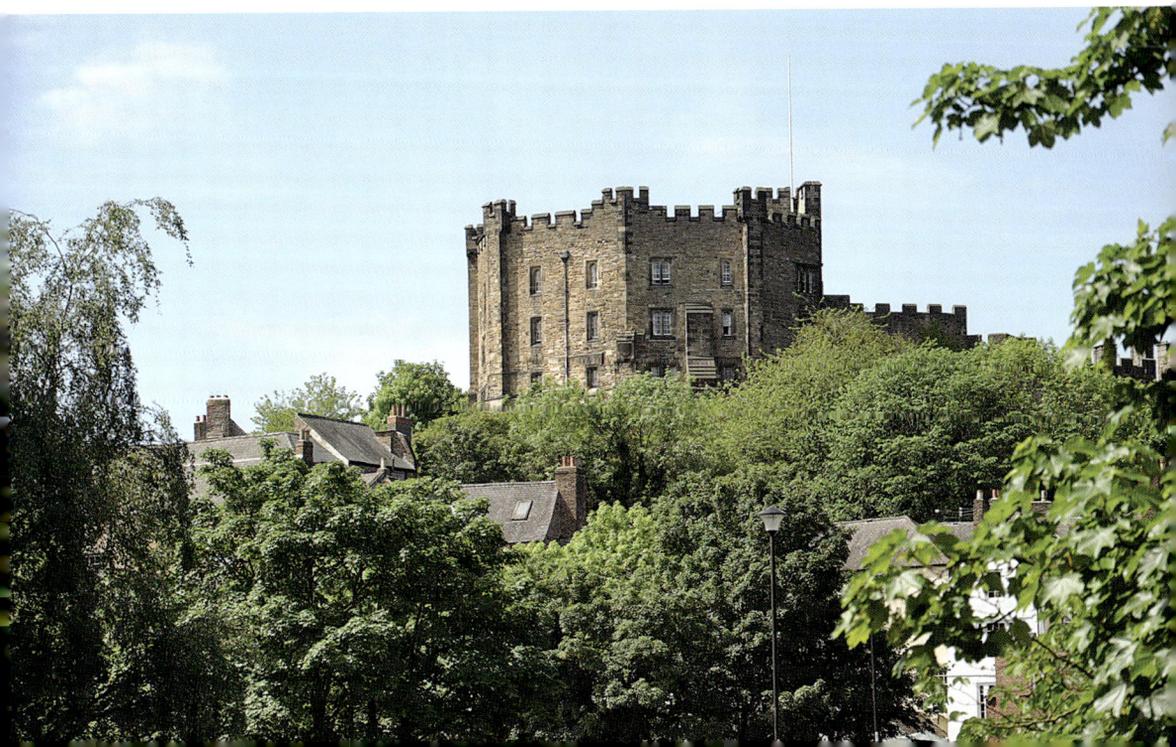

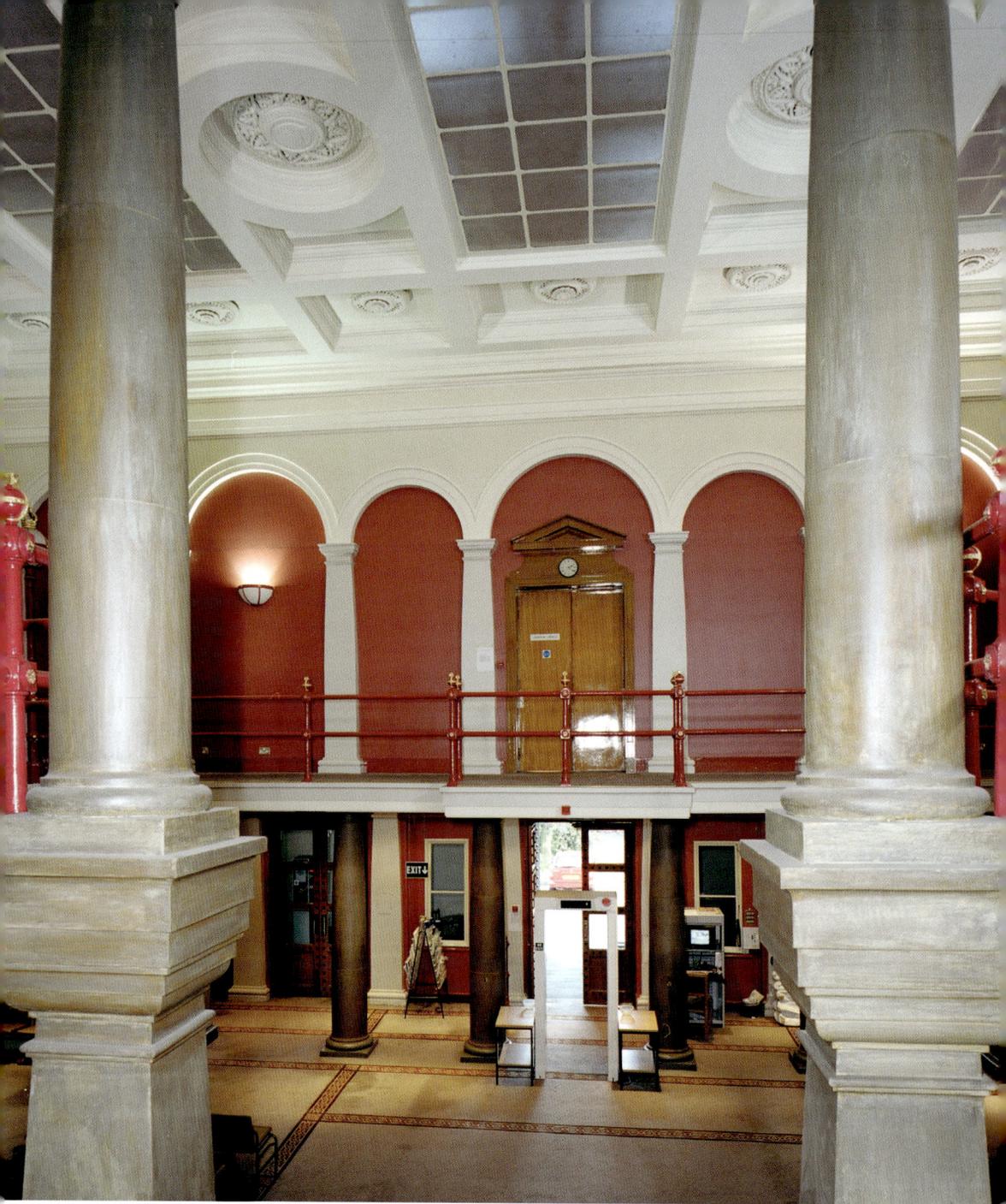

Durham Crown Court

Impressive and rarely photographed, Durham Crown Court's interior is well illustrated here by Keith Buck in September 2000. Resembling as much a stately home as a courthouse, the neoclassical-style building on Old Elvet was the work of local architect Ignatius Bonomi in 1811. Some of his fine work was undone in 1870, however, by clumsy alterations carried out by the county architect W. Crozier. (© Historic England Archive)

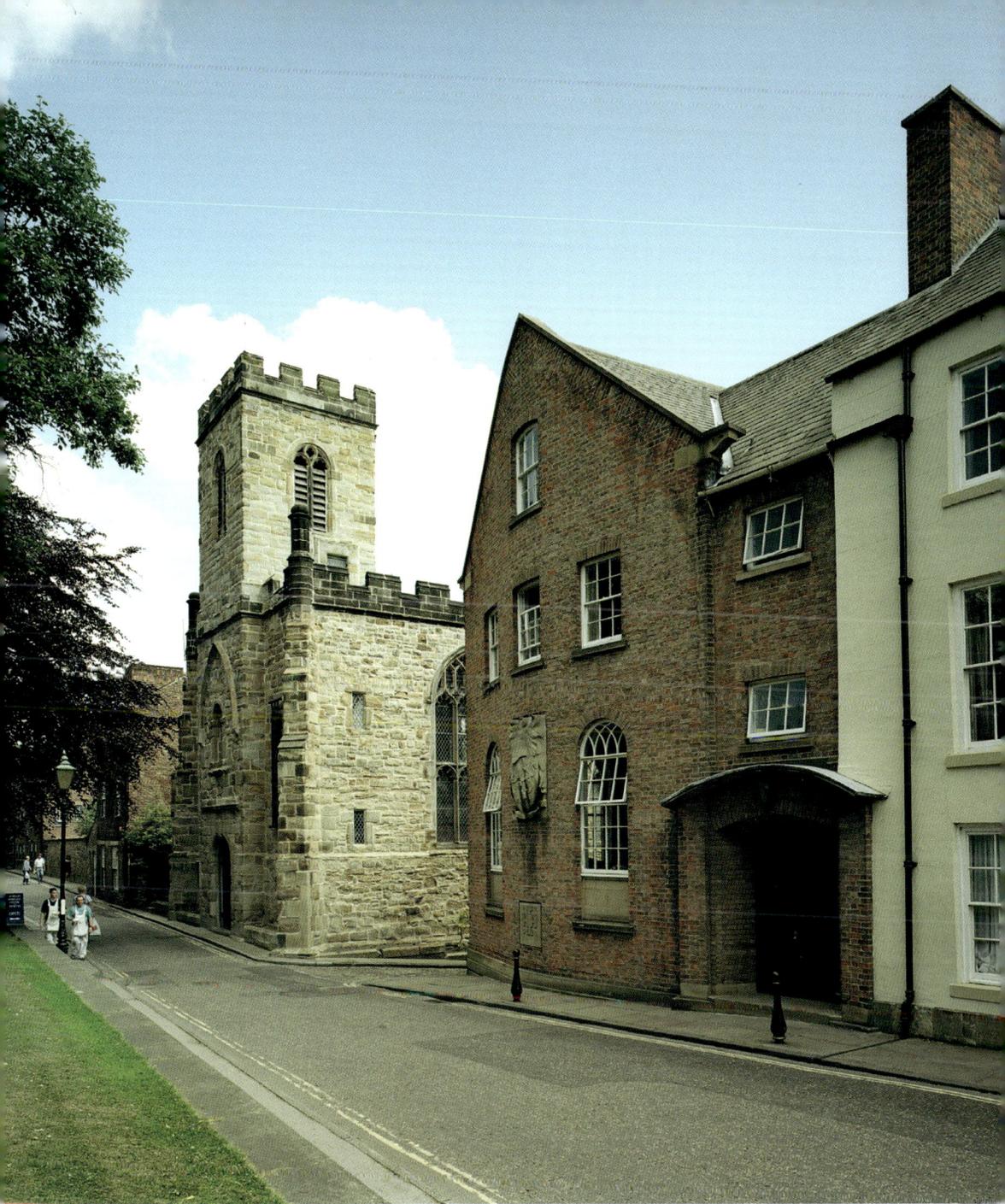

North Bailey, Durham
College and church stand together on Durham's North Bailey. St Chad's University College on the right was founded in 1904 long after its neighbour St Mary-le-Bow, which is now a museum. Originally a medieval parish church, St Mary's was largely rebuilt in the 1670s. A blind arch over the west doorway is believed to be a remnant of the town wall, which collapsed onto the church in 1637. (© Historic England Archive)

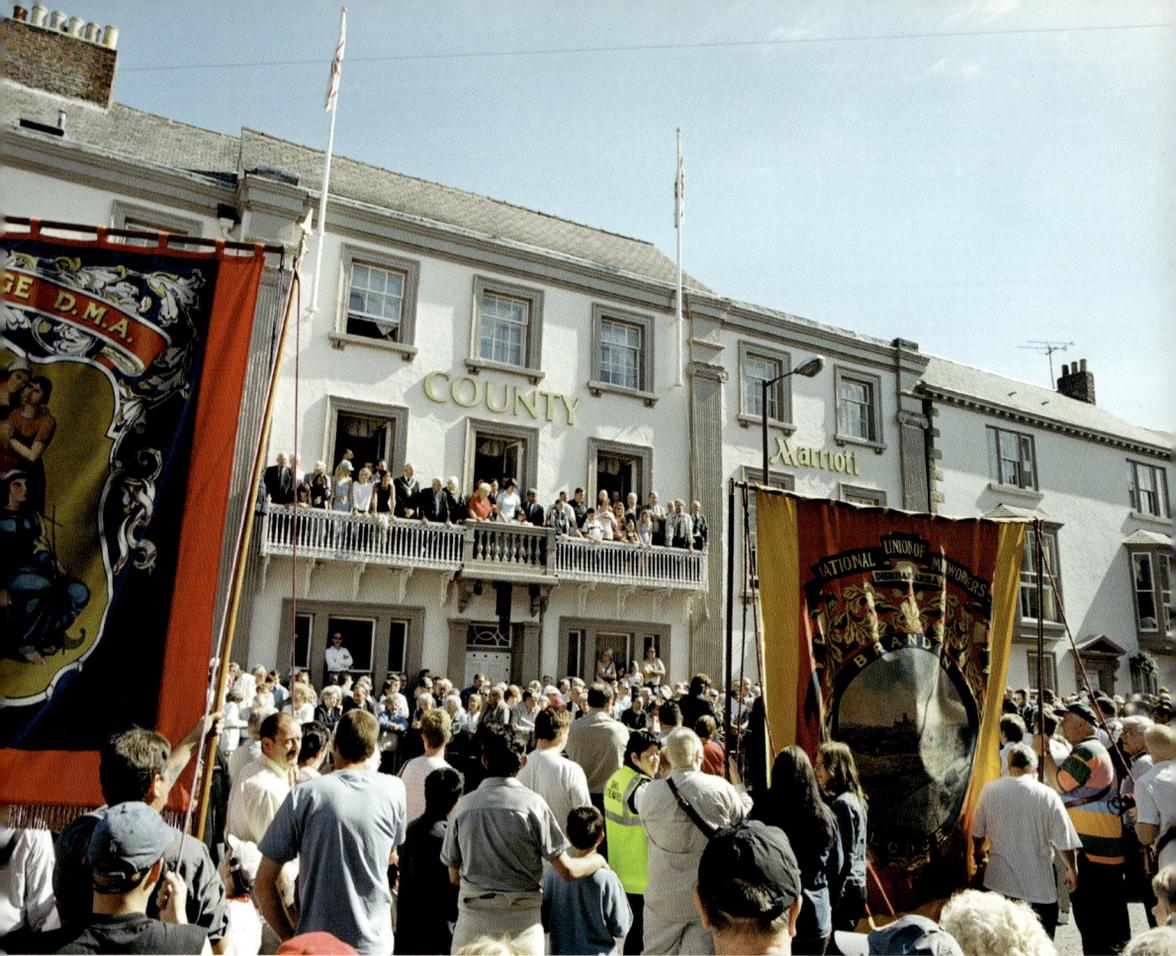

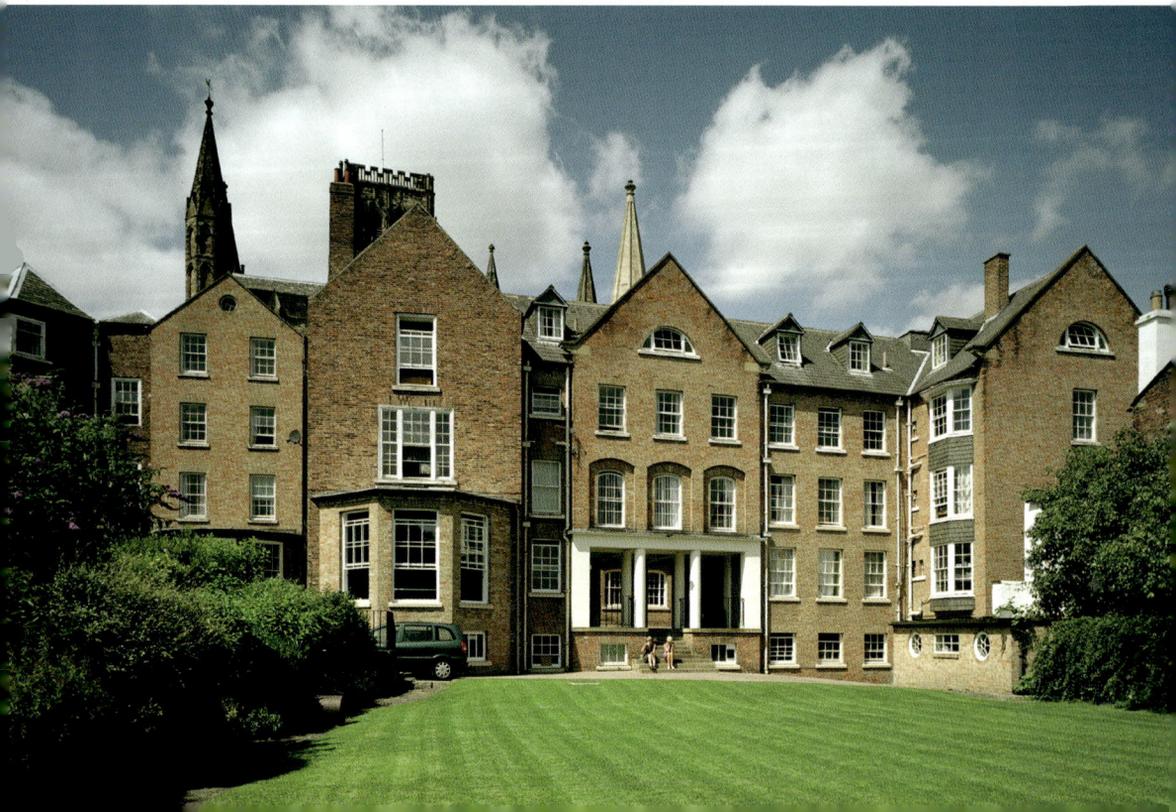

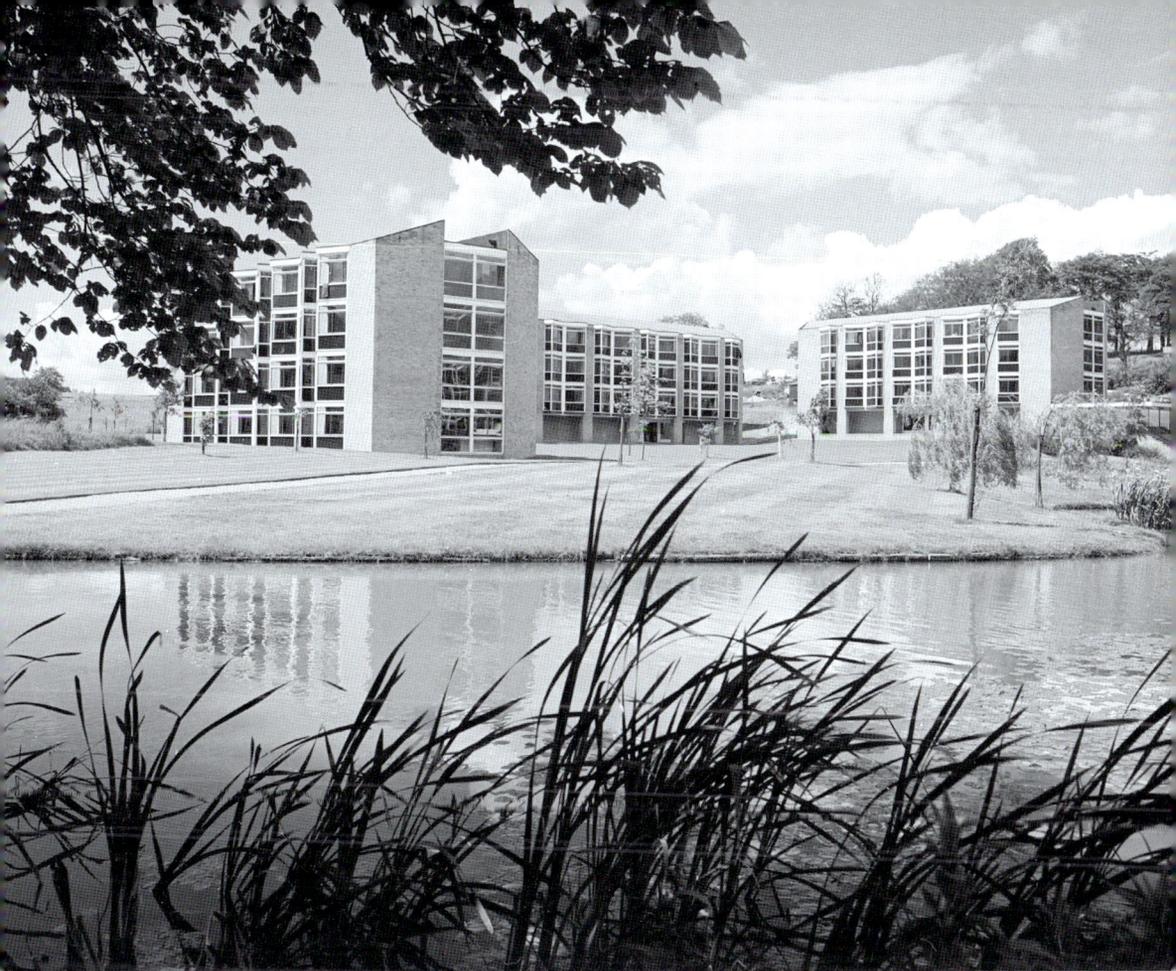

Above: Van Mildert College, Durham

Van Mildert College looks idyllic in this thoughtfully composed image by John Gay. Named to honour Durham's final prince-bishop, the college was founded in 1965. Built on South Road as one of the larger 'hill' colleges, it was designed by architects Middleton, Fletcher & Co. Over 1,000 students now occupy a leafy, lakeside environment. That must be an aid as well as a distraction to the learning process. (© Historic England Archive)

Opposite above: Miners' Parade, Durham

Lodge banners flying, miners gather around the County Hotel in Durham's Old Elvet. First held in 1871, the Durham Miners' Gala, or 'Big Meeting', is a celebration of coal-mining life and tradition. Although Durham's last colliery closed in 1994, the Gala continues, drawing large crowds to the city every year. Brass bands playing below the County Hotel balcony, shown here in 2002, add to the Gala's great sense of occasion. (© Historic England Archive)

Opposite below: Rear Elevation of St Chad's College

St Chad's theological college was established by Doncaster clergyman F. S. Willoughby with financial backing from businessman Douglas Horsfall. Located at first on South Bailey and then acquiring North Bailey property in 1925, St Chad's was Durham University's first independent hall. Although among Durham's smaller colleges, it now has around 500 students occupying fourteen listed buildings. Shown here is the rear of the neoclassical Main College, designed by Francis Johnson in 1961. (© Historic England Archive)

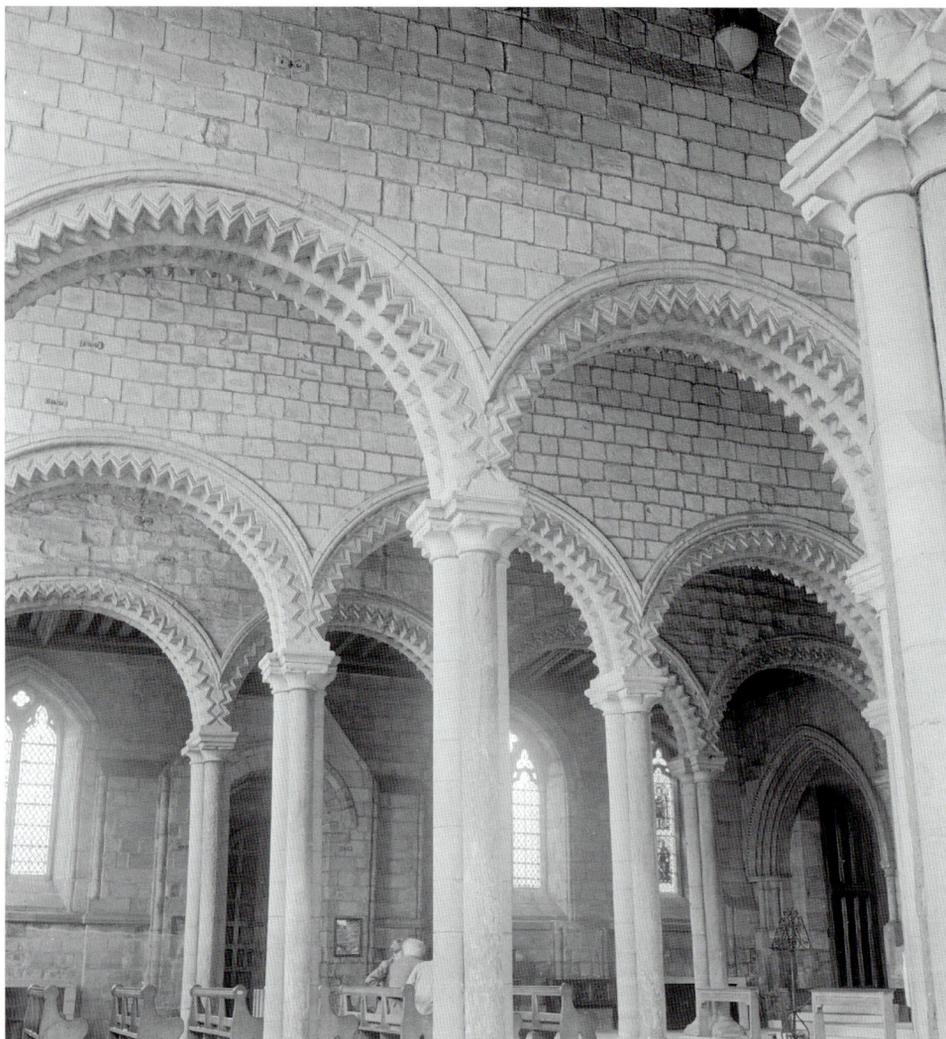

Above: Galilee Chapel, Durham Cathedral

After failed attempts to extend Durham Cathedral eastwards, Bishop Pudsey had the Galilee Chapel built at the west end around 1175. Galilee chapels or porches are traditionally associated with Christ's procession into Jerusalem and also functioned as a gathering place before entering the main body of the church. Durham's version is renowned for St Bede's tomb and remarkable for its transitional Romanesque architecture and rare medieval wall paintings. (© Historic England Archive)

Opposite above: Chapel of the Nine Altars, Durham Cathedral

At the east end of Durham Cathedral, but close to its spiritual heart, the Chapel of the Nine Altars was completed in 1280. Built to repair and extend the church, it also provided extra space for pilgrims who flocked to St Cuthbert's tomb. A series of altars dedicated to various other saints lined the east wall. Above them is the magnificent rose window, originally fifteenth century but reglazed in Victorian times.

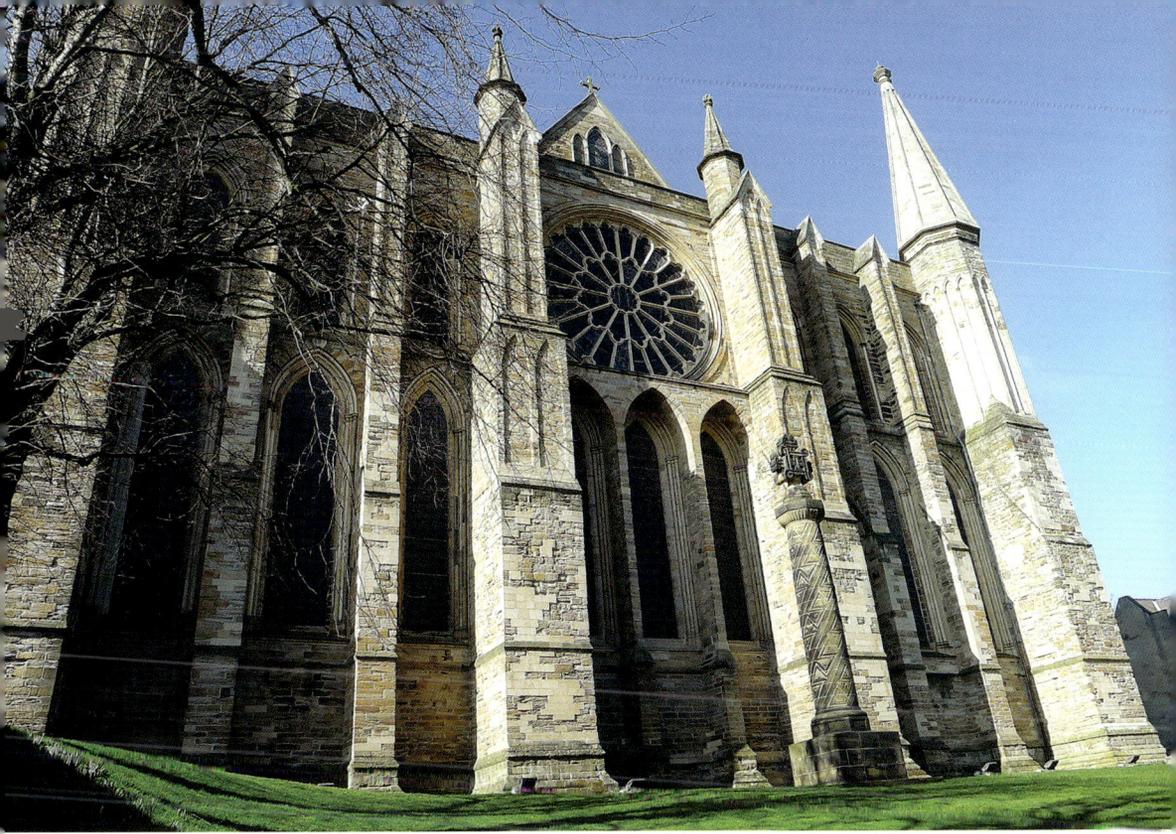

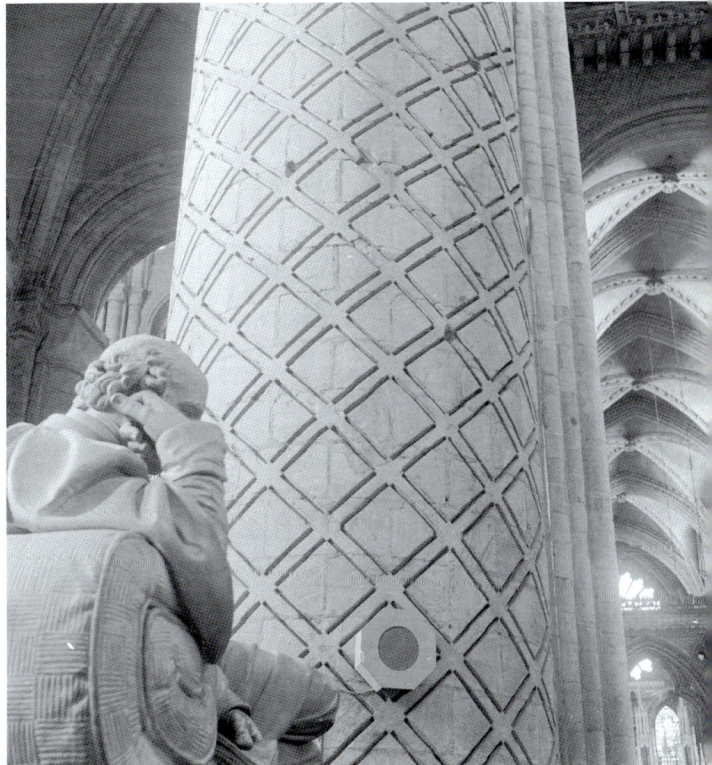

Nave of Durham Cathedral
Completed in 1133, Durham Cathedral's nave is dominated by massive piers, composite and round, typical of contemporary Norman architecture. Boldly decorated with geometric patterns, the circular piers are 27 feet high and almost 7 feet in diameter. It has been estimated that the monument to schoolmaster James Britton, seen here in the foreground, could fit inside any one of them. (© Historic England Archive)

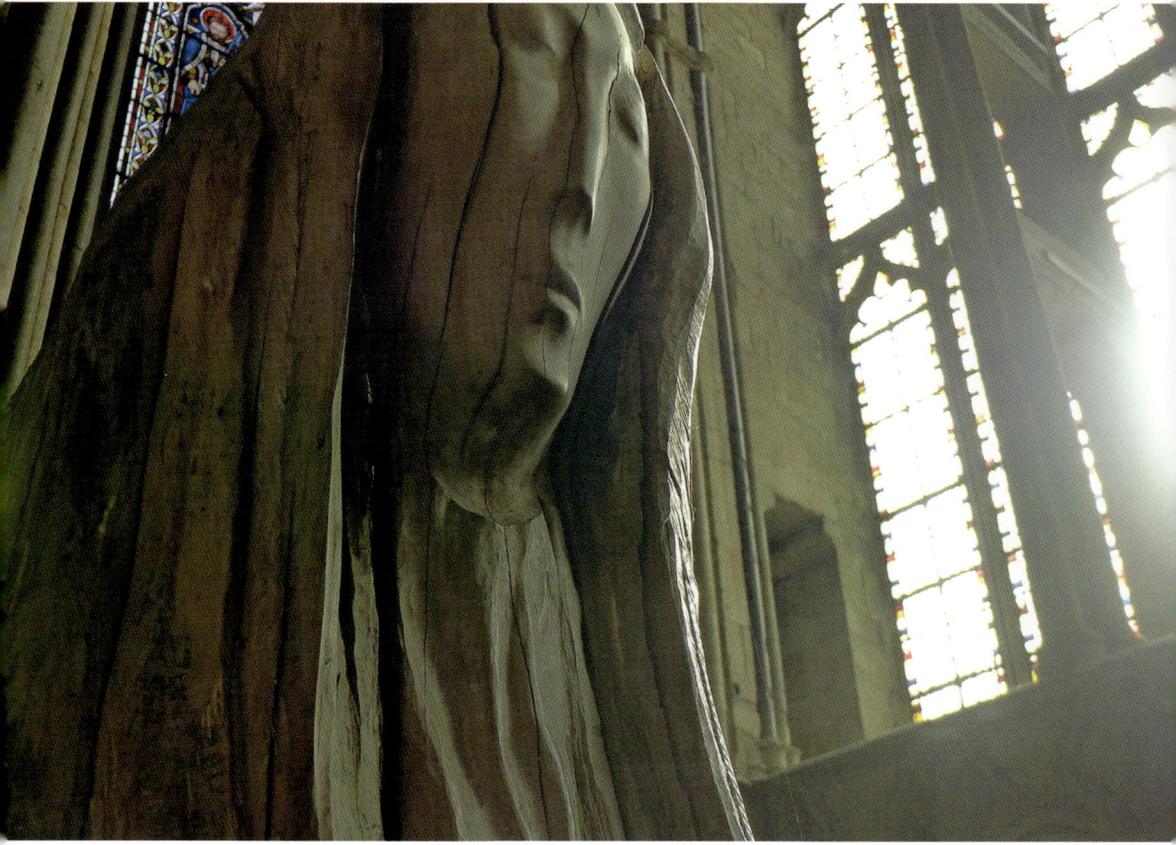

Above: Pietà, Chapel of Nine Altars
Medieval architecture and modern art combine in Durham Cathedral's Chapel of the Nine Altars. Made from beechwood and brass insets, the pietà is Fenwick Lawson's moving expression of humanity and religious belief. Local artist Lawson took almost seven years to carve the work, which was installed at York Minster before returning home to Durham in 2004. (Reproduced with permission of Durham Cathedral)

Opposite above: South Street, Durham
Despite its steepness, Durham's South Street was once an important thoroughfare. Stephenson's Locomotion No. 1 is believed to have been hauled up the paved street on the way to Shildon in 1825. Long since superseded by gentler routes, the former highway is now a one-way street. To the top left of this early twentieth-century image of lower South Street, the first Durham Johnston School can be seen, established in 1899. (Historic England Archive)

Opposite below: North Road, Durham
Laid down during William IV's reign, Durham's North Road became a thriving shopping street when the railway came. Relatively cheap rail travel in the later nineteenth century encouraged mining families from around the city to spend their wages in North Road's wide range of shops. The railway viaduct is just visible in the background and the copper-domed Miners' Hall on the left (built in 1875) brought a touch of class to a rough but always ready street. (Historic England Archive)

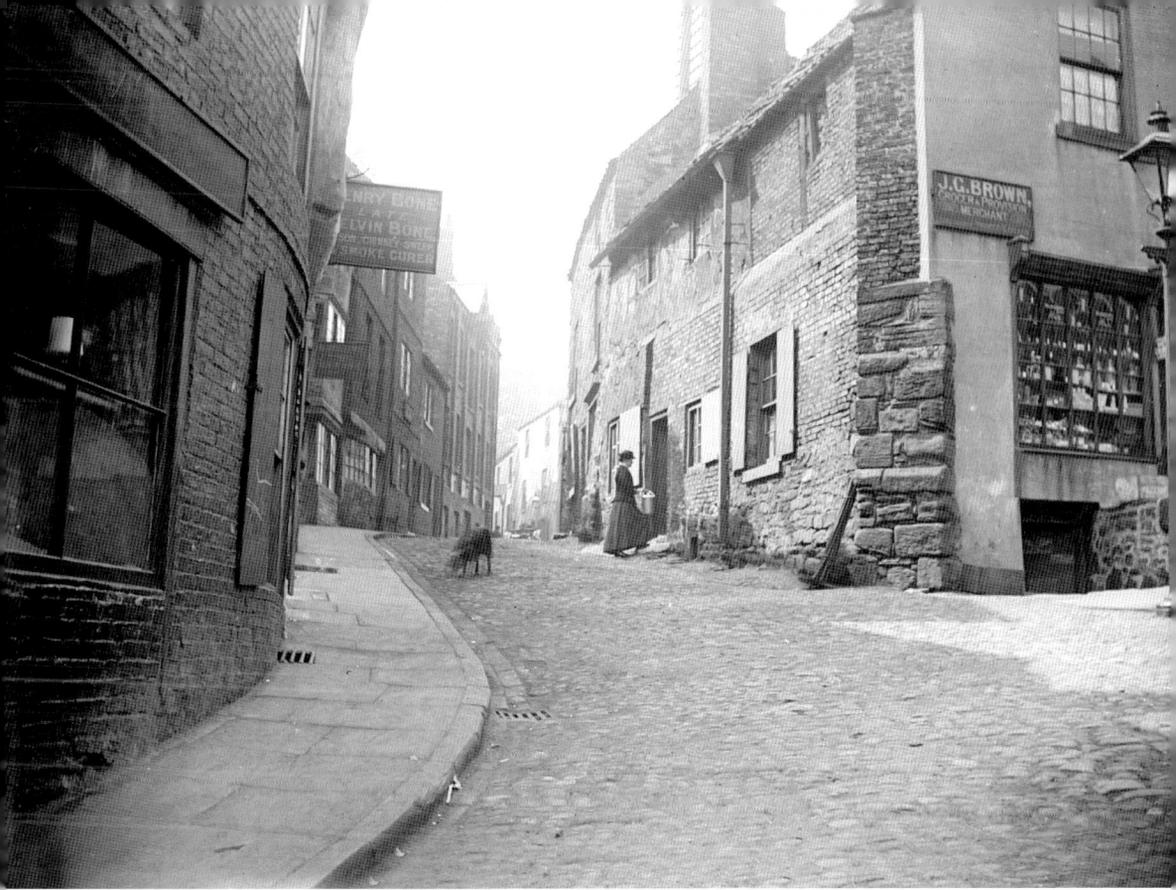

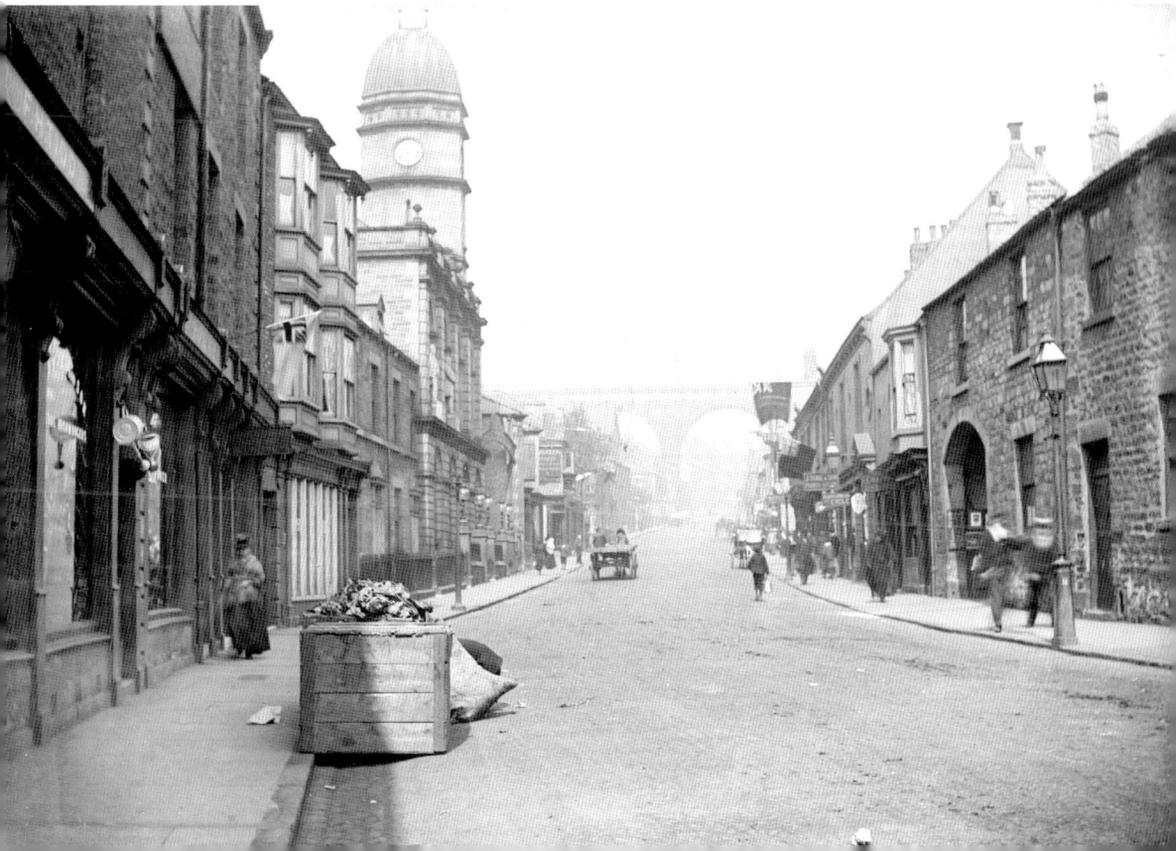

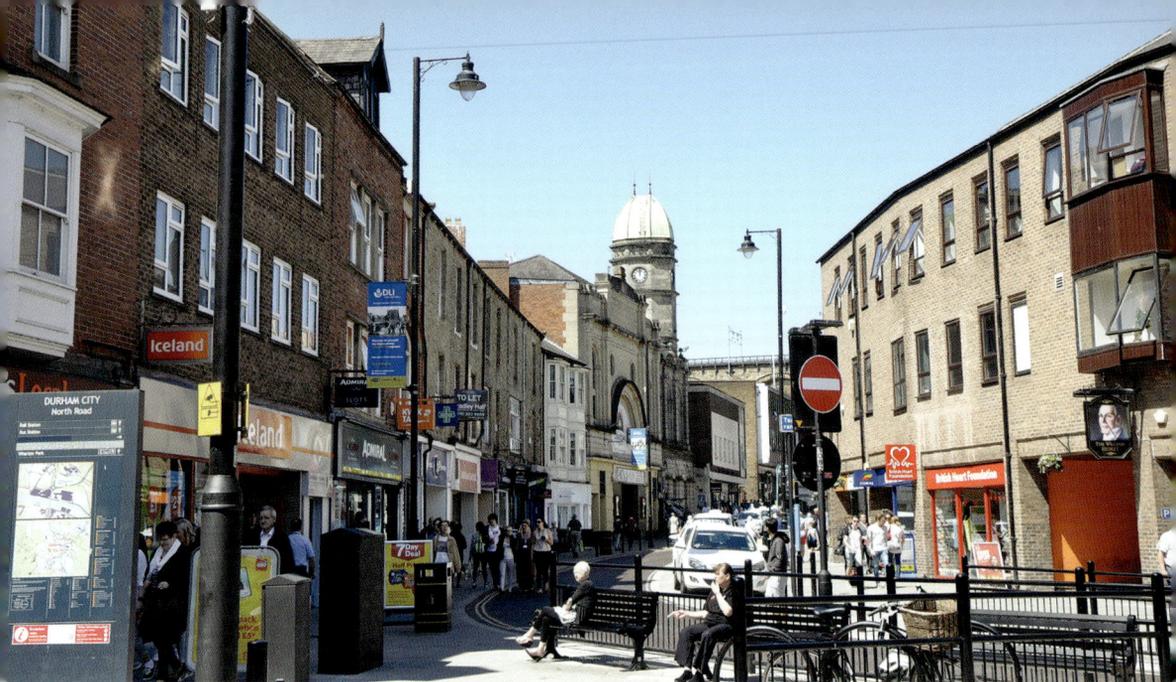

Above: North Road

Durham's North Road has kept its familiar landmarks. The dome of the former Miners' Hall is unmistakable. Vacated by the Miners' Union in 1915, the hall eventually reopened as the Regal Cinema in 1934. A long-standing 'picture palace', it has been a pub and is now a music venue. Just remaining in sight is the majestic railway viaduct, built in 1856 and still watching over North Road and the city beyond.

Below: Cosin's Hall

One of many fine buildings grouped around Durham's Palace Green, Cosin's Hall dates from the early eighteenth century. Known as Archdeacon's Inn and then University House, its present name was adopted in the 1850s when it was used for accommodation and lectures by Durham's new university. Eric de Mare stood back to record this image and a closer inspection is required to appreciate the hall's exquisitely carved door canopy. (Historic England Archive)

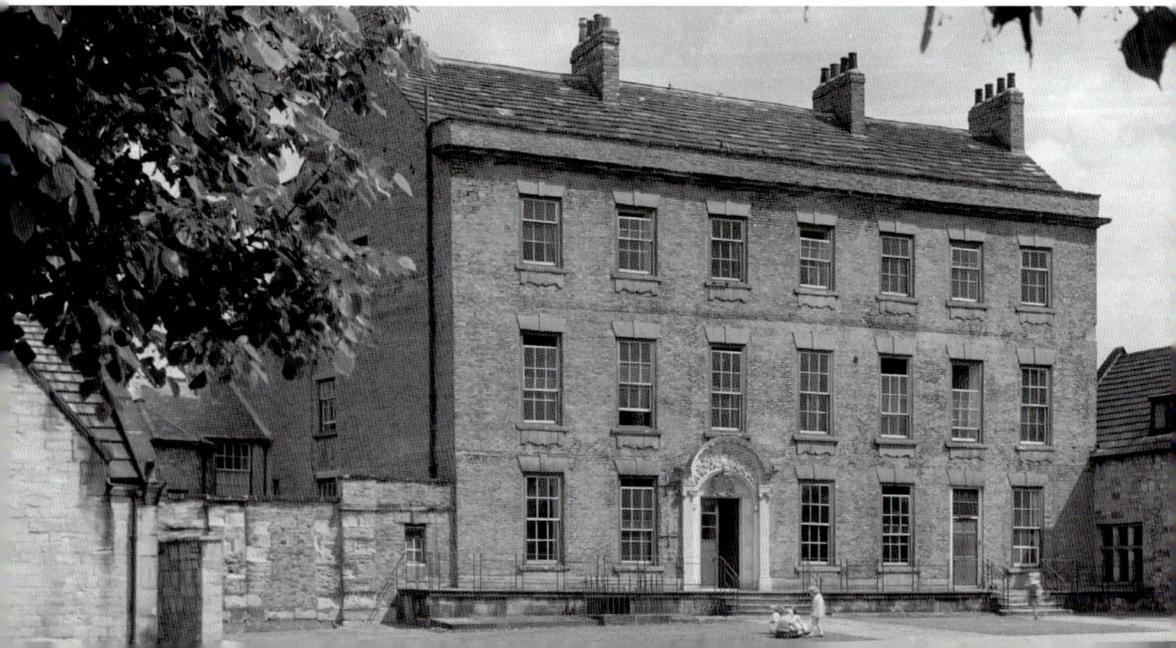

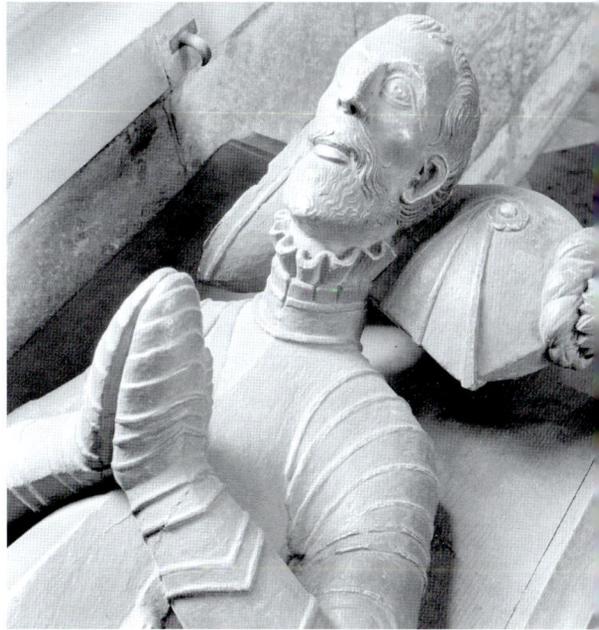

John Heath Monument

Resembling as much a medieval knight as an Elizabethan gentleman, the wooden effigy of John Heath lies in Durham St Giles. His head rests on a helmet with a cockscomb attached – part of the Heath family crest. The family prospered after coming to Durham, residing at Kepier and Old Durham manors. Heath, who died in 1591, reminds us all of our fate. His tomb is inscribed *'Hodie michi, cras tibi'* – 'here today, gone tomorrow'. (Historic England Archive)

Church of St Giles

Overlooking Durham City, the Church of St Giles was dedicated by Bishop Flambard in 1112. Constructed originally as a chapel for the Hospital of St Giles, the church narrowly escaped destruction in 1144 during Scottish attempts to overthrow the prince-bishop. A proposal to demolish the parish church in 1868 was also resisted and St Giles has been subsequently enlarged, restored and awarded Grade I-listed status.

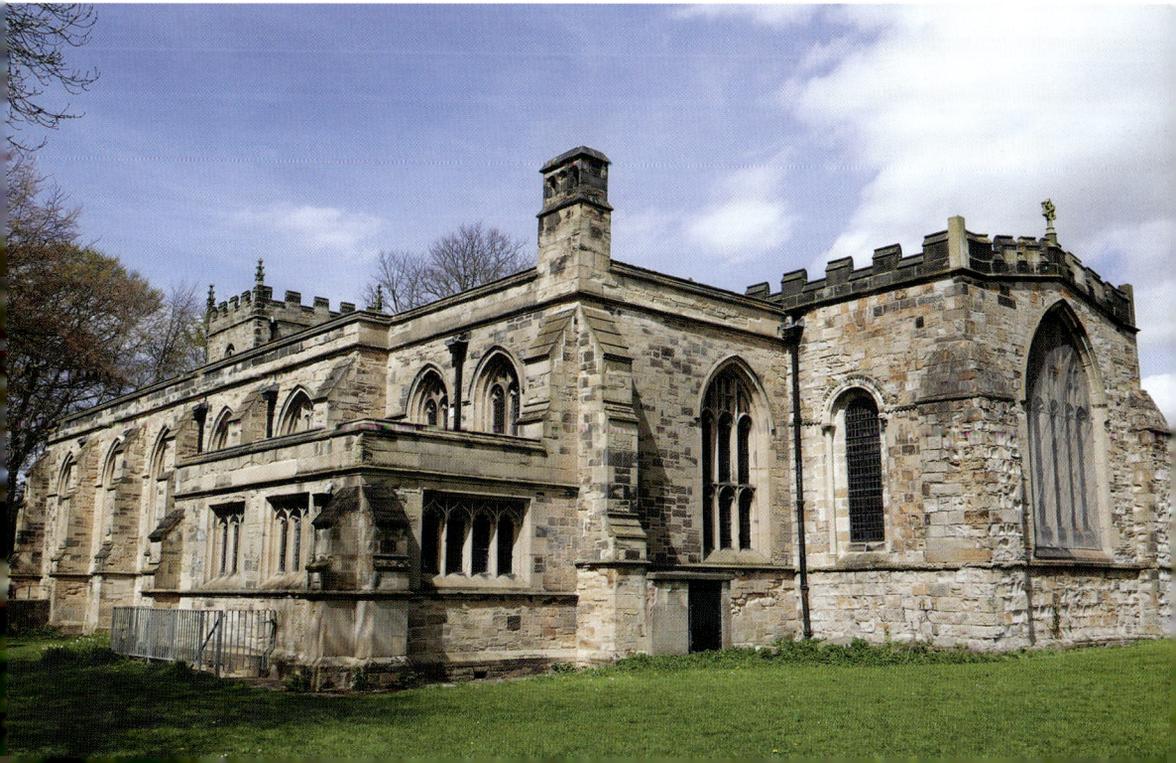

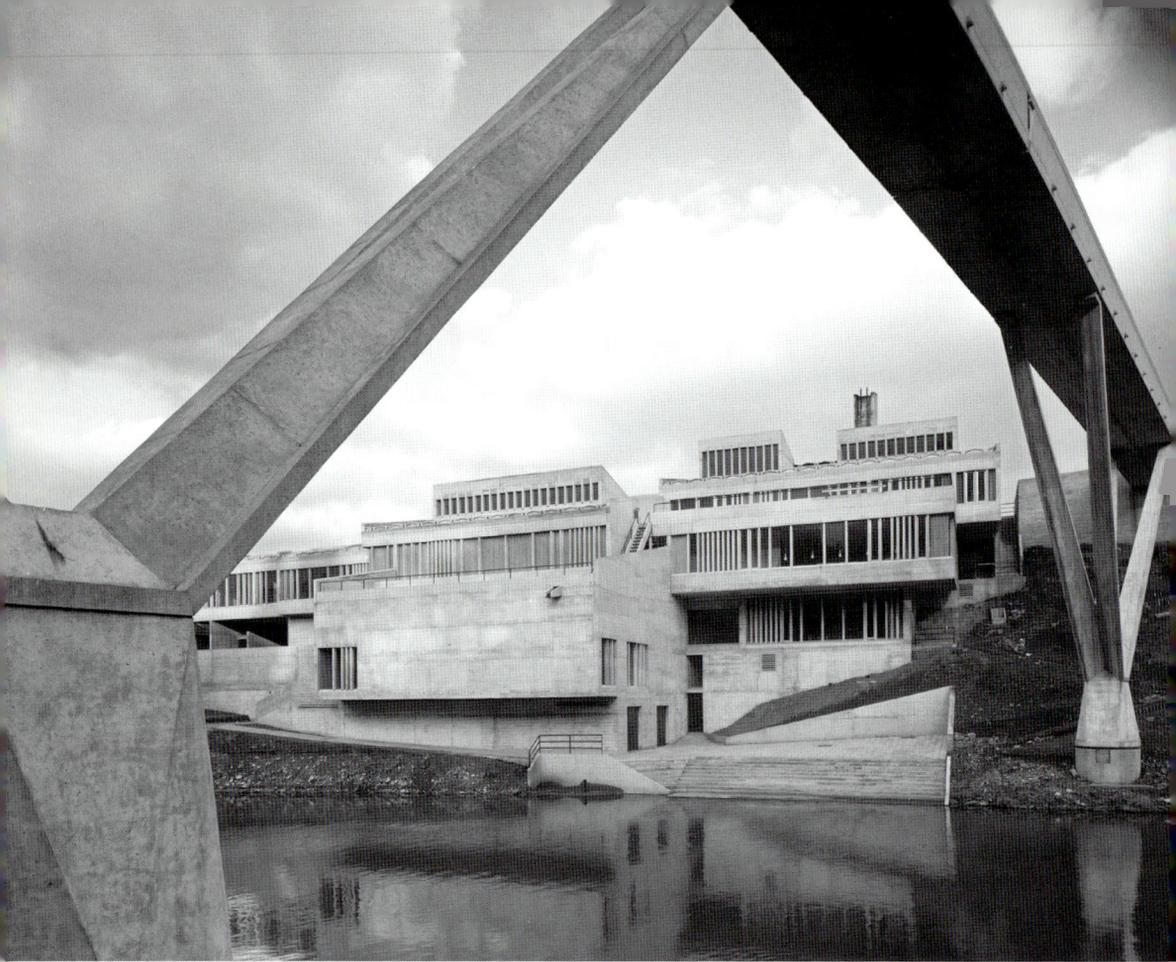

Above: Dunelm House and Kingsgate
Dunelm House (the Student Union building) and the adjacent Kingsgate Bridge were designed by Architects Partnership, supervised by Anglo-Danish 'engineer and philosopher' Ove Arup. Fiercely brutalist in design, both structures (unlike many of their contempories) have been highly praised. Built between 1961 and 1965, they stand on historic ground. Kingsgate was on an ancient river crossing, reputedly used by William the Conqueror in 1072. (© Historic England Archive. John Laing Collection)

Opposite above: Christ the King Church, Bowburn
Marvellously quirky yet now demolished, the church of Christ the King at Bowburn near Durham was designed by Harold Wharfe and dedicated in 1978. Influenced by the Festival of Britain, the futuristic church was accompanied by a space age freestanding spire. The former mining village Bowburn was nicknamed 'Rocket City' but its 'pineapple' church, which was expensive to maintain, was knocked down in 2007. The steeple was blown down in a storm two years later. (© Historic England Archive)

Opposite below: Maidens Bower
Known as the 'Maidens Bower', this prehistoric burial mound lies hidden in Flass Vale, a quiet woodland enclave within walking distance of Durham city centre. Never excavated, the round-topped cairn is believed to have Bronze Age origins. However, it also has a more recent claim to fame. During the Battle of Neville's Cross in 1346, monks climbed to the top of the ancient barrow and prayed for an English victory. (© Historic England Archive)

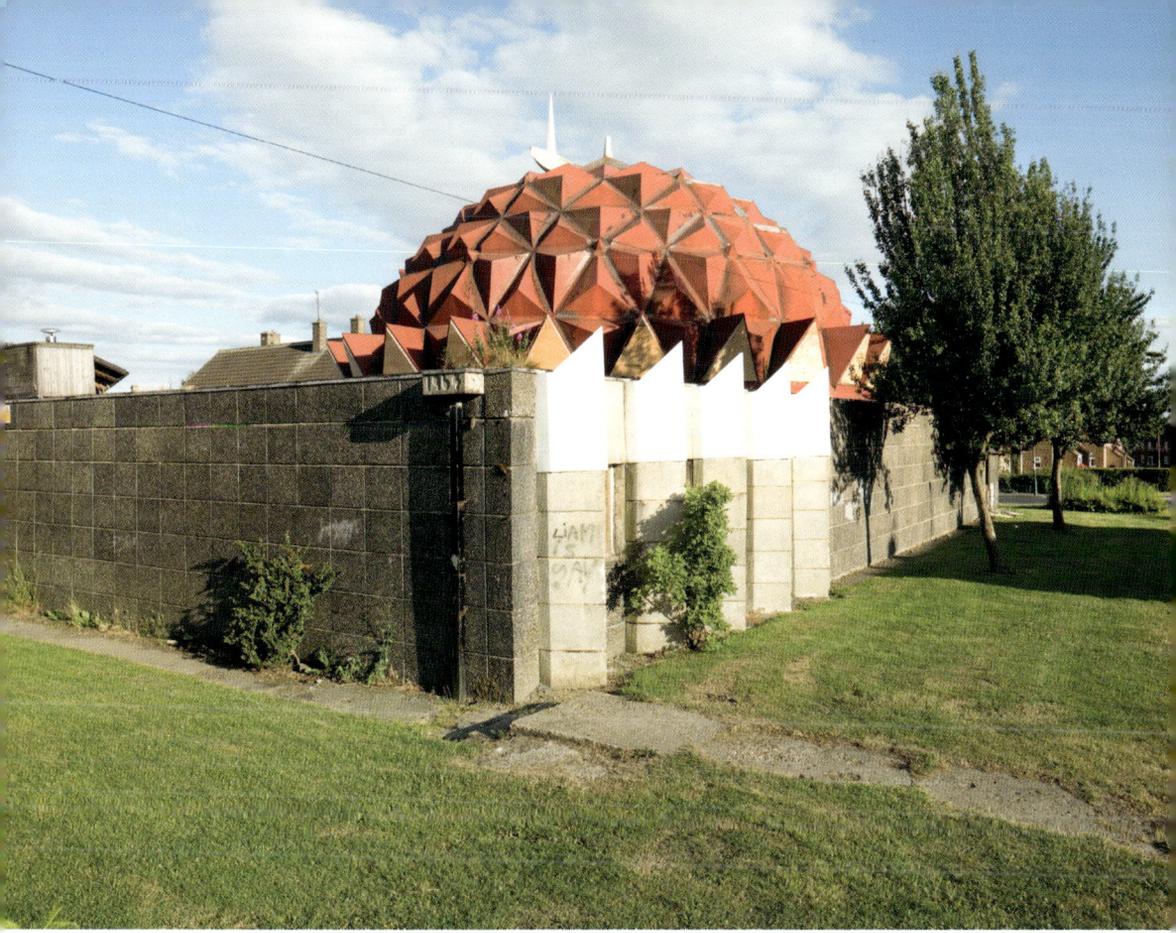

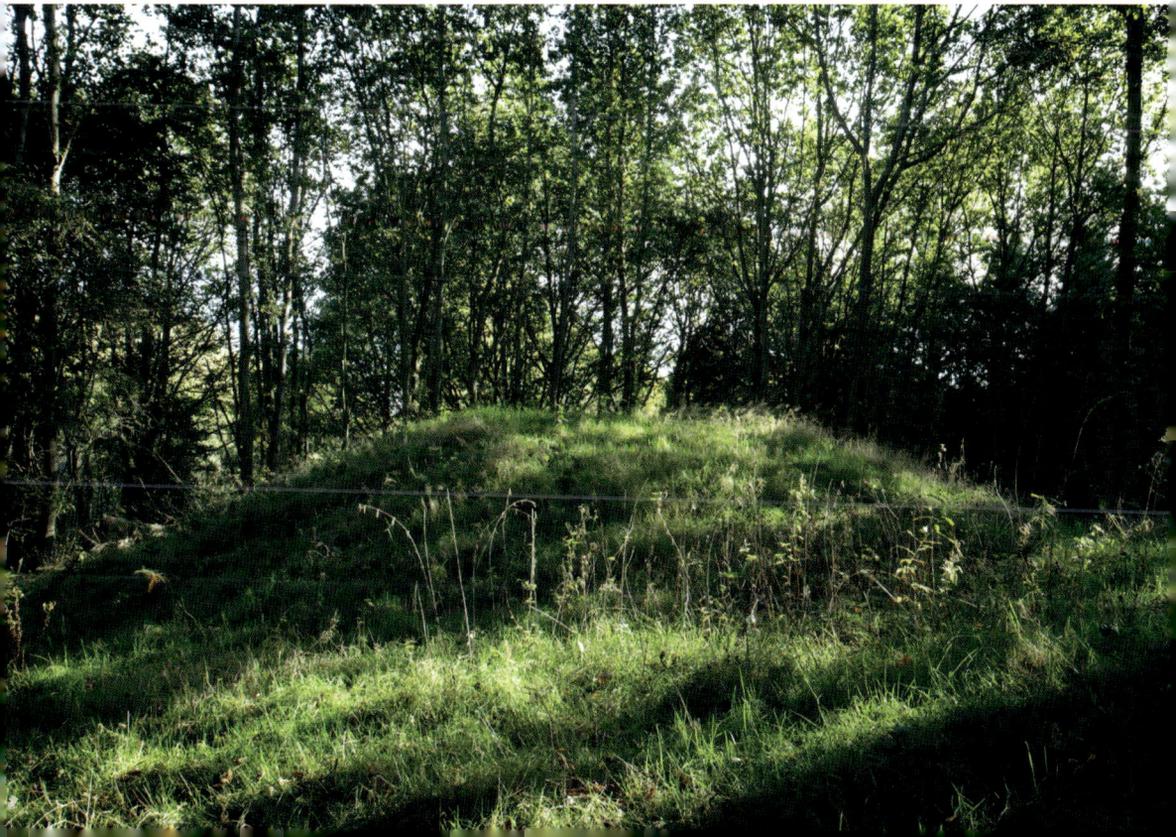

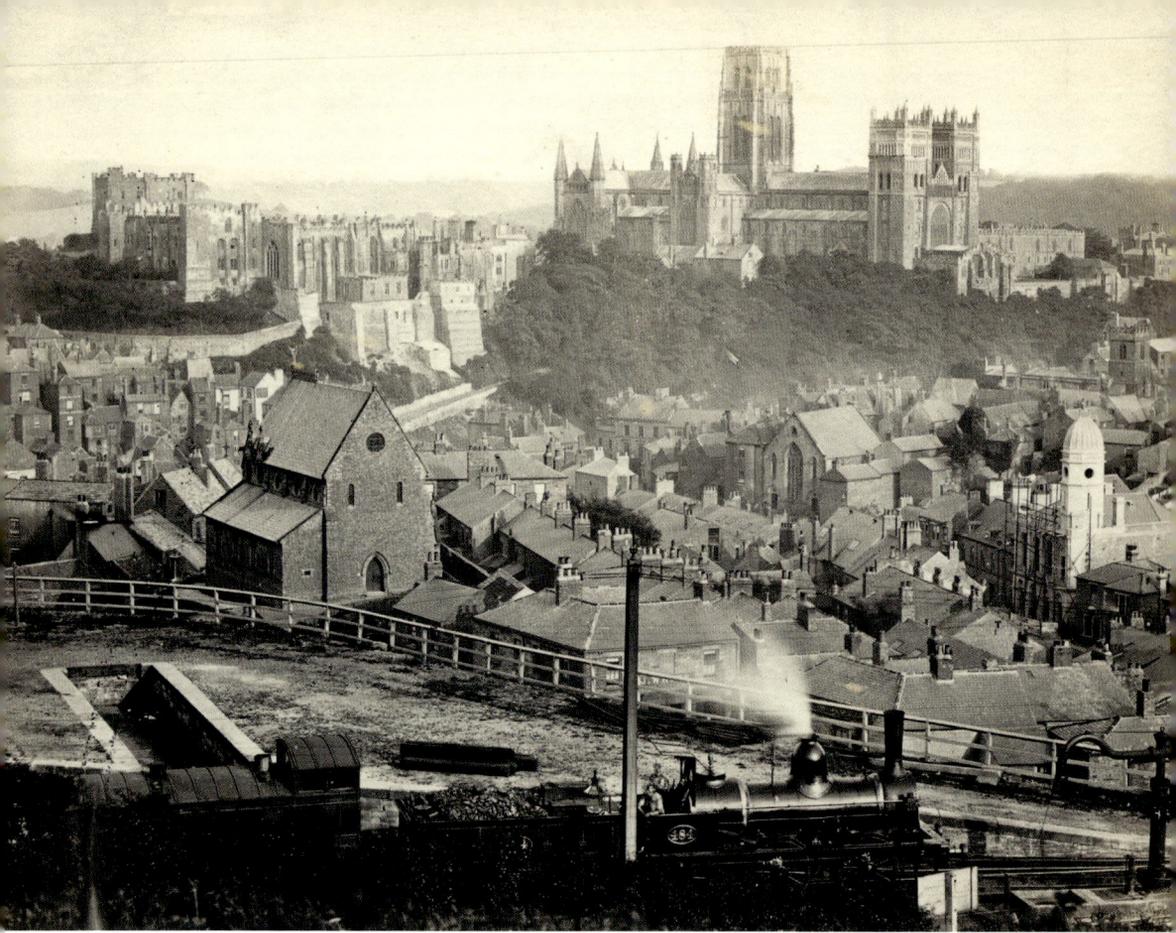

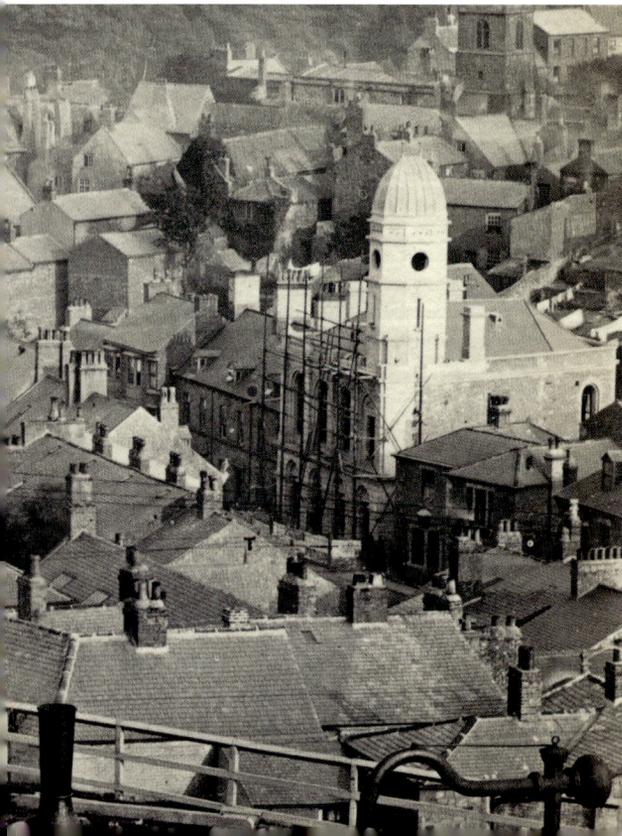

Panorama of Durham

Looking from Wharton Park over the railway station, this quintessential Durham city panorama was taken in 1875. Ever since opening in 1857, the park has provided breathtaking views and is a perfect vantage point for the photographer. In this image, the cathedral and castle are supreme as always, but on the right notice the shining new Miners' Hall on North Road. On the left, St Godric's Catholic Church awaits its west tower, added in 1909. (Historic England Archive)

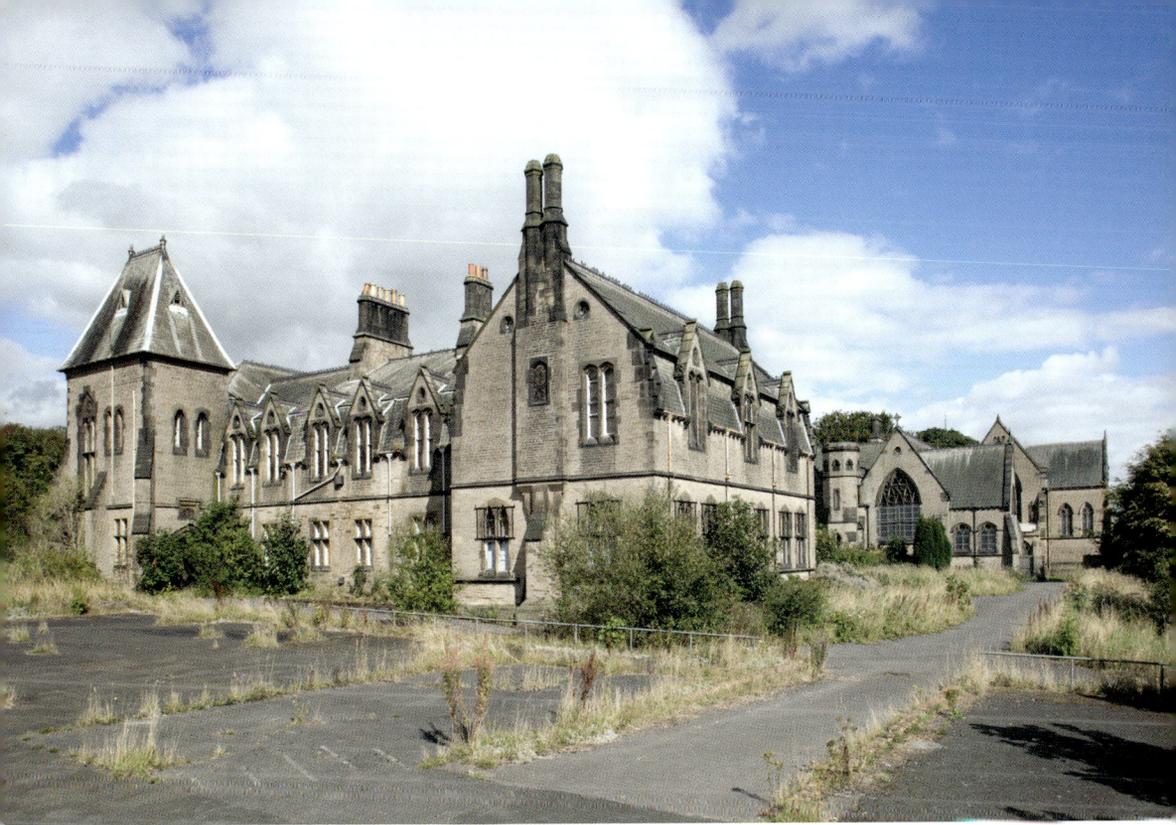

Ushaw College

After generations of exile in France, Catholic scholars established a new theological college at Ushaw, outside Durham City, in 1808. An outstanding complex of buildings arose on Ushaw's rural site, designed by celebrated architects such as Augustus Pugin and Joseph Hansom. Although closed in 2011, much of the former Catholic seminary has now reopened for public visits and events. Junior House, however, seen neglected here in 2012, still requires extensive renovation. (© Historic England Archive)

County Durham

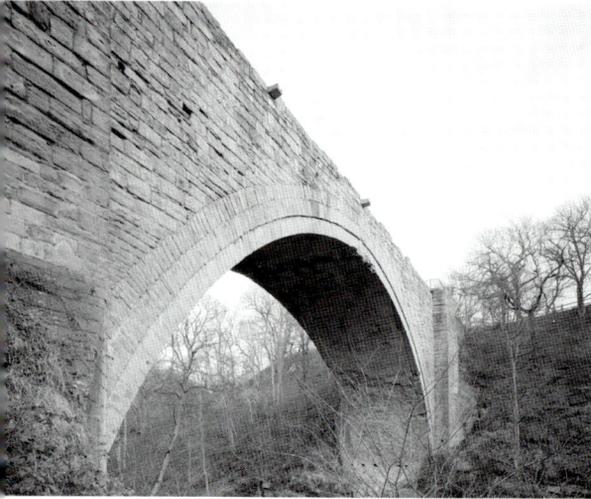

Causey Arch

Causey Arch, near Stanley, is much more than a Georgian bridge. Constructed by local stonemason Ralph Wood, it was opened in 1727 and is the world's oldest standing railway bridge. Achieving a feat of engineering not seen since Roman times, Wood spanned the cavernous gorge of the Causey Burn with a 105-foot single archway. In use until around 1800, it was part of a waggonway that carried coal to the River Tyne. (© Crown copyright. Historic England Archive)

Lumley Castle

Lumley Castle's ornate Garter Room is illustrated here by architectural photographer Herbert Leo Felton. One of County Durham's best-preserved castles, Lumley was restored in the 1720s by Sir John Vanbrugh. He also left plans for the Banqueting Room and Ballroom, afterwards known as the Garter Room. Still pristine, its baroque plasterwork is attributed to Pietro La Francini and is now an elaborate backdrop to conferences and wedding receptions. (Historic England Archive)

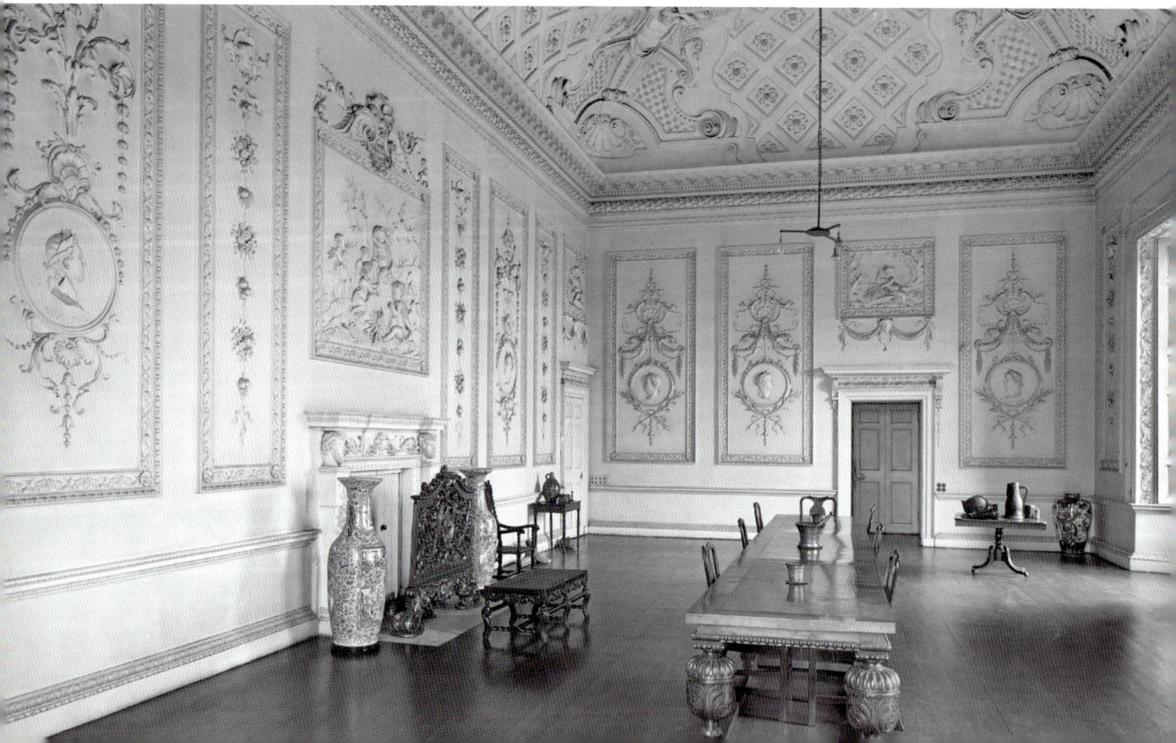

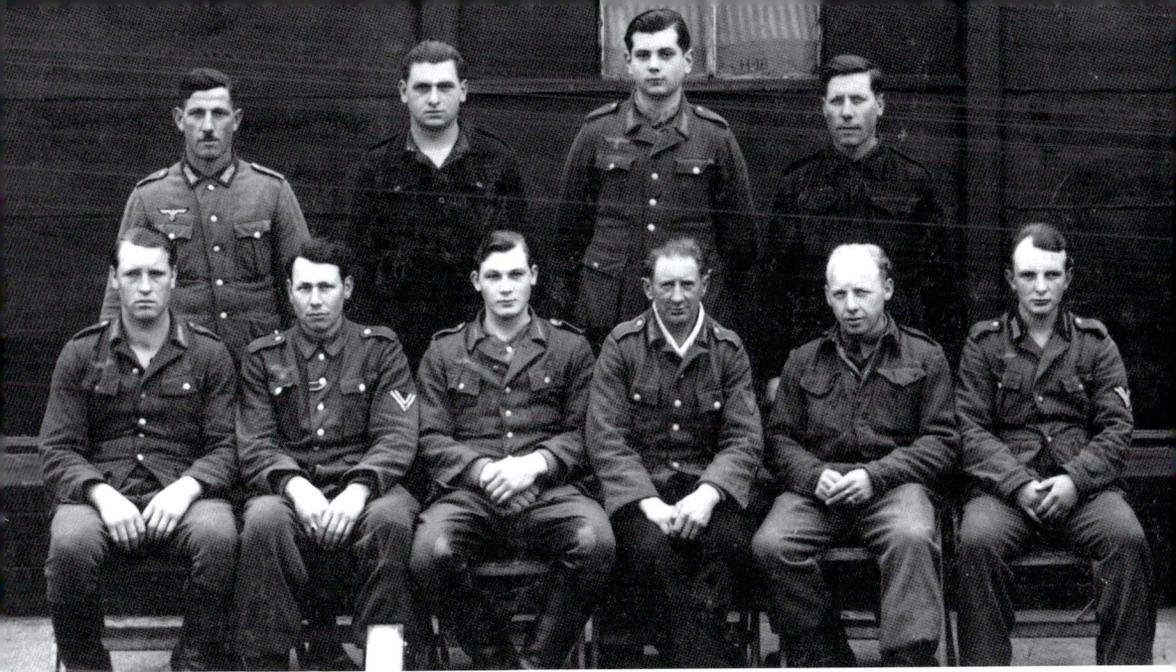

Harperley Camp

Harperley Camp in Weardale was built largely by Italian POWs in 1943. One of almost 500 similar internment camps built across Britain during the Second World War, its fifty single-storey brick and asbestos-roofed huts were intended to house up to 1,400 prisoners. After their country surrendered in 1943 many Italian's were transferred out of Harperley. They were replaced by Germans, some of whom must be the glum inmates pictured here. (Historic England Archive)

Shotley Spa

Shotley Bridge is famed for sword making but almost forgotten for its spa. 'Taking the waters' was popular here in the nineteenth century and the spa, or Hally Well as it was known locally, was on the outskirts of the village beside the River Derwent. Contamination from Consett Ironworks is claimed to have ruined the spa as a visitor attraction and now cricket is played on the site instead. (Historic England Archive)

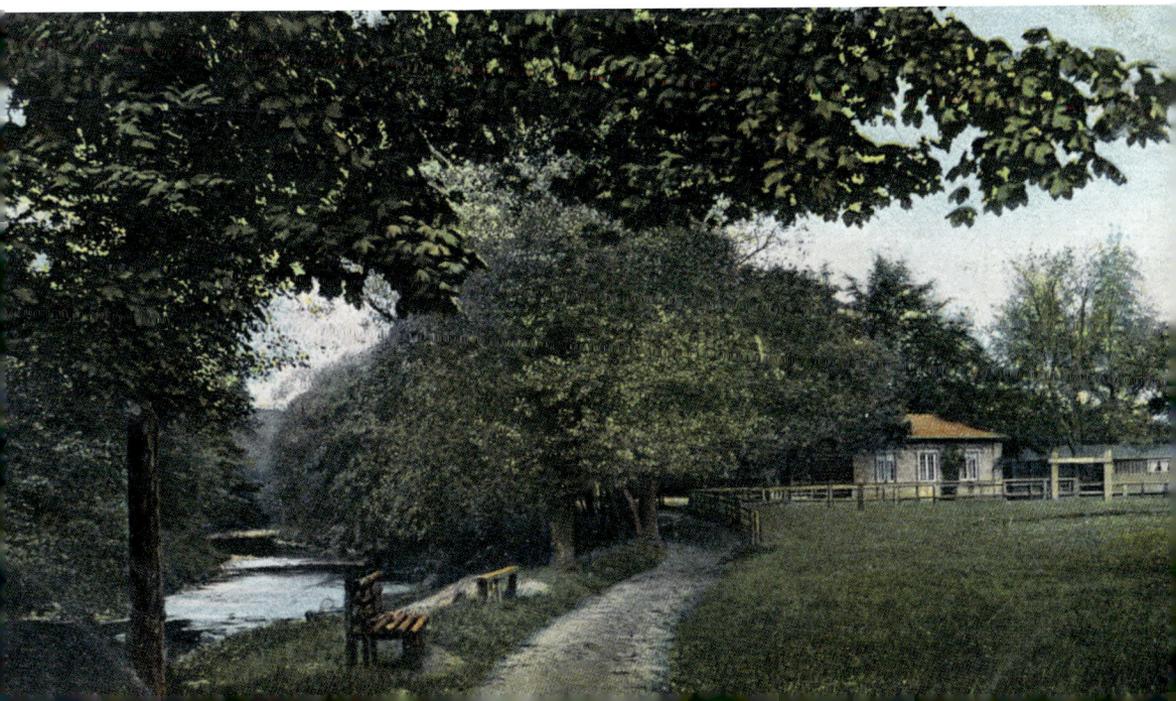

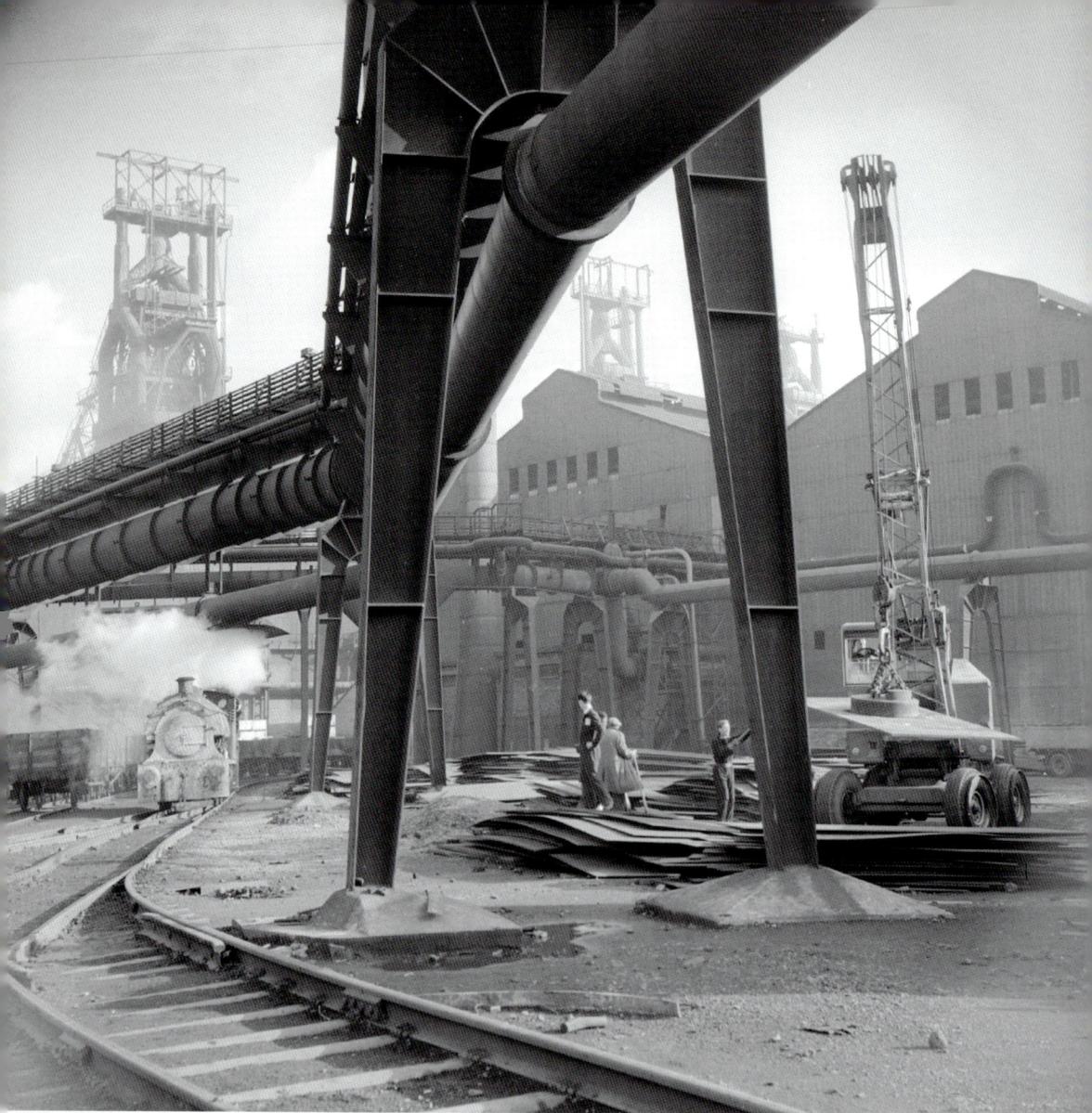

Above: Consett Steelworks
Eric de Mare's dramatic image perfectly frames the former Consett Steelworks. The town grew up around the metalworks after the formation of the Derwent Iron Co. in 1840. Steel making began in 1881, rivalling Sheffield for its quality and employing thousands. But closure of the works in 1980 dealt Consett an economic blow from which it has not yet fully recovered. (Historic England Archive)

Opposite above: Urpeth Lodge
One of County Durham's less publicised country houses, Urpeth Lodge stands in an elevated position a few miles north-west of Chester-le-Street. Built in the eighteenth century, the five-bay, two-and-a-half-storey house was the residence of William James Joicey, High Sherriff of Durham. Immaculate lawns and a sweeping drive lead onto an incongruous front porch, an obvious later addition to the plain façade. (Historic England Archive)

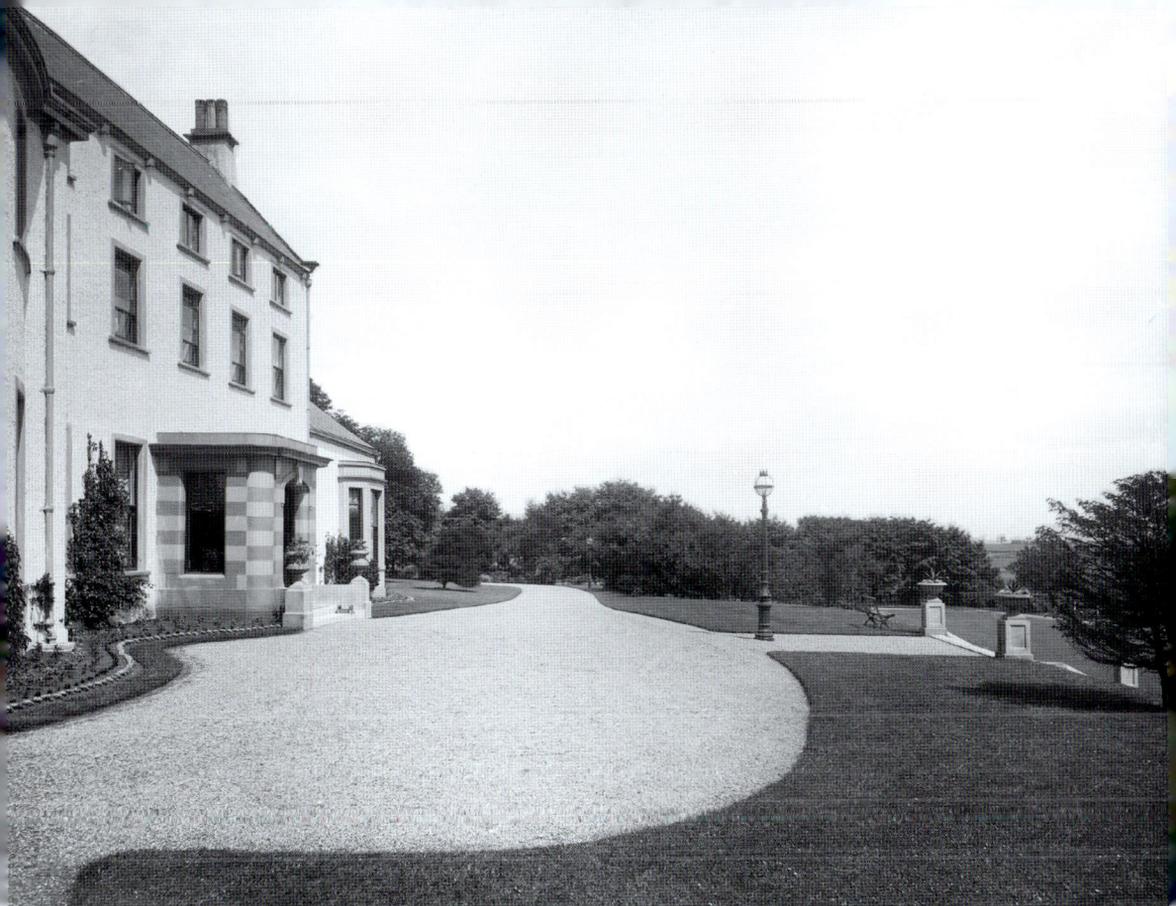

Urpeth Lodge Interior
Coal trade profits helped to pay for the lavish interior of Urpeth Lodge. The Joicey family were prominent mine owners and in 1890, when this photograph was taken, their numerous collieries around Urpeth had a combined yearly output of over 1.5 million tons. Sopwith & Sons of Newcastle supplied the drawing room furniture seen in this image from the Lemere Co. files. (Historic England Archive)

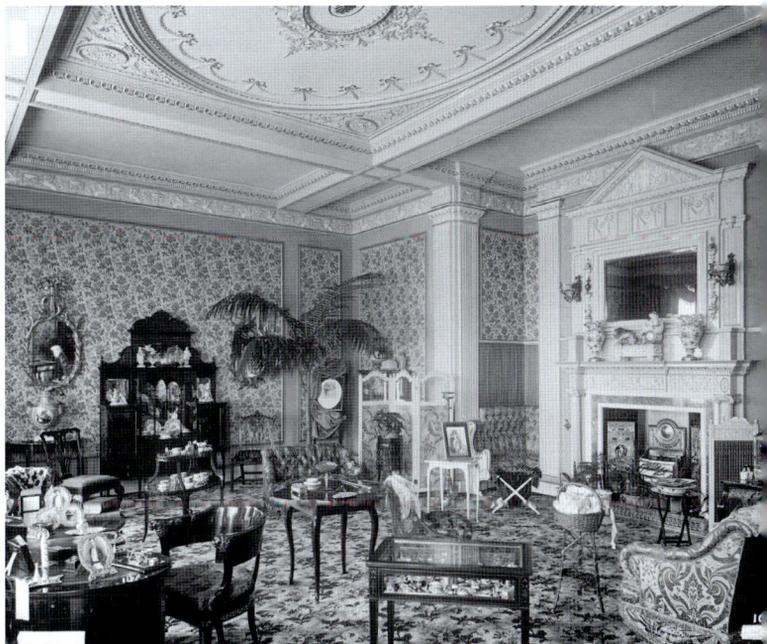

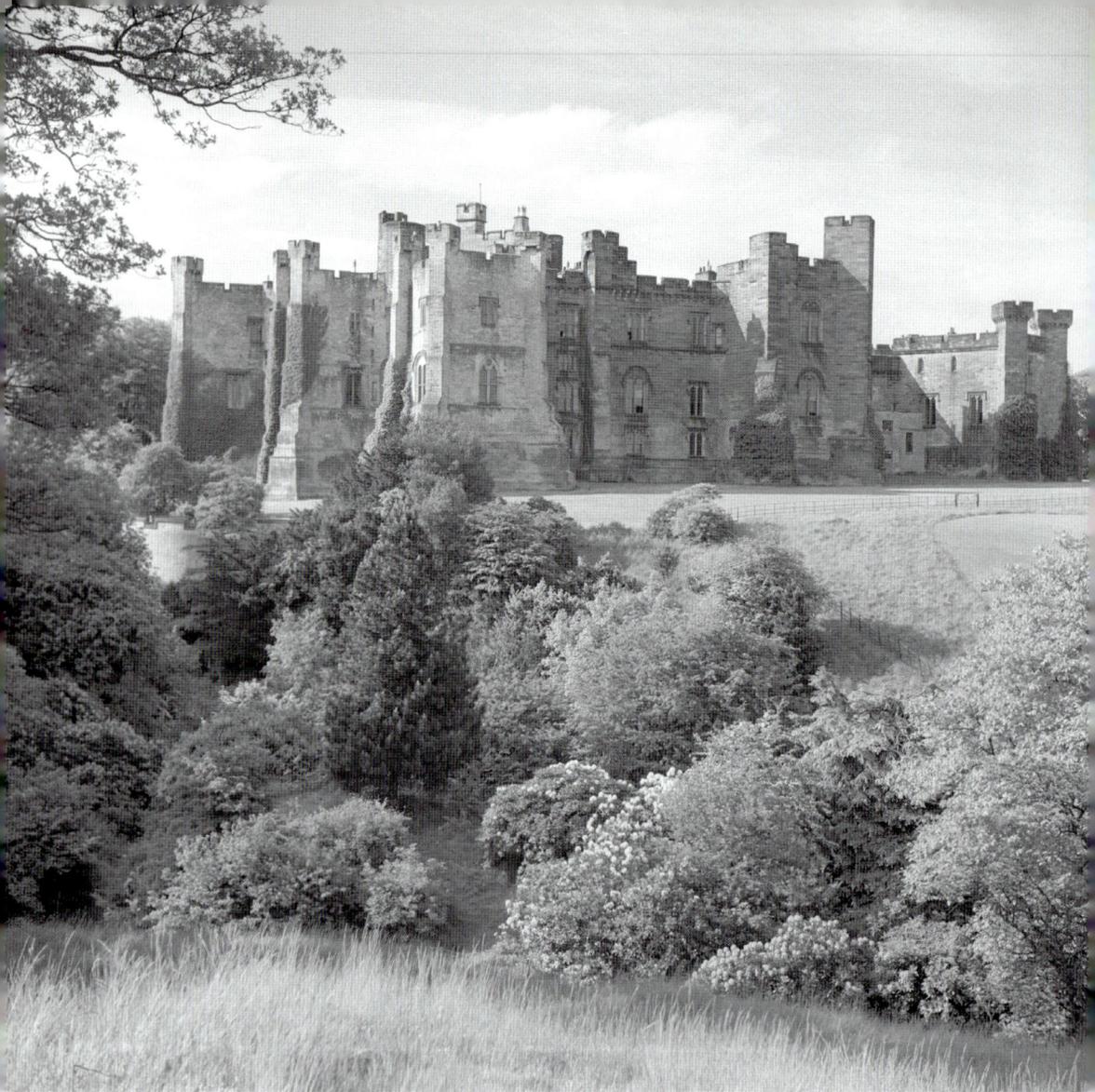

Above: Brancepeth Castle
Brancepeth Castle was held by County Durham's mightiest dynasty. This Norman stronghold was occupied and strengthened by the Neville family until it was confiscated in 1569 as punishment for their part in the failed Rising of the North. Consequently the castle changed owners several times and is now in private hands. What stands today is a nineteenth-century fantasy created by coal magnate Matthew Russell and his Scottish architect John Paterson. (Historic England Archive)

Opposite above: St Brandon's Church, Brancepeth
Historic woodcarving like this was tragically destroyed in 1998 by a fire that left only the walls of St Brandon standing. Possibly of Saxon foundation, the church was particularly celebrated for the magnificent woodwork of its interior, installed by John Cosin after he became rector of Brancepeth in 1626. Everything was incinerated, including the old parish chest and altar recorded here by Eric de Mare. (Historic England Archive)

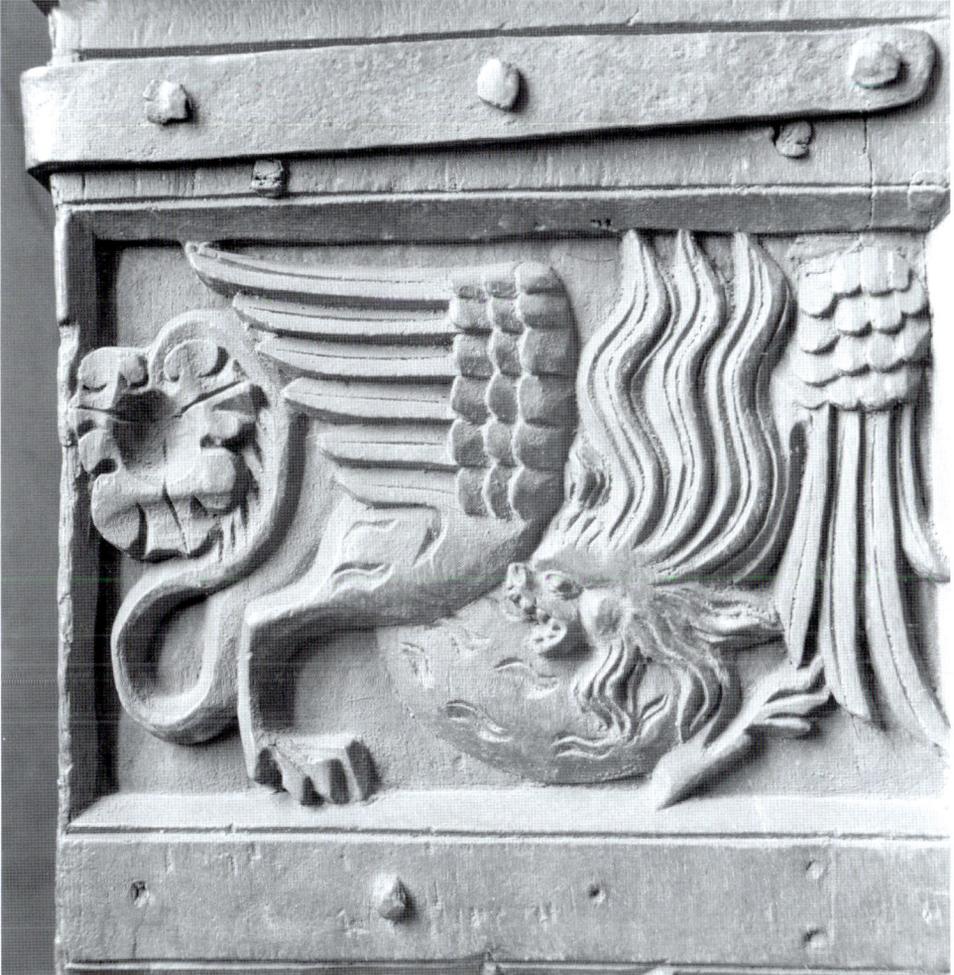

All Saints' Church, Lanchester
What seems to be a bishop's head peers
across the nave of All Saints' Church in
Lanchester. It has Norman or possibly Saxon
origins and its builders liberally reused
stone from Lanchester's Roman fort of
Longovicium. Lanchester was an important
parish in medieval times, reflected by the
size and architectural quality of its church.
Inside All Saints' is a memorial to railway
pioneer William Hedley who lived nearby.
(Historic England Archive)

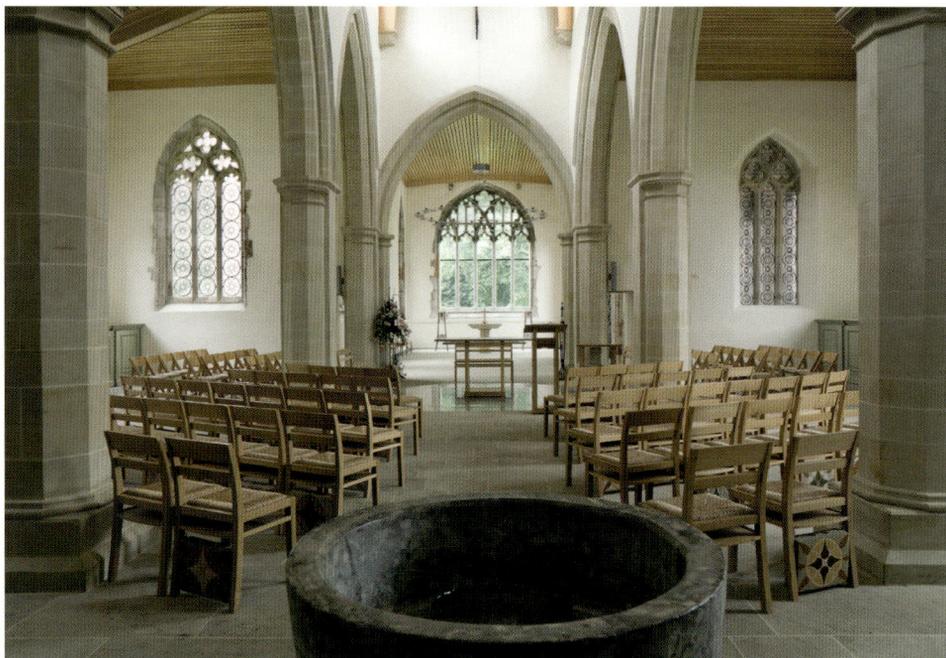

Above: St Brandon's Interior

Following a total renovation costing over £3 million, St Brandon's was rededicated in 2006. What had formerly been a dark and traditional church interior was transformed into a light and modern place of worship. As a finishing touch, a new stained-glass window was added to the east end of the building in 2014. (© Historic England Archive)

Below: Seaham Hall

Under Seaham Hall's new skin lies an old and prestigious history. Now a luxury hotel and spa, the hall was built as a seaside residence for the Milbanke family in 1791. Sold to the future Lord Londonderry in 1821, this rather plain house later served as a sanatorium and hospital before first becoming a hotel in 1985. Seaham Hall's historic guest list includes the Duke of Wellington, Disraeli and Byron. (© Historic England Archive)

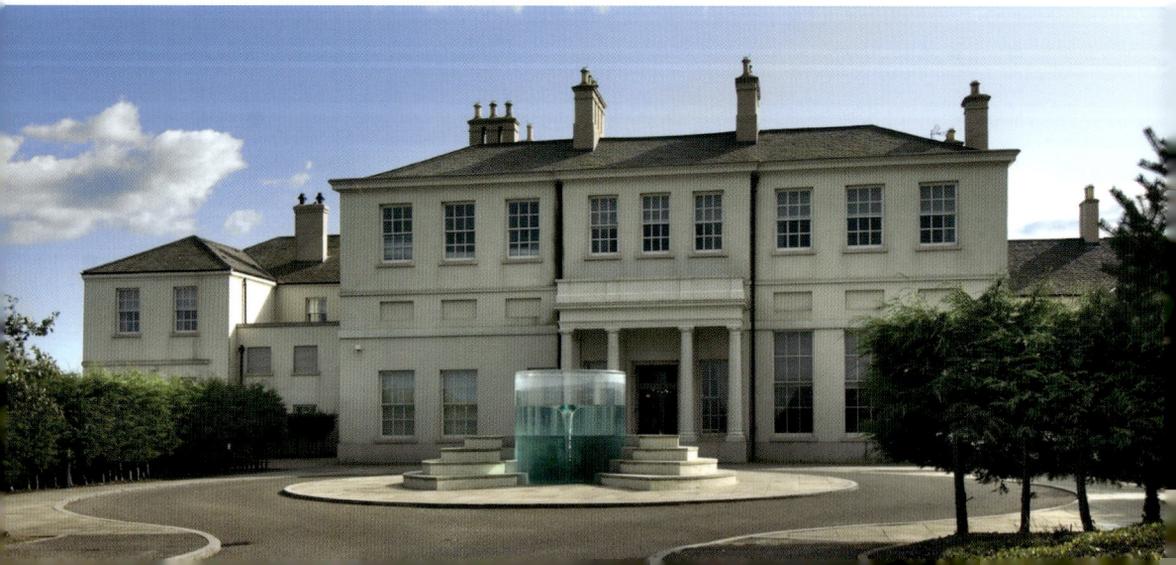

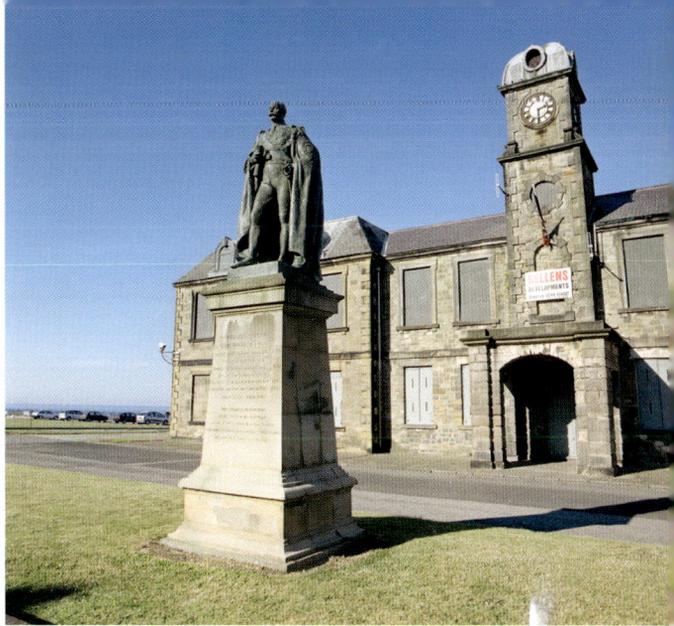

Londonderry Statue, Seaham

Charles Stewart Vane-Tempest-Stewart, the 6th Marquis of Londonderry, surveys the town his family helped to create. Born in 1852, he inherited large areas of coal-rich Seaham and its prosperous harbour town but focused his attention on politics, achieving high offices such as Postmaster General and Lord Privy Seal. He died in 1915 and his bronze statue, sculpted by John Tweed, remains outside the former Londonderry offices (now apartments) in Seaham Harbour.
(© Historic England Archive)

Seaham Harbour

First planned by Sir Ralph Milbanke, Seaham Harbour was constructed for the 3rd Marquis of Londonderry after he purchased the Seaham estate in 1821. Thomas Telford and John Rennie contributed to plans drawn up by Newcastle's William Chapman and the harbour was completed by 1840. Badly affected by the end of local coal exports, the port was given a new lease of life by the Victoria Group, who acquired it in 2003. (© Crown copyright. Historic England Archive)

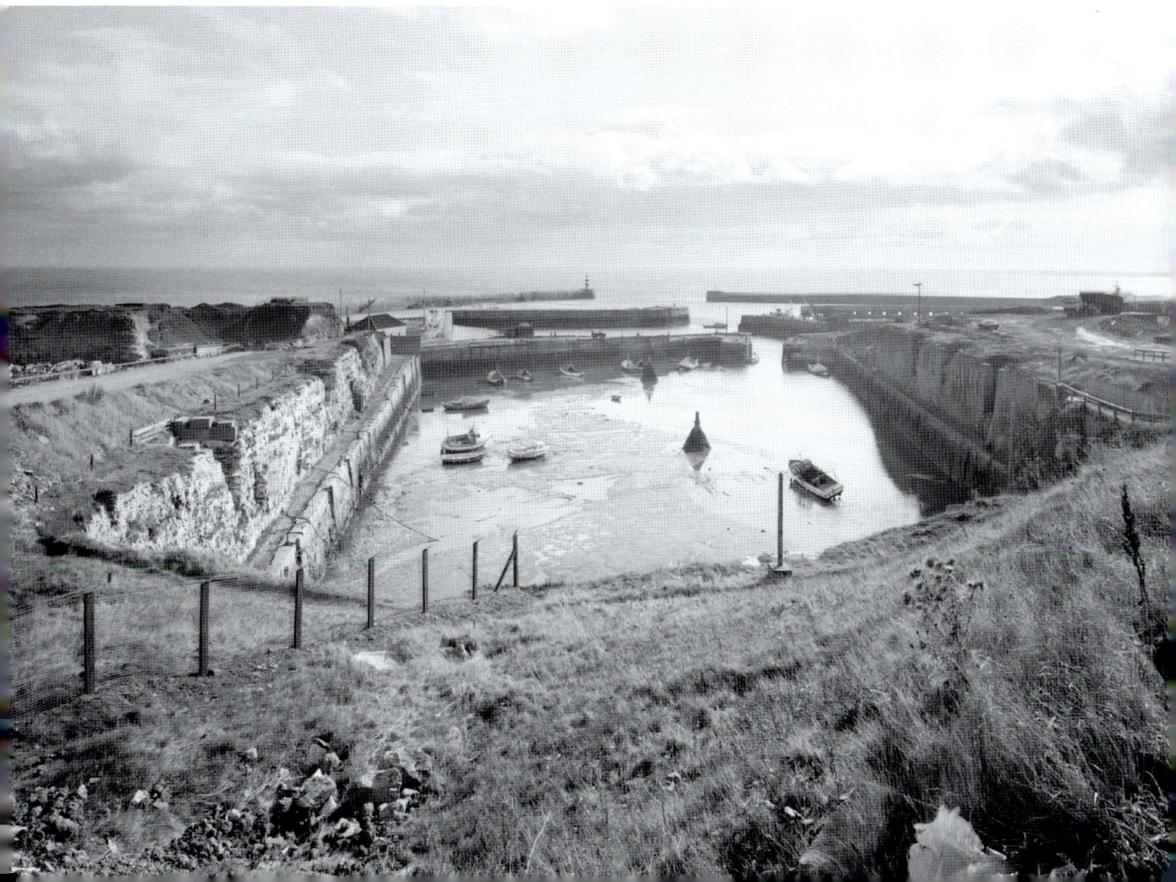

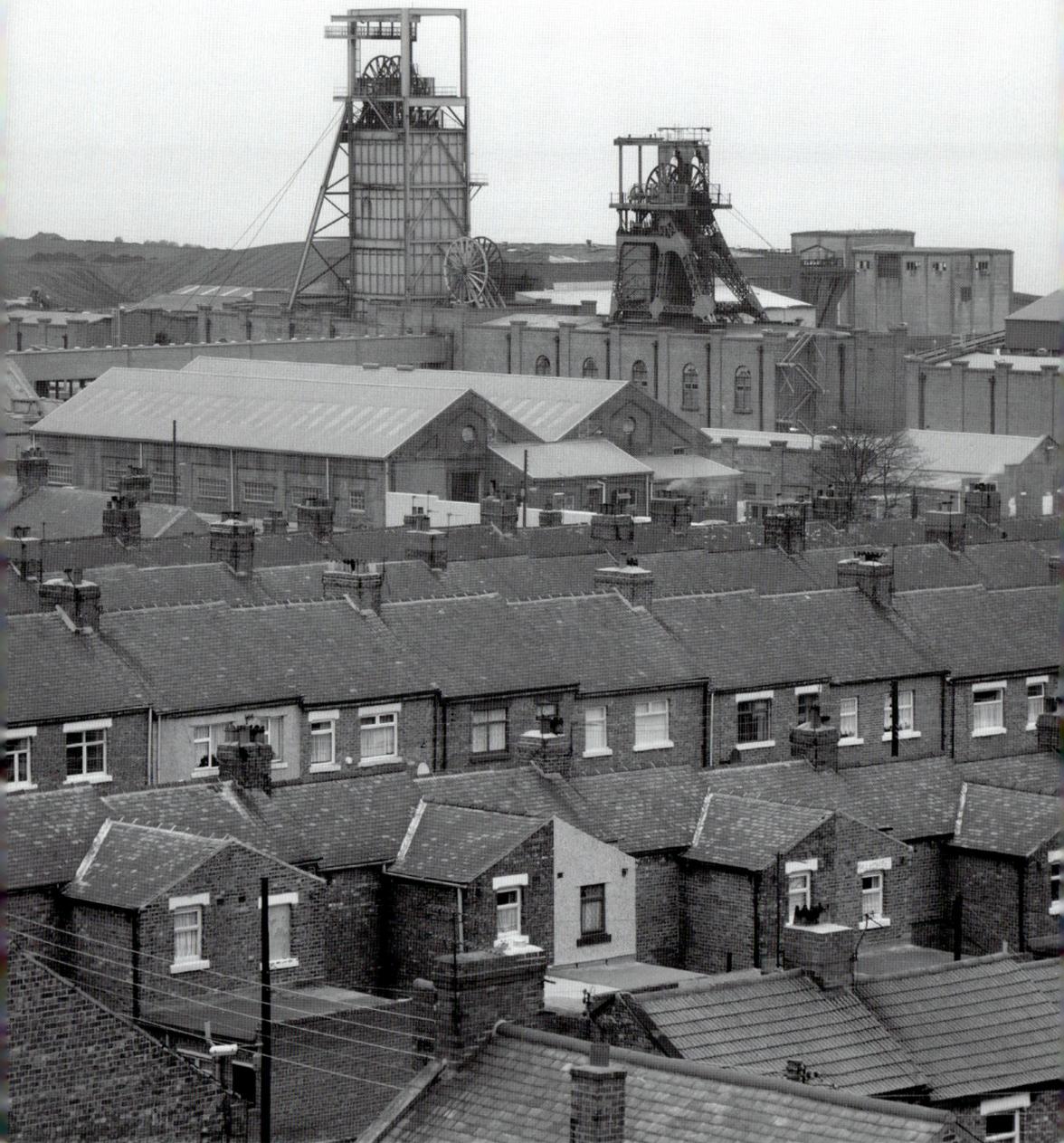

Easington Colliery

Collieries and their communities were close companions in the Durham coalfield. For centuries an important agricultural centre, Easington developed a new industrial identity in the streets clustered around the pit after it opened in 1899. Although community spirit was shaken by the death of eighty-three pitmen in 1951 and shattered by the mine's closure in 1993, Easington Colliery has held onto its name and its pride. (© Crown copyright. Historic England Archive)

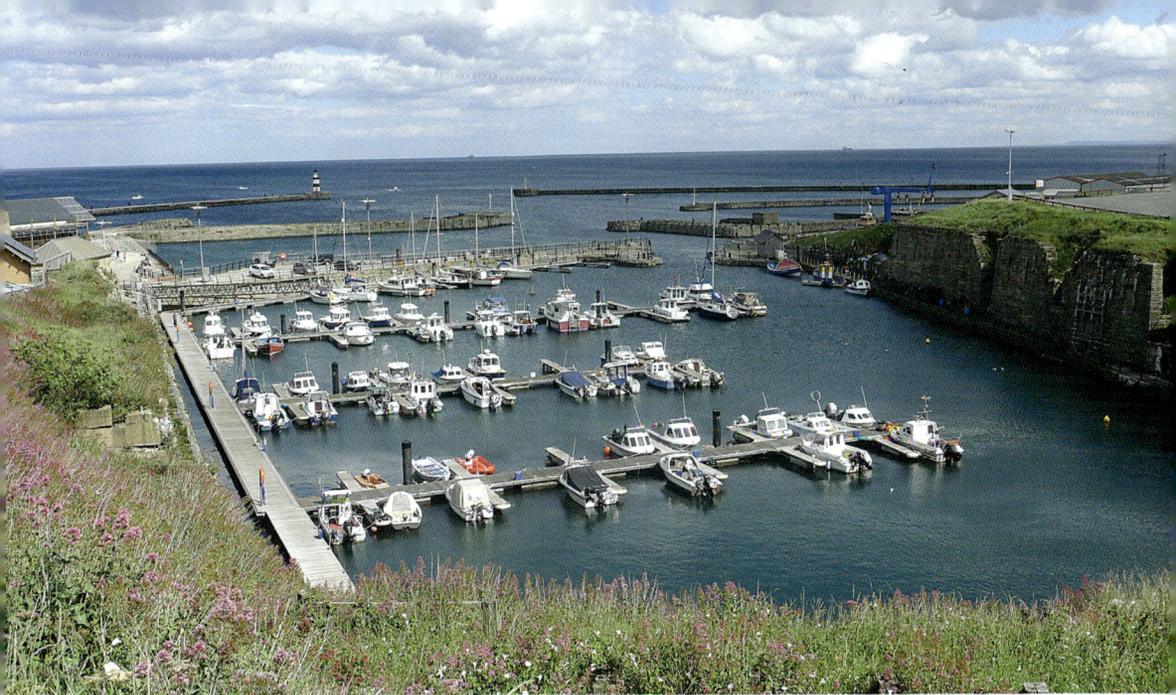

Above: Seaham Marina

As well as improved dock facilities, Seaham Harbour now has a thriving marina. Opened in 2013, the former coal port's North Dock provides mooring facilities for seventy-seven vessels and welcomes local and international leisure craft. It also has a Visitor and Heritage Centre, which houses the restored Seaham lifeboat *George Elmy*. Built in 1949, the boat tragically capsized in 1962, drowning five crew and four local fishermen.

Below: Easington Colliery School

Easington Colliery School was up for sale when this photograph was taken in 2006. Built on Seaside Lane, the double blocks provided education for an expanding mining community. Constructed in a baroque style by Durham architect J. Morson, the attention-grabbing structures cost £21,000 when opened in 1913. Empty since 1997, the school buildings failed to attract a suitable buyer and now face an uncertain future. (© Historic England Archive)

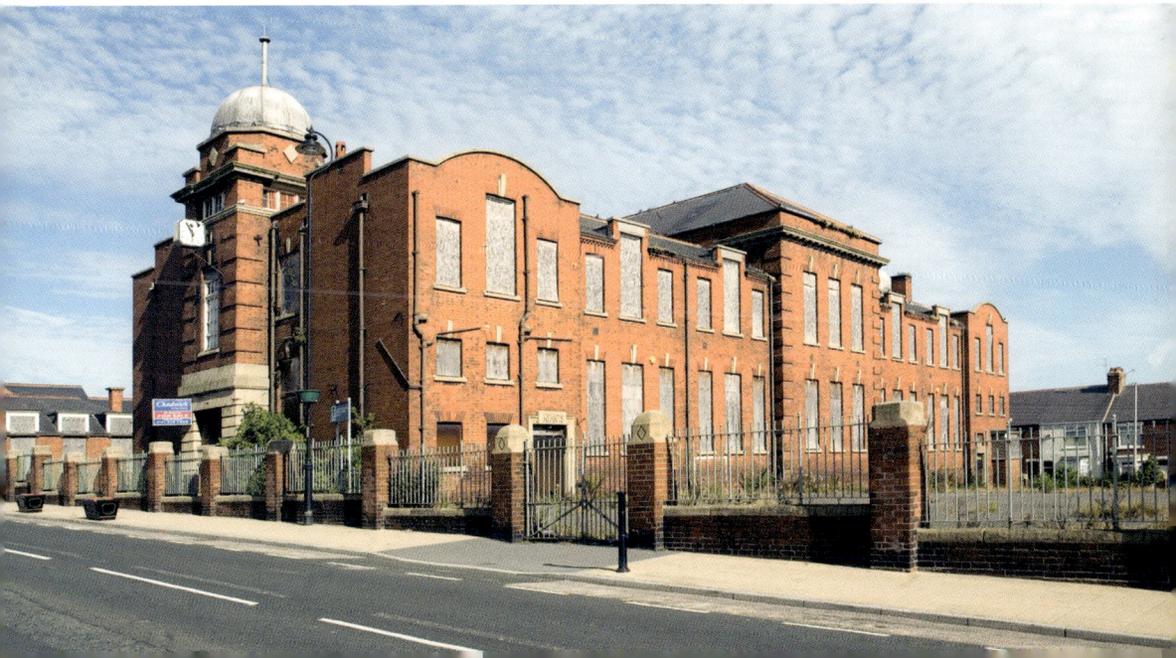

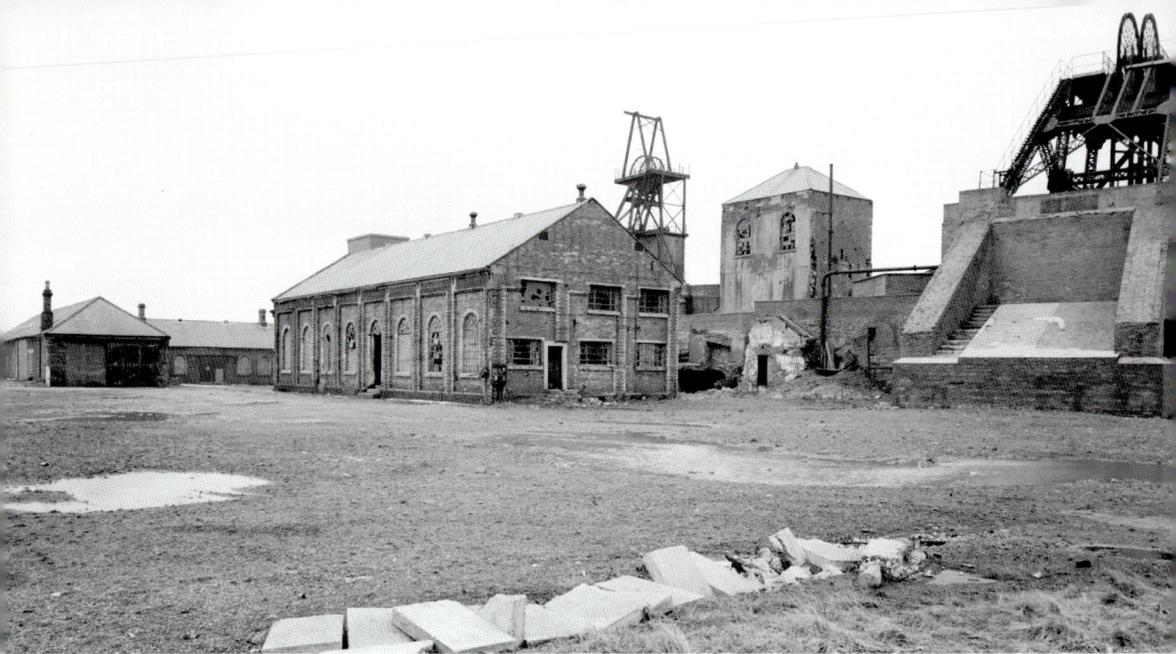

Above: Elemore Colliery

One of three adjacent coal mines in the Hetton district, Elemore Colliery opened in 1827. It was sunk on the Elemore estate and had shafts named after George and Isabella Baker of Elemore Hall. Owned by the Hetton Coal Co., the mine temporarily closed in 1893 but afterwards regularly employed more than 1,000 workers. Shut for good in 1974, its huge waste tip is now a golf course. (© Crown copyright. Historic England Archive)

Below: Grove Rake Mine, Stanhope

Lead ore has been mined around Stanhope in Weardale since medieval times at least. Pictured in 1988 against a rugged moorland backdrop is the Grove Rake Mine on Wolfcleugh Common. Operated by several companies since the late 1700s, the mine struggled for commercial success until it switched to fluorspar extraction (used in steel and chemical production) in the twentieth century. Cheap foreign imports led to the closure of Grove Rake in 1999. (© Crown copyright. Historic England Archive)

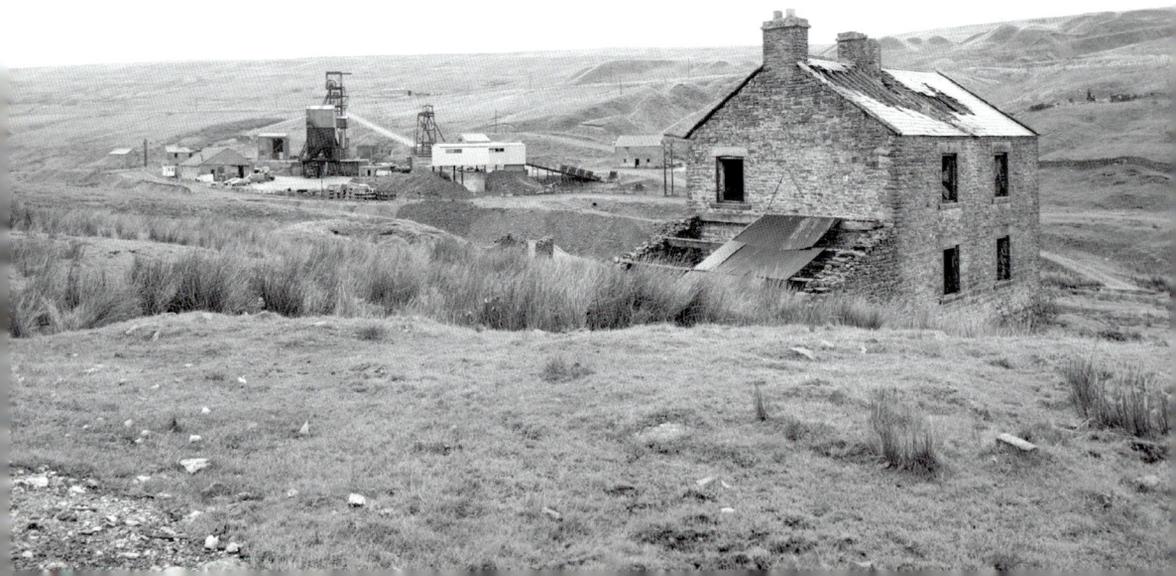

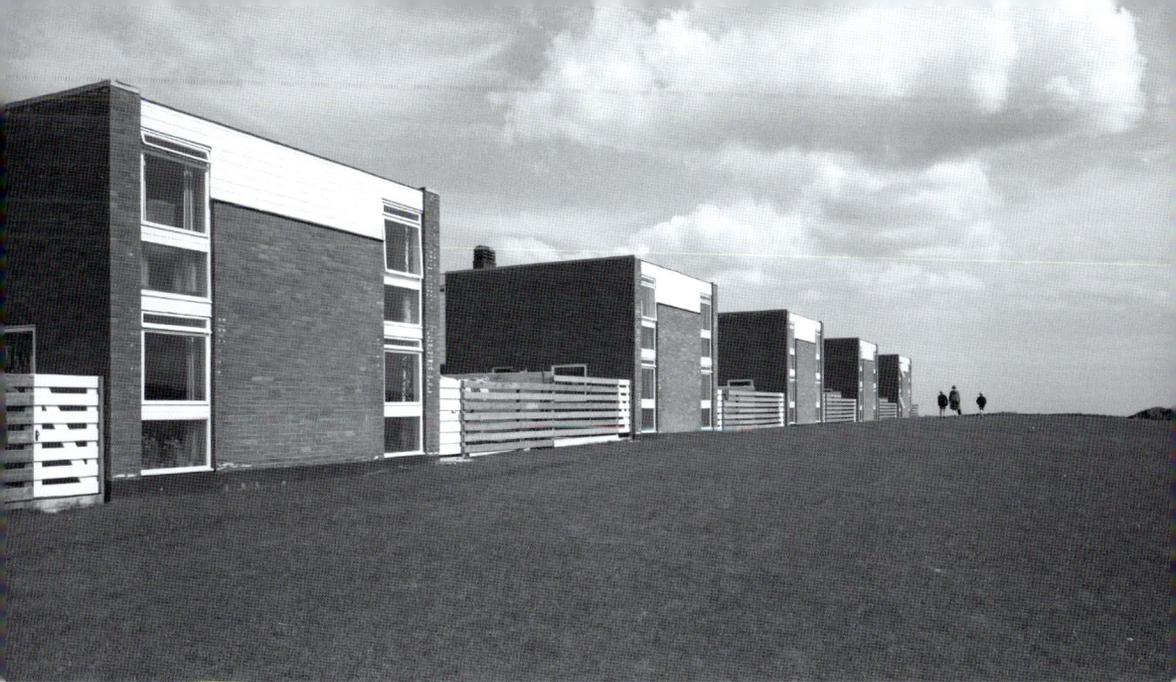

Above: Peterlee
Named after an esteemed local miners' leader, Peterlee was an ambitious new town project intended to move mining populations away from the pithead and provide better housing. The plan was approved in 1948 and building began shortly afterwards. Progress was slowed, however, by arguments over architectural style and poor-quality construction. Architect Berthold Lubetkin, who led an international team of architects, resigned in 1950 and Peterlee was not completed until 1975. (Historic England Archive)

Below: Apollo Pavilion
Newcastle art professor Victor Pasmore was drafted onto Peterlee's design team in 1955. Abstract artist Pasmore left his mark on Peterlee with cubist-inspired houses and his own radical sculpture. He helped to design the Sunny Blunts housing estate and created its centrepiece, the Apollo Pavilion. Pasmore's concrete structure, however, unlike the space flights it was named after, has largely failed to capture the public imagination. (© Historic England Archive)

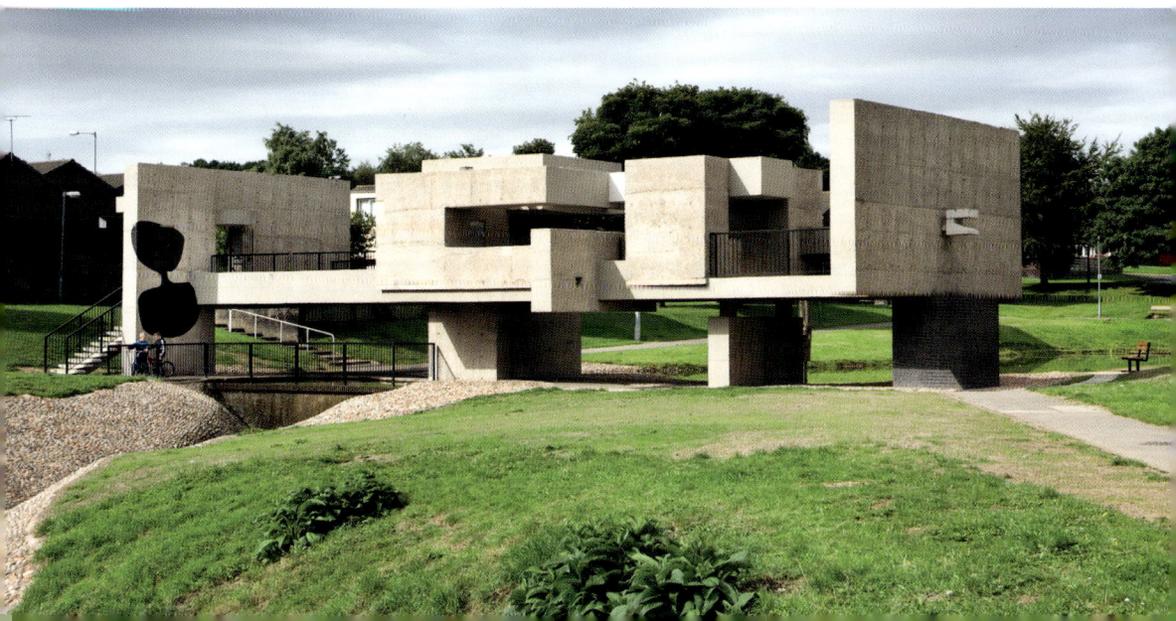

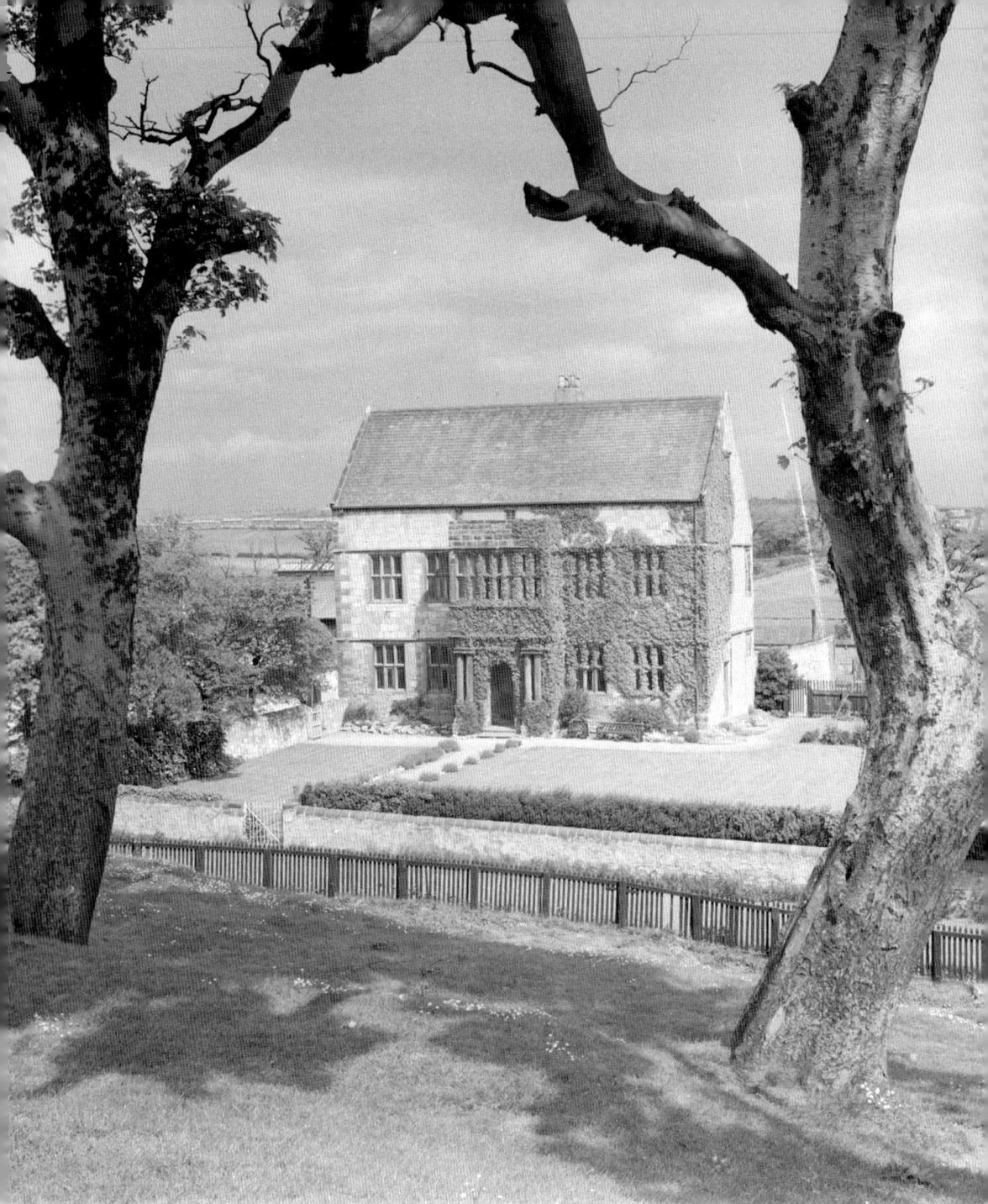

Horden Hall near Seaham
Usually described as a small manor house, Horden Hall stands on farmland not far from the North Sea. A mid-seventeenth-century construction probably on older foundations, it stood virtually alone until Horden Colliery opened nearby in 1900. Erected by the Conyers family, their Jacobean house has withstood the weather and outlived the giant pit that closed in 1987. Part of a working farm, it retains historic internal features. (Historic England Archive)

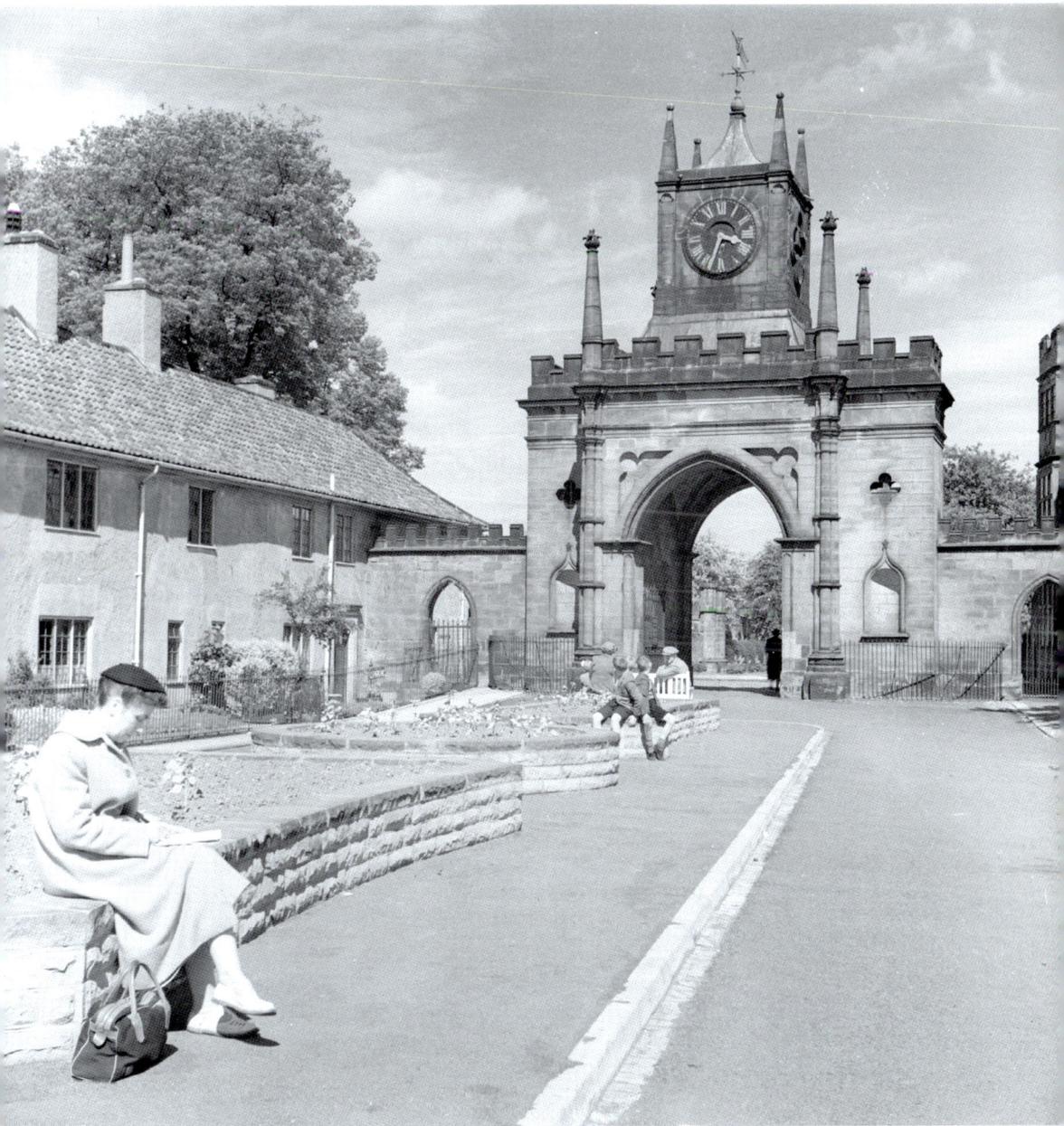

Bishop Auckland Gateway

This Gothic gateway is a perfect introduction to the Bishop's Palace beyond. For centuries Auckland Castle and Hunting Park was a favourite retreat for Durham's prince-bishops. The rebuilding of their medieval palace was begun by Bishop Cosin and continued by his successors. Bishop Trevor had the gatehouse erected around 1750, rejecting a design by experienced architect Richard Bentley in favour of one by Thomas Robinson, an aristocratic amateur. (Historic England Archive)

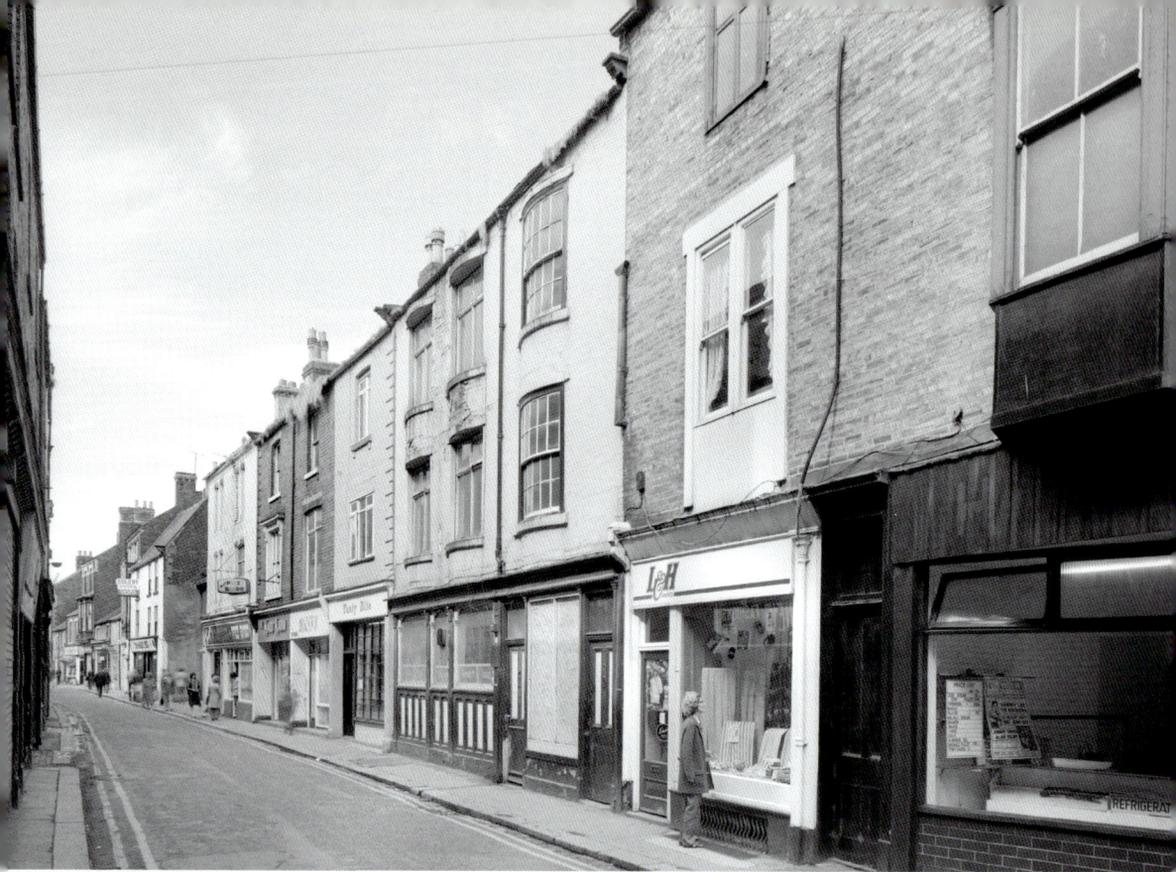

Fore Bondgate, Bishop Auckland
Fore Bondgate stands on the site of Bishop Auckland's ancient village green. Always an important market town, Bishop Auckland became more industrial in the nineteenth century with the growth of local coal and allied trades. By then Fore Bondgate was a mixture of commercial and domestic property. Notice the bow-fronted building on the right. In 1981, when this photograph, was taken it was Cooper's Pub. It later became Bar Mondo but is now vacant. (© Crown copyright. Historic England Archive)

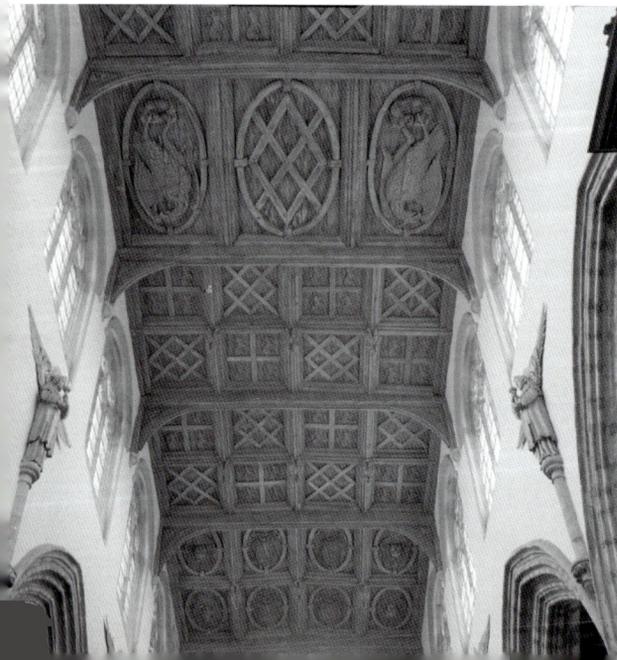

Bishop's Palace, Bishop Auckland
Acknowledged as Auckland Castle's outstanding feature, the chapel is also one of its oldest parts. Bishop Pudsey is believed to have started the castle, which grew from a Norman manor house. Its original hall was transformed into a chapel by the industrious John Cosin, Prince Bishop of Durham between 1660 and 1672. His tomb lies in the nave below the intricately carved ceiling pictured here by Eric de Mare. (Historic England Archive)

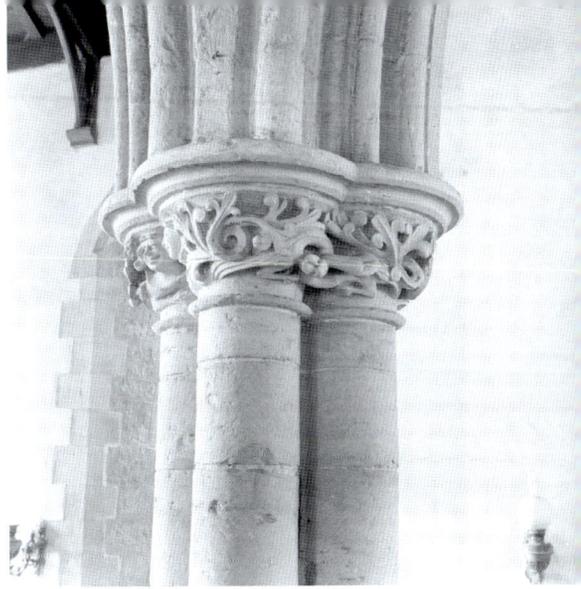

Sedgefield St Edmund

Delicately carved capitals like this are just one attraction of St Edmund's in Sedgefield. Built in the thirteenth century, the church was made more imposing by a 90-foot tower, added two centuries later. The nave, believed to be crafted by the same hand responsible for Durham Cathedral's Chapel of the Nine Altars, is inviting. But most impressive is its splendid woodwork, which equals the county's best. (Historic England Archive)

Escomb Church

Escomb's humble little church dates from the infancy of English Christianity. Even finding this Saxon building, screened by trees and houses, is a revelation. It incorporates robbed stone from nearby Binchester Roman fort and is fortunate to survive almost intact. After years of neglect it was considerably restored in 1965 by Sir Albert Richardson. Today, Escomb's St John the Evangelist remains a place of peace and quiet reflection. (Historic England Archive)

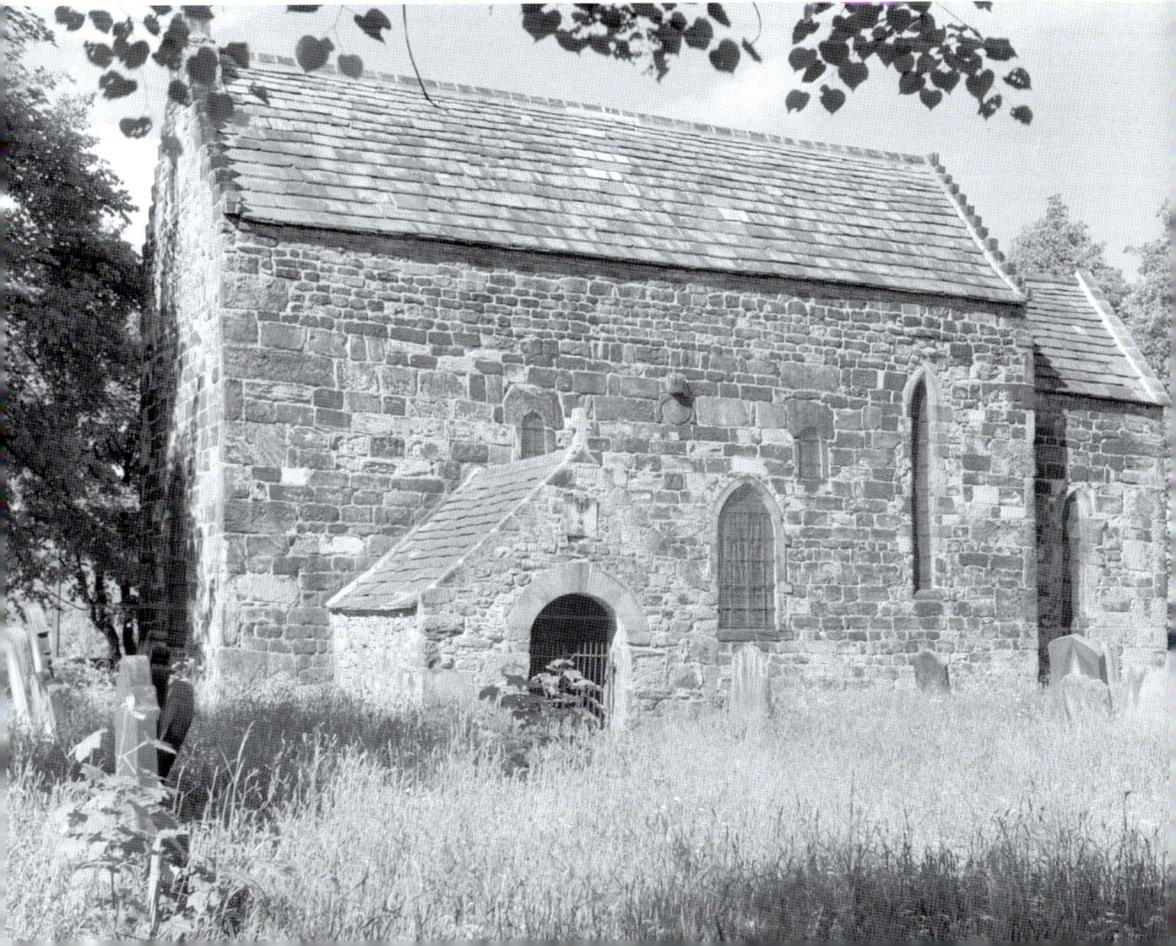

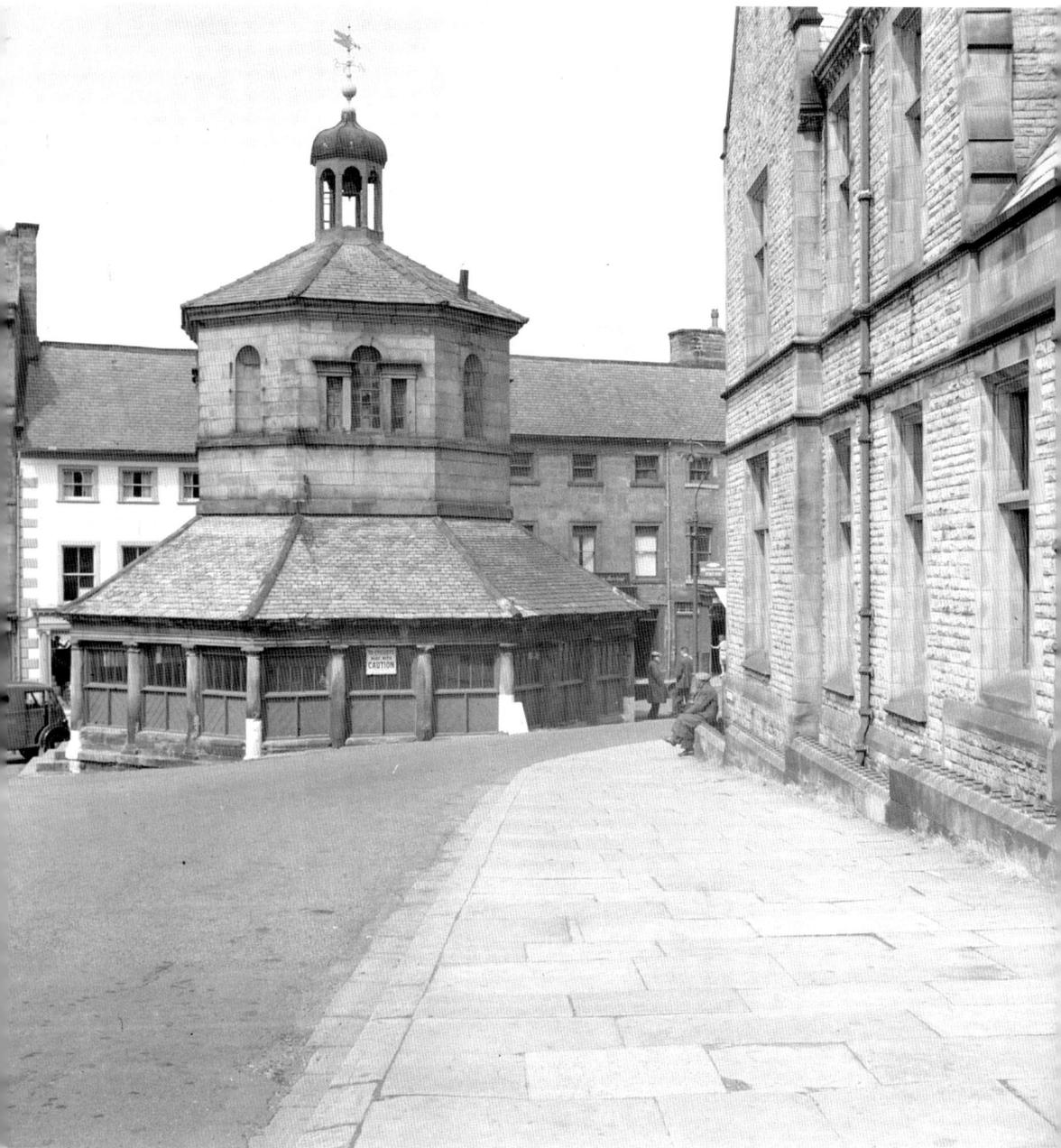

Barnard Castle, Market Place
'Barney', as it is affectionately known, has great appeal for history lovers. Its quaint Town Hall is a good start. Also known as the Market Cross, it was constructed in 1747 by local man Thomas Breaks. Used as a courtroom and prison cell, the Town Hall was also useful for target practice in the early nineteenth century. Holes in the octagonal building's weathervane were made by musket balls. (Historic England Archive)

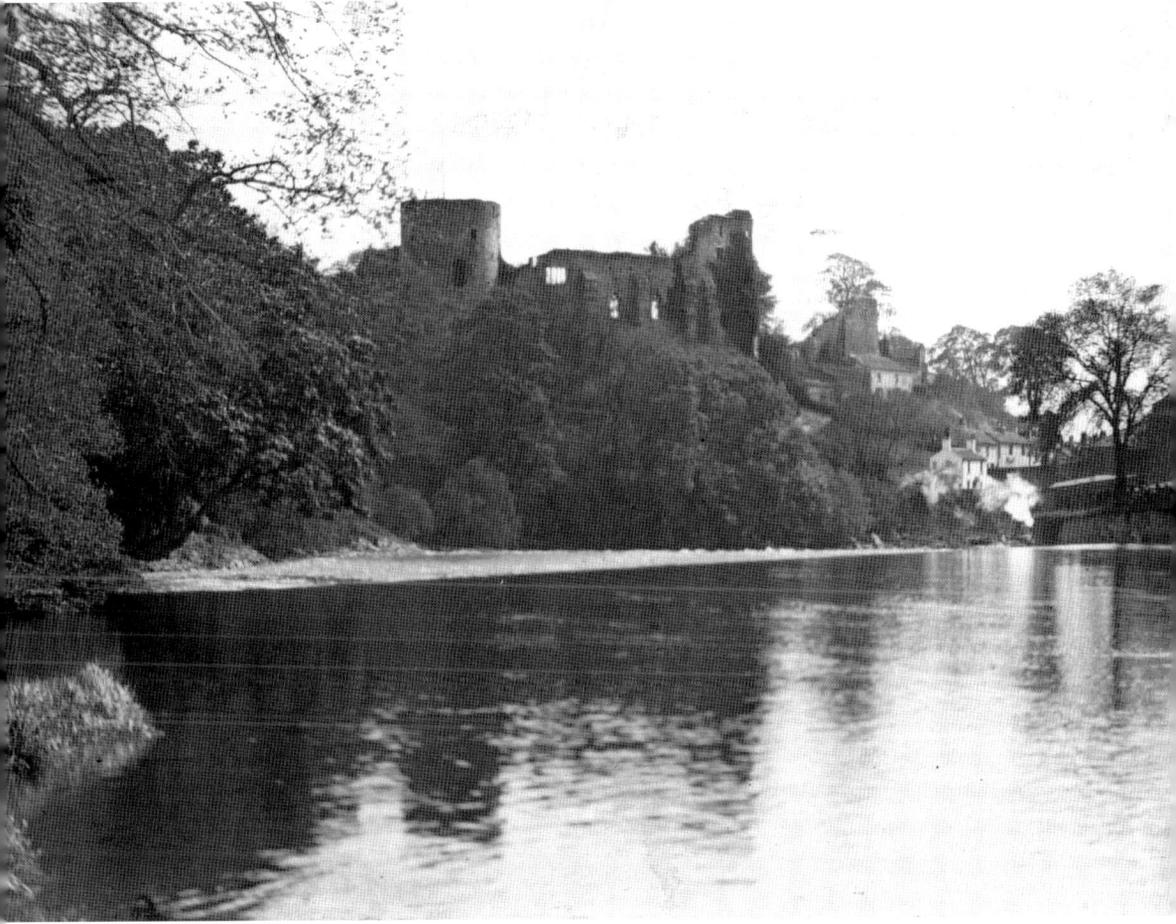

Barnard Castle
Often imitated, this view of Barnard Castle was produced by historian and archivist Sir Henry Churchill Maxwell Lyte around 1900. Both the castle and town acquired their name from Bernard, nephew of Norman baron Guy de Balliol, who around 1095 was granted rich Teesdale lands by William Rufus, son of William the Conqueror. The castle was reduced to a magnificent ruin not by enemy action but by owner Henry Vane in the 1630s. (Historic England Archive)

South Tyneside

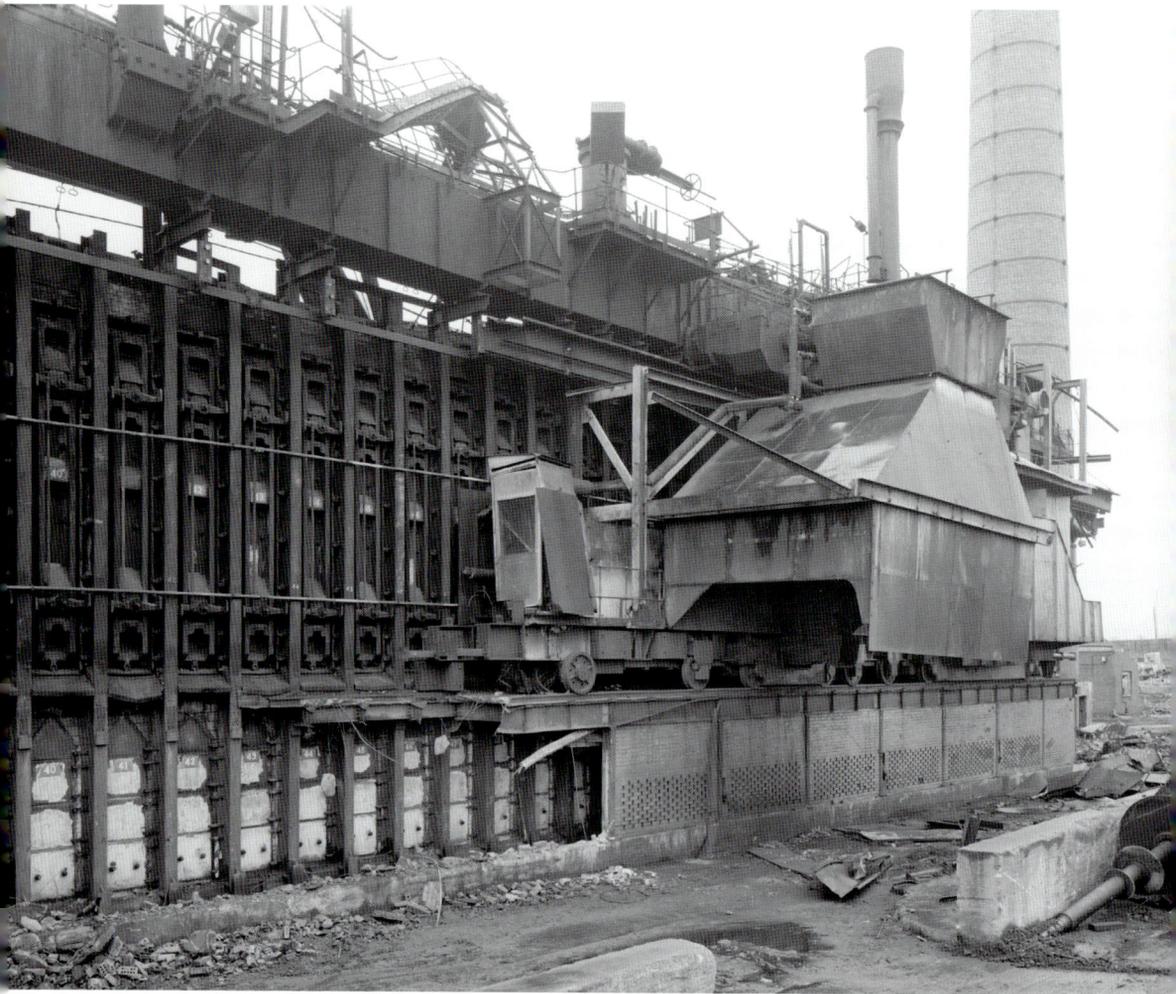

Hebburn Coke Works

Hebburn on Tyne expanded rapidly during the Victorian era. Its main industries were shipbuilding, coal mining and manufacturing. Coke production began in 1936 and the coke ovens dominated the southern fringe of the town at Monkton until closure in 1991, and demolition a few years later, when this photograph was taken. Parkland and an industrial estate now occupy the site. (© Crown copyright. Historic England Archive)

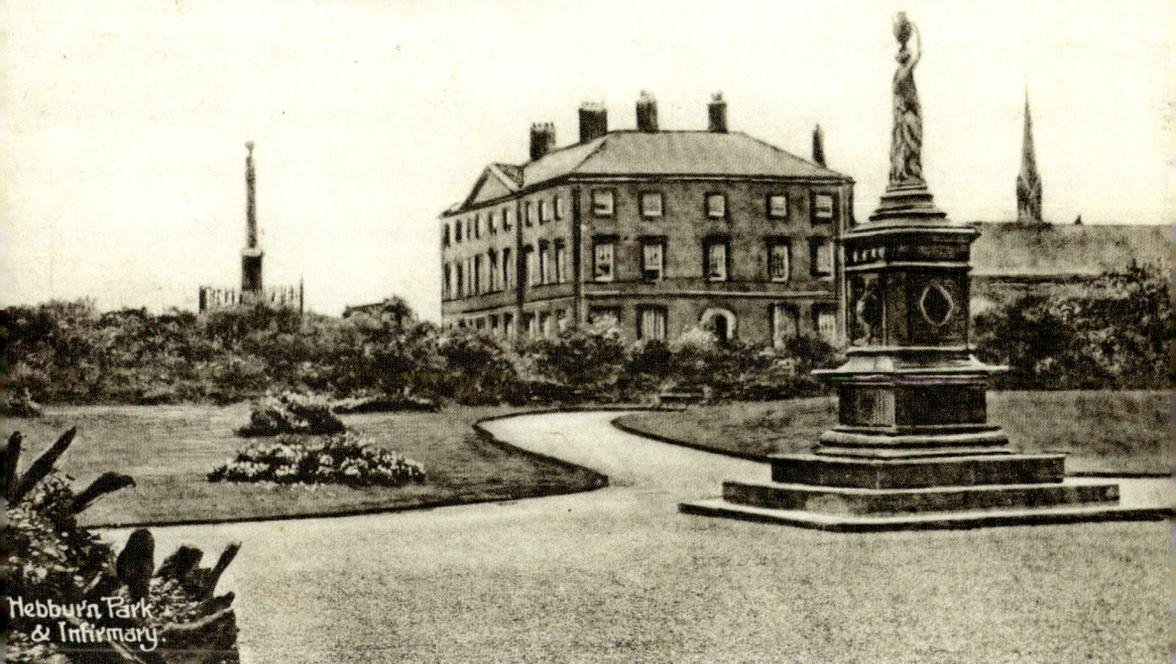

Hebbur'n Park
& Infirmary.

Above: Hebburn Hall

Hebburn Hall was built for coal owner Henry Ellison around 1790. By the early twentieth century, when this postcard view was made, the impressive classical mansion and its grounds had been handed over to make a public park and Hebburn's first accident infirmary. The drinking fountain in the foreground has now vanished but the hall and accompanying church, as well as the Boer War memorial column on the left, remain safely in place. (Historic England Archive)

Below: Hebburn Park Aviary

Along with brass bands, sports and other entertainments, an aviary was one of Hebburn Park's popular attractions during the early twentieth century. It stood not far from the bowling greens still used today. Canning Street can be seen in the background. (Historic England Archive)

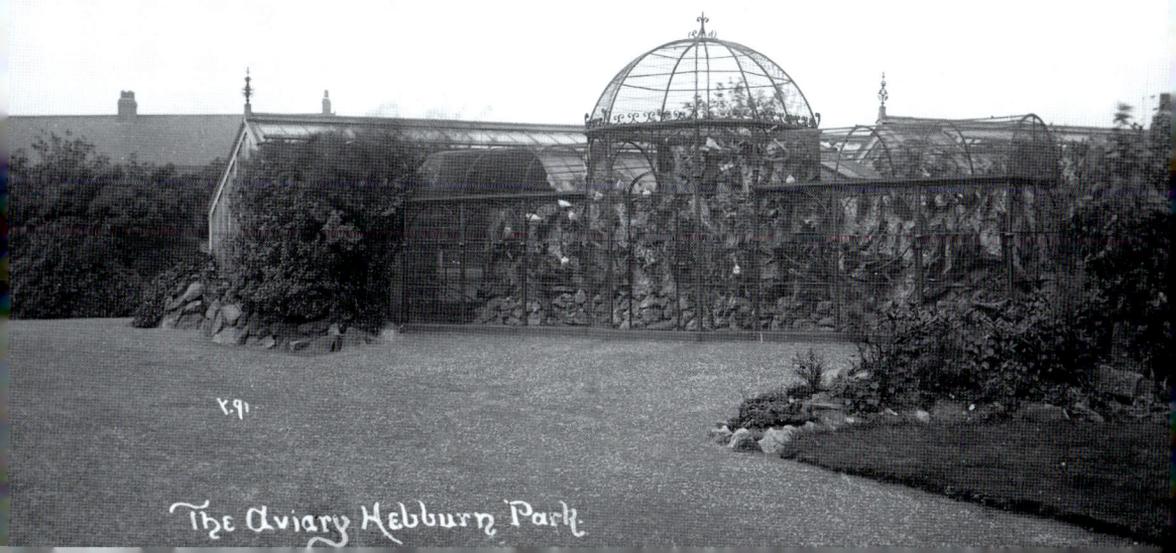

The Aviary Hebburn Park.

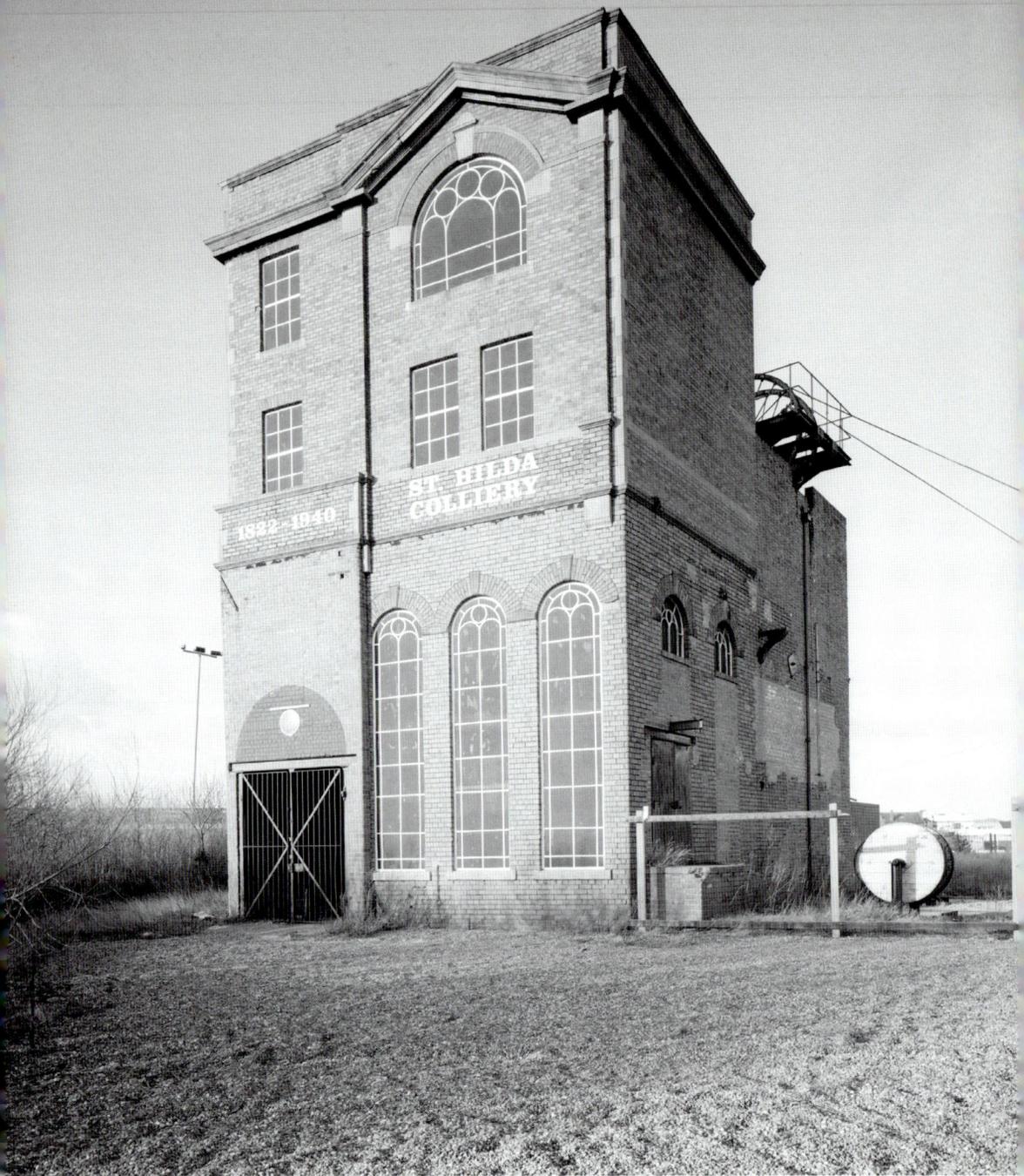

St Hilda Colliery, South Shields

Named after the ancient parish church nearby, St Hilda's Colliery was opened in 1810 and continued until 1940, though its long working history was marred in 1839 by an explosion that claimed over fifty lives. The headstock and pump house pictured above were preserved and it is now hoped to further restore them, not just as a coal-mining monument, but as a modern business centre and workspace. (© Crown copyright. Historic England Archive)

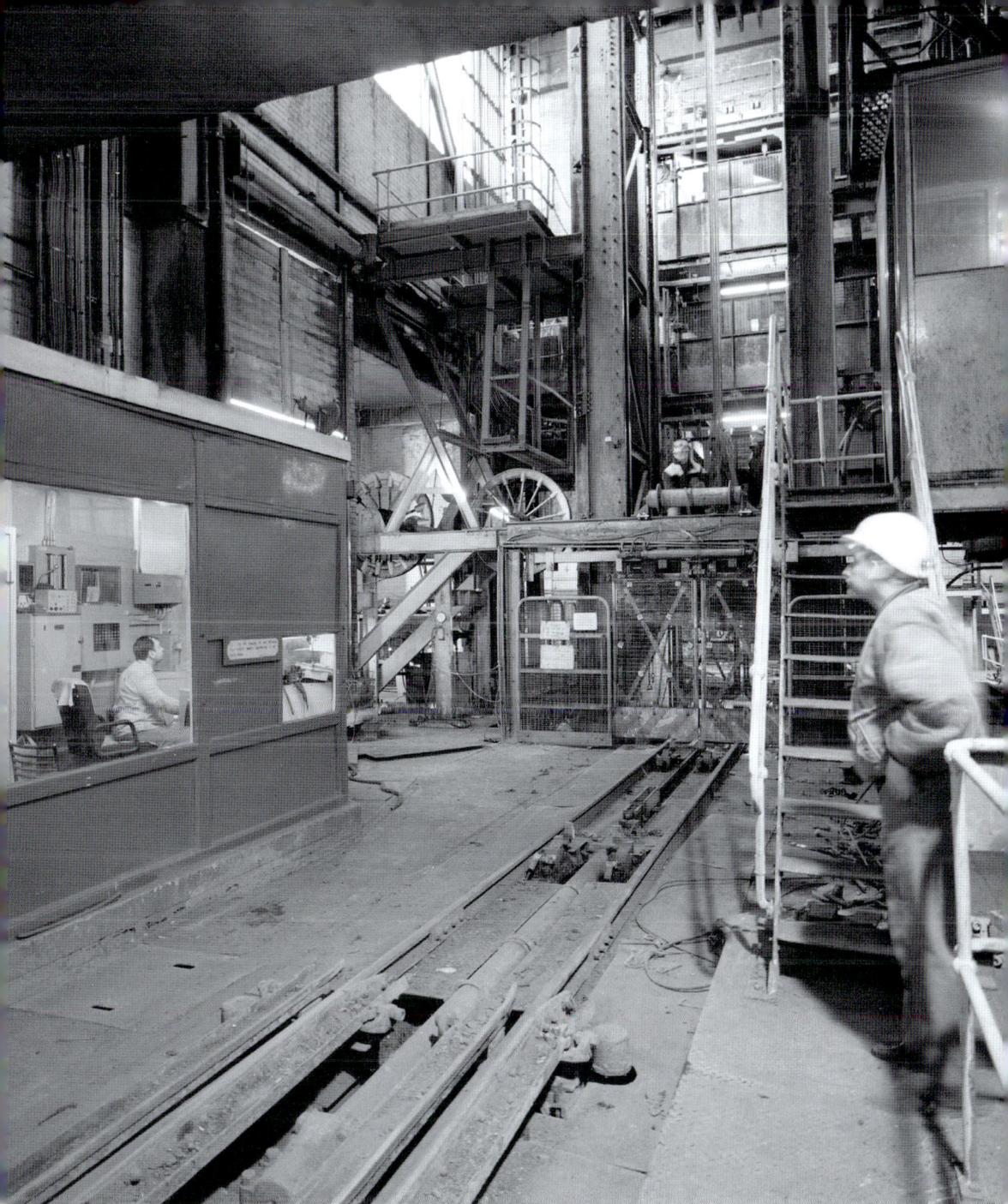

Westoe Colliery, South Shields

Interior salvage work at Westoe Colliery prior to demolition is underway in this Bob Skingle photograph. Westoe was regarded as a 'superpit', which employed 2,500 men at its peak. The mine began underground operations in 1909 and in 1957 a new shaft was sunk to exploit offshore coal reserves. This is recalled by Sea Winnings Way – a street name on the housing estate now covering the site. (© Crown copyright. Historic England Archive)

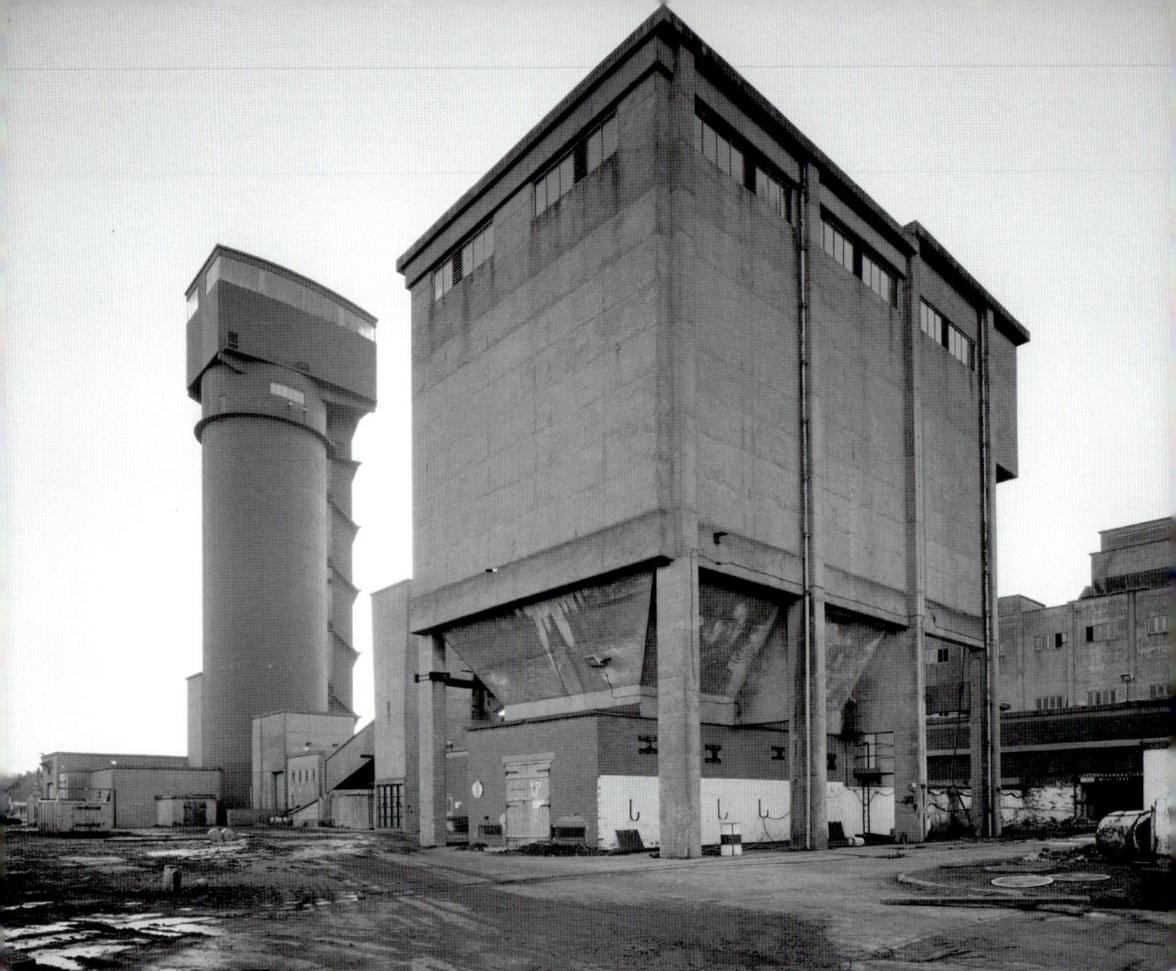

Above: Westoe Colliery, South Shields
Centuries of coal mining in South Shields ended with the closure of Westoe Colliery. As the coal industry contracted towards the end of the twentieth century, production was concentrated at deep coastal mines such as Westoe. But this too shared the fate of Durham's once numerous pits and was shut in 1993. A spectacular explosion brought down the Crown Shaft Tower (seen here on the left) in the following year. (© Crown copyright. Historic England Archive)

Opposite above: Middle Docks, Holborn, South Shields
Holborn was one of South Shields' most historic riverside areas. A ship was recorded for sale there at Middle Dock in 1770 and the company expanded to become the Middle Dock & Engineering Co. in 1899. During the Second World War it established a reputation for ship 'surgery' – stitching together shattered hulls and making vessels seaworthy again. Appropriately sombre, this image was taken in 1992 near the end of the dock's long life. (© Crown copyright. Historic England Archive)

Opposite below: South Marine Park, South Shields
Public parks brightened England's dull industrial townscapes. Designed by South Shields borough engineer Matthew Hall, South Marine Park opened in 1890 and quickly became popular, offering entertainments such as open-air dancing, fireworks and illuminations. The ornate bandstand was added in 1904 and the harbour and life brigade watch house are seen in the background of this postcard view. (Historic England Archive)

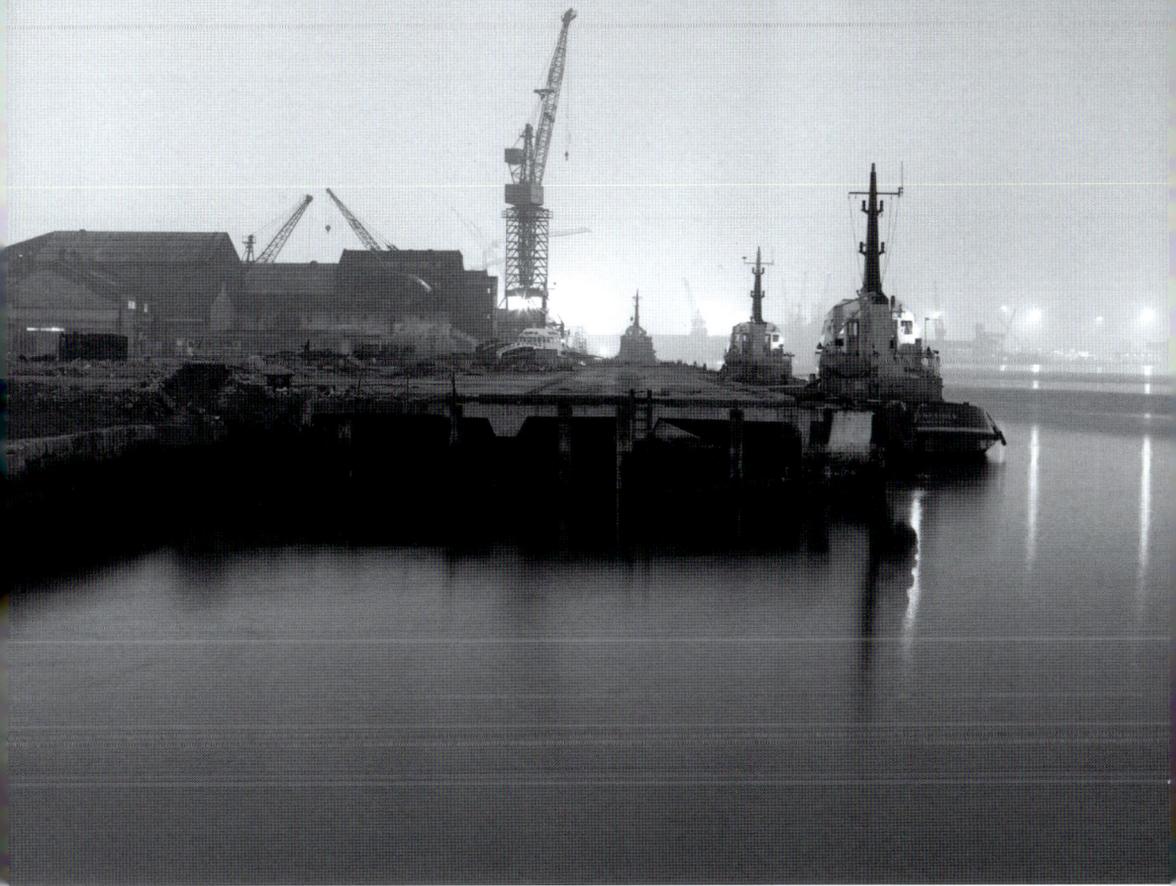

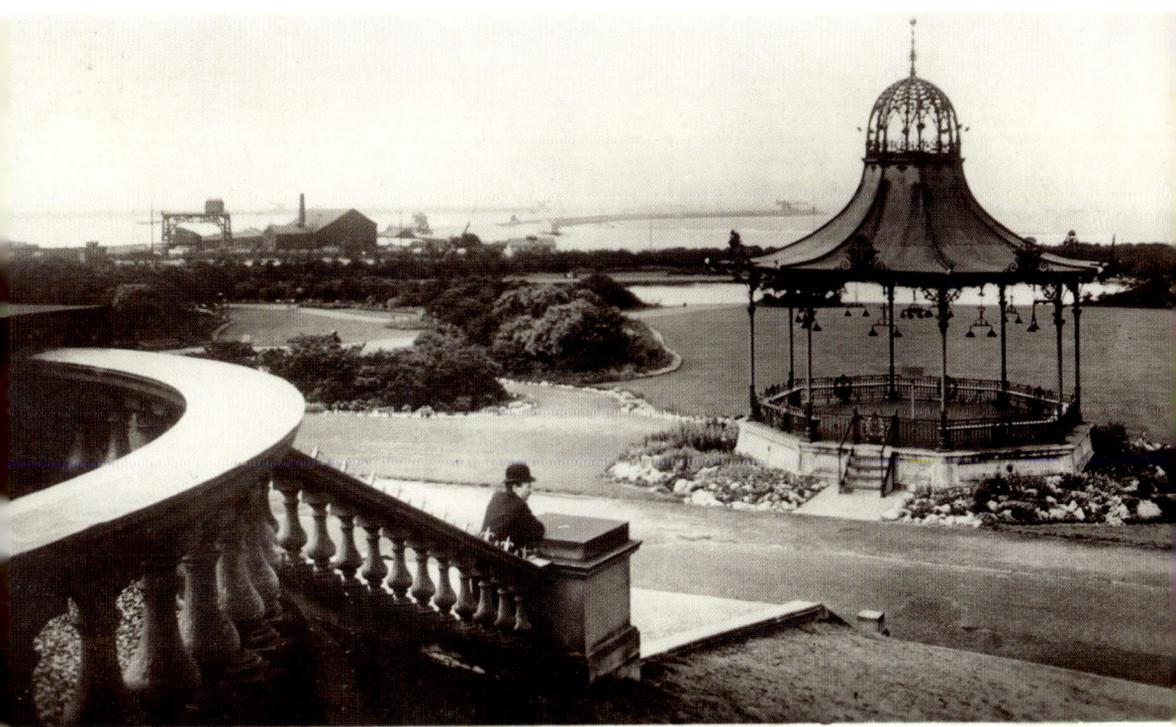

S 3304 SOUTH MARINE PARK, SOUTH SHIELDS.

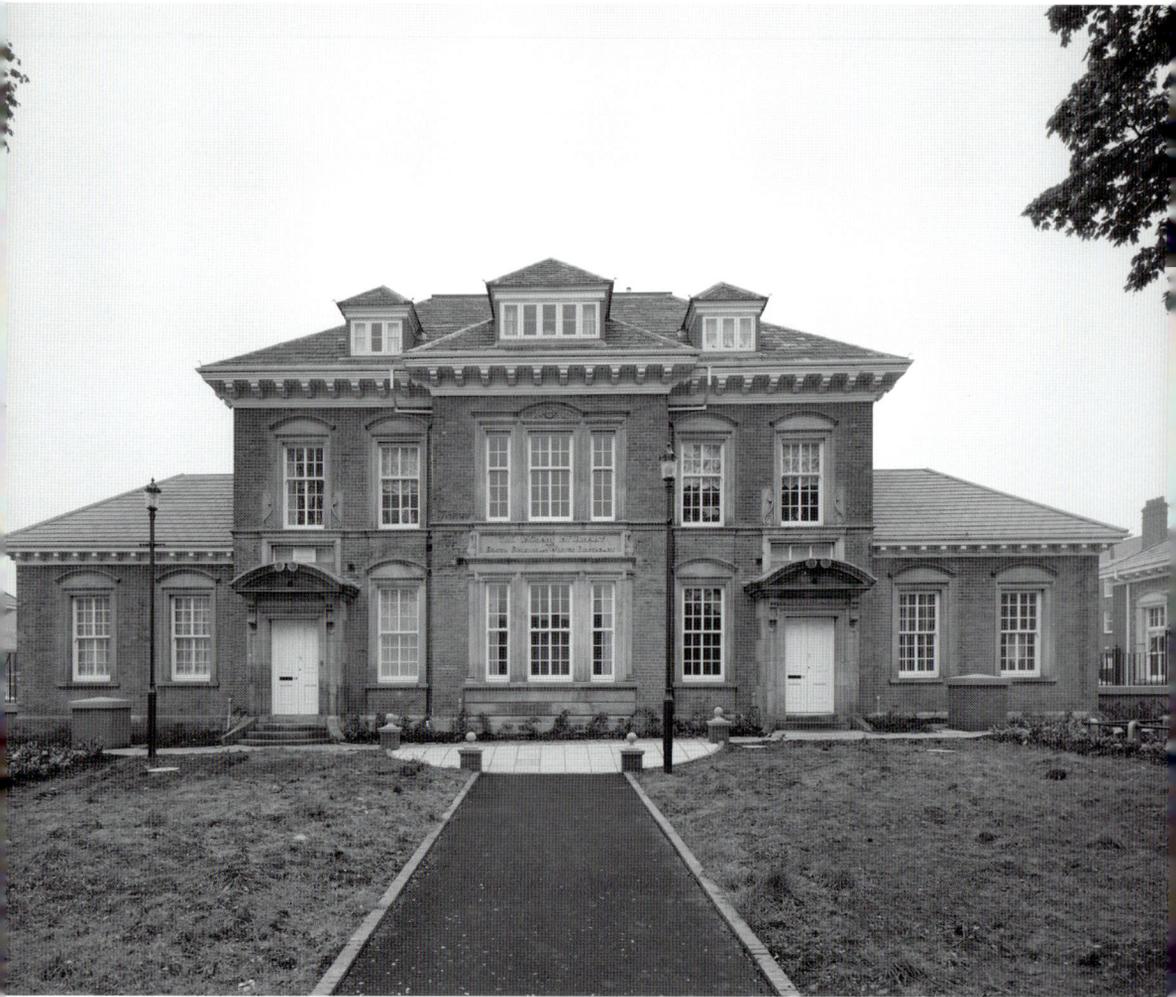

Above: Ingham Infirmary, South Shields

Financed from public subscriptions as an accident infirmary, the Ingham was opened in June 1873. It was built to honour the widely respected Robert Ingham, elected in 1859 as the first MP of South Shields. Like the long-serving MP, the Ingham Infirmary served the town faithfully for many years. It closed in 1993 but the Queen Anne-style administration block, pictured above, survives to dignify the surrounding housing development. (© Crown copyright. Historic England Archive)

Opposite: King Street, South Shields

Judging by the blurred figures in this image, King Street was busy with shoppers in August 1886. Featured are Crossling & Co. and Henry Potts, who shared the address with solicitors and architect J. Morton. Crossling – listed as a trunk maker – vacated the premises a few years after the photograph was taken and Henry Potts – a tailor – left before the First World War. Still occupied, the handsome building is now an opticians and a coffee shop. (Historic England Archive)

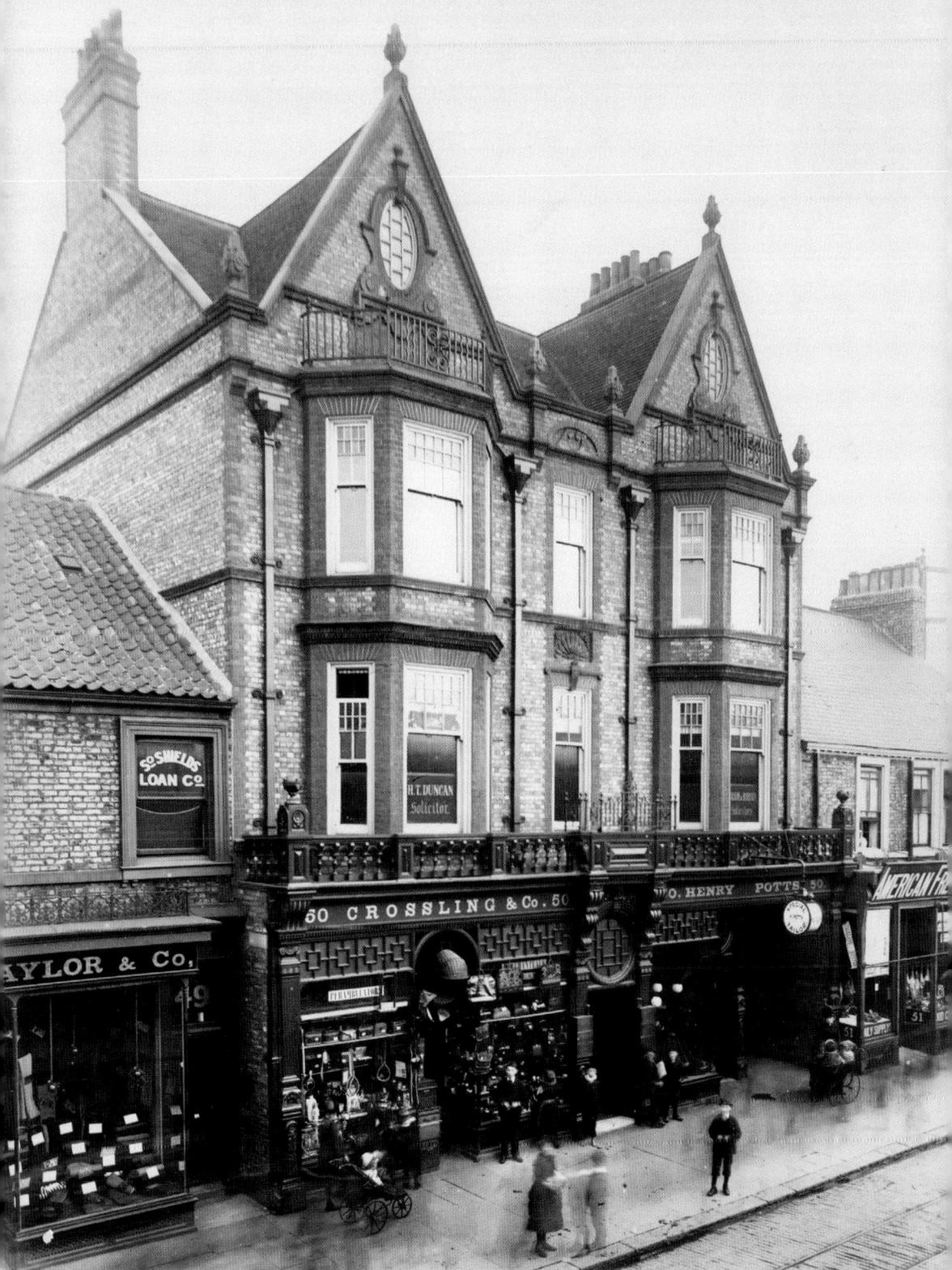

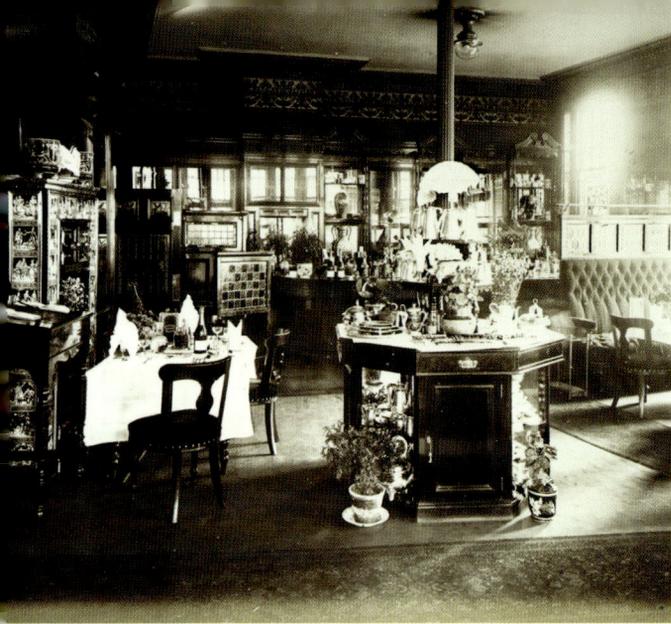

The Criterion's Main Dining Room, South Shields

A luxurious new dining room was added to proprietor William Jackson's public house in the 1880s. Influenced by the Criterion Grill in London, its South Shields namesake intended to cater for business and family customers alike. Open since around 1840, the pub was reconstructed by architect T. A. Page and furnished by Robson & Sons, who commissioned this 1886 image. Closed in 2012, the building at the corner of King and Fowler Streets is now a betting shop. (Historic England Archive)

South Shields Union Offices

Built on Barrington Street in 1882 (probably designed by local architect J. Morton), these offices were home to the South Shields Poor Law Union. Administered by the local Board of Guardians, the building contained a soup kitchen. The impressive block escaped the worse of nearby bomb damage during the Second World War and was restored in 1993. Grade II listed, it continues to provide local authority social services. (Historic England Archive)

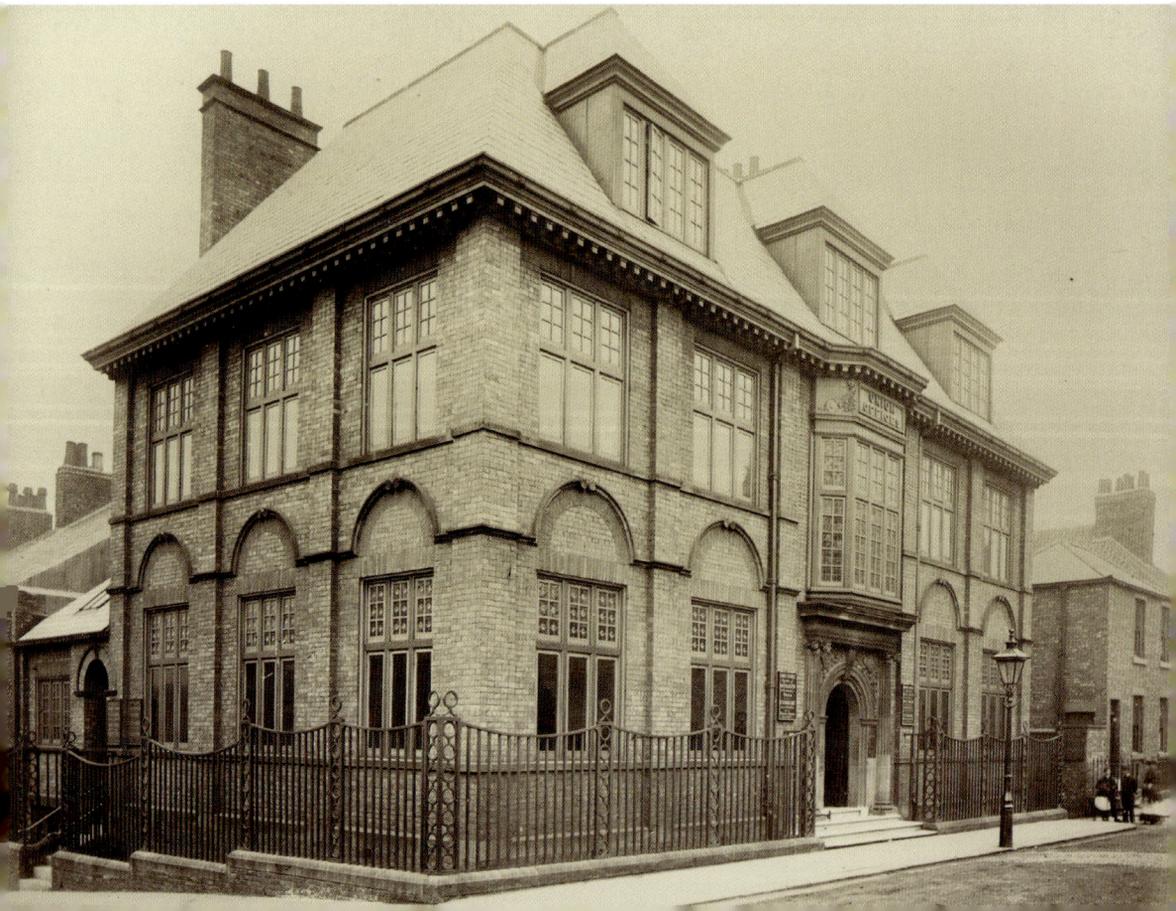

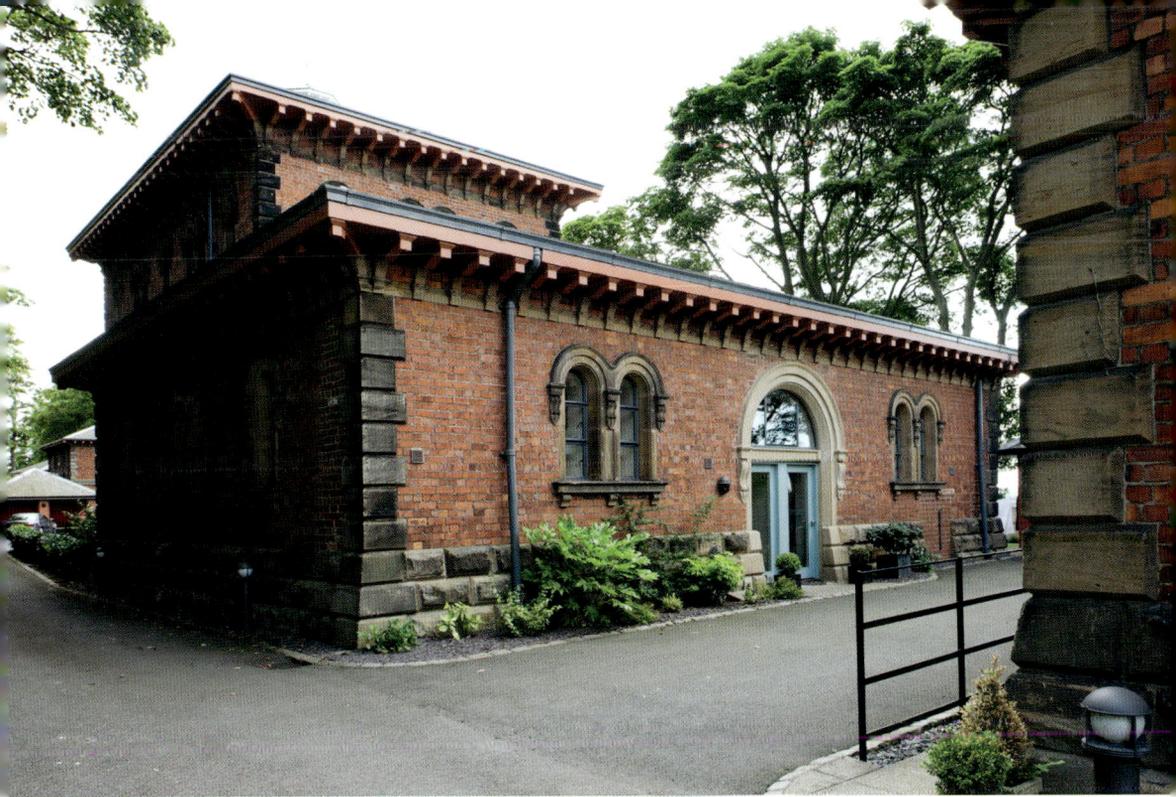

Cleadon Pumping House
With its 100-foot-high chimney, Cleadon's old waterworks dominates the surrounding coastal landscape. Built to supply the expanding neighbourhood of South Shields, the works were in use for over a century. Redundant since 1976, the Italianate tower and matching ancillary buildings like the pump house shown here remain as a testament to the ingenuity and design flair of Victorian engineers such as Thomas Hawksley, who designed the site during the 1860s. (© Historic England Archive)

St Paul's Dedication Stone, Jarrow
An early albumen print illustrates the dedication stone of St Paul's Church in Jarrow. Set high over the chancel arch, the tablet records a dedication date of 23 April 685. It is believed to be the oldest such ecclesiastical survival in England. (Historic England Archive)

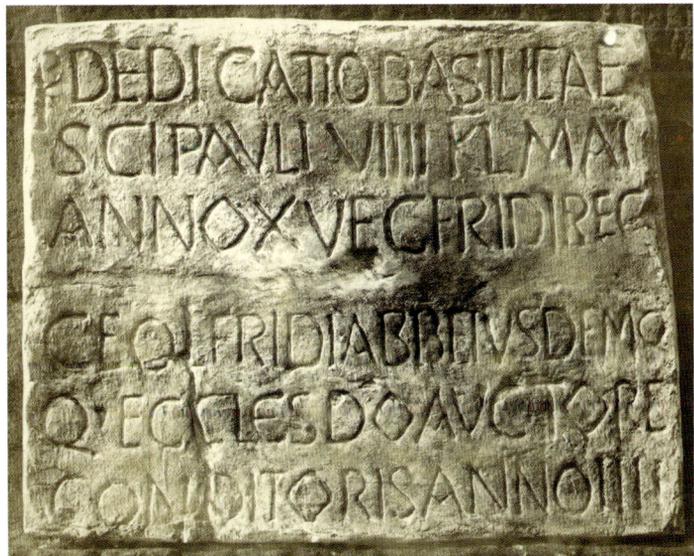

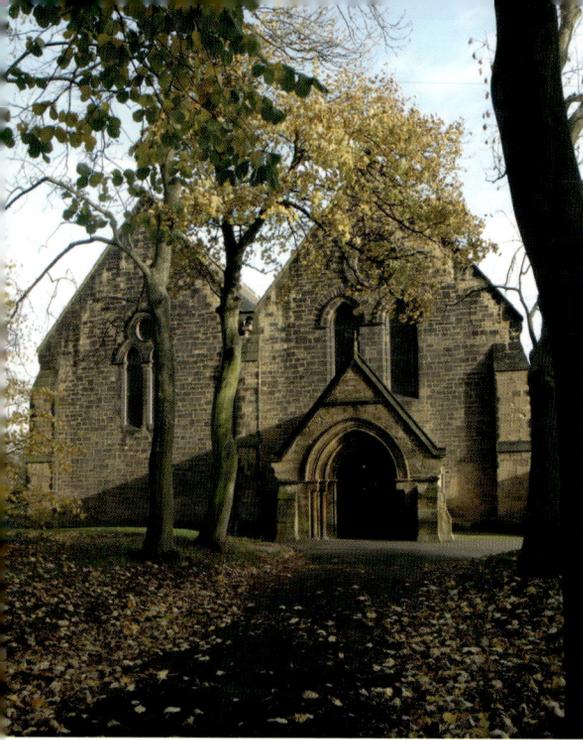

St Paul's, Jarrow

Jarrow's greatest antiquity was very familiar to the Venerable Bede, who devoted his productive monastic life to the twin Benedictine communities at St Paul's, Jarrow, and St Peter's at Monkwearmouth. But the 'Father of English History' would not have recognised this 2008 view towards the Jarrow church porch. These structures are relatively modern additions to the Anglo-Saxon core. (© Historic England Archive)

Whitburn

This early twentieth-century aquatint postcard by Hills depicts the Green in Whitburn's pretty village near South Shields. With its stately Whitburn Hall and thirteenth-century church, the coastal village was a popular retreat for the well-to-do locals, eager to escape Tyneside's grime and smoke. Behind the trees on the bank to the left of the image, the fanciful half-timbered Whitburn House was created for Victorian industrialist Thomas Barnes. (Historic England Archive)

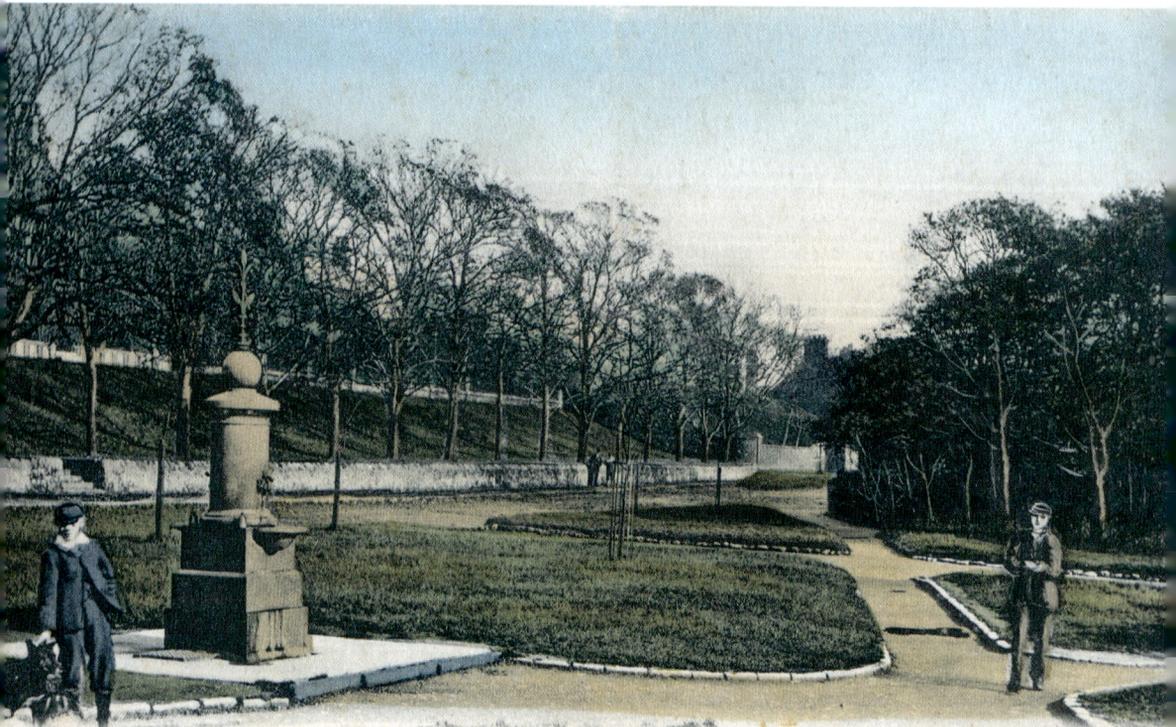

The Green. Whitburn.

Tyne & Wear

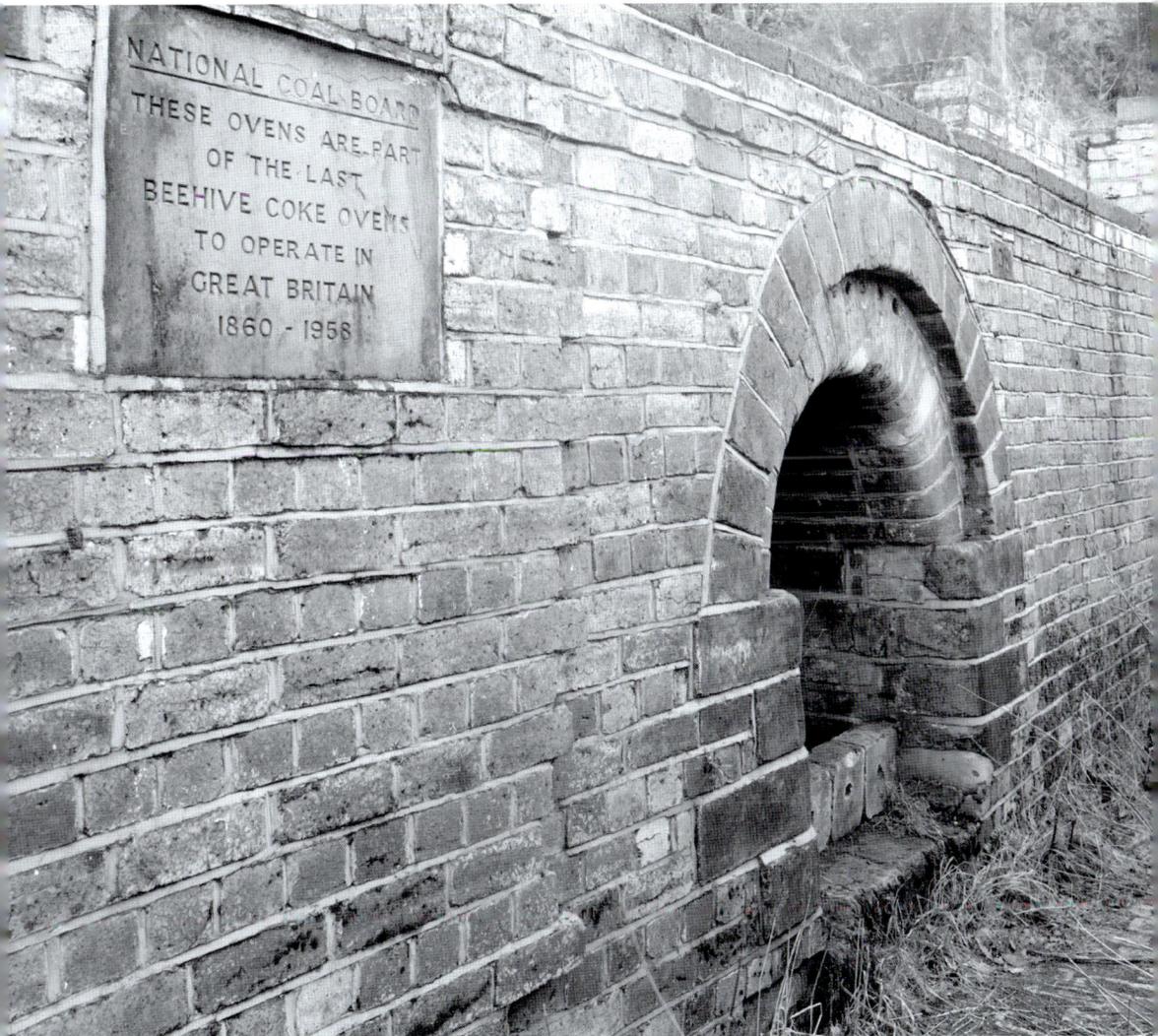

NATIONAL COAL BOARD
THESE OVENS ARE PART
OF THE LAST
BEEHIVE COKE OVENS
TO OPERATE IN
GREAT BRITAIN
1860 - 1958

Whinfield Coke Ovens

Whinfield's coke ovens are rare survivors. Once commonly seen, these beehive-shaped receptacles were loaded with coal and fired to produce coke. At their peak the Whinfield plant at Rowlands Gill turned out over 1,000 tons of high-quality coke per week. It began operations in 1861 and after closure in 1958 a few brick-built ovens were spared to mark the passing of an overlooked but once vital industry. (© Crown copyright. Historic England Archive)

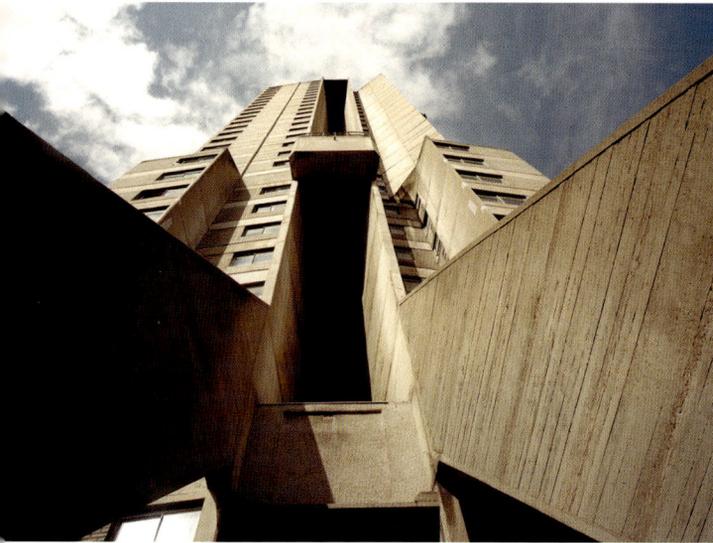

Derwent Tower, Gateshead
Bob Skingle's 2002 photograph brilliantly captures why Derwent Tower was nicknamed 'The Rocket'. Projecting 273 feet above Dunston, the concrete structure was designed by the Owen Luder Patnership and built in the late 1960s to provide much-needed local accommodation. Always controversial, however, and plagued with structural faults, its top levels were carefully deconstructed in 2011 and the brutalist monolith was completely demolished in the following year. (© Historic England Archive)

Dunston Staiths, Gateshead
A rather forlorn-looking Dunston Staiths are pictured here four years after closure in 1980. Built in the late nineteenth century by the North Eastern Railway Co., the huge timber structure shipped over 5 million tons of coal per year from its six river berths. Fire damaged but now under repair, the staiths are a monument to County Durham's great age of coal. (© Crown copyright. Historic England Archive)

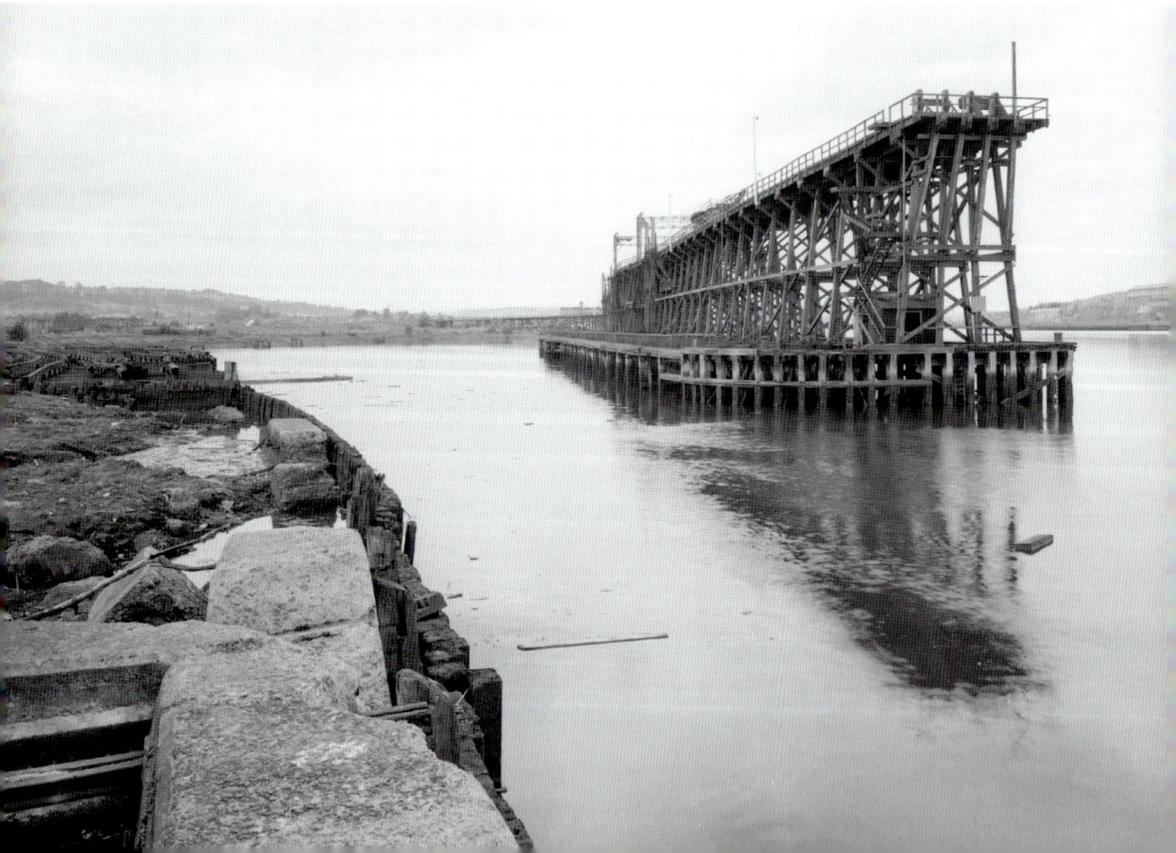

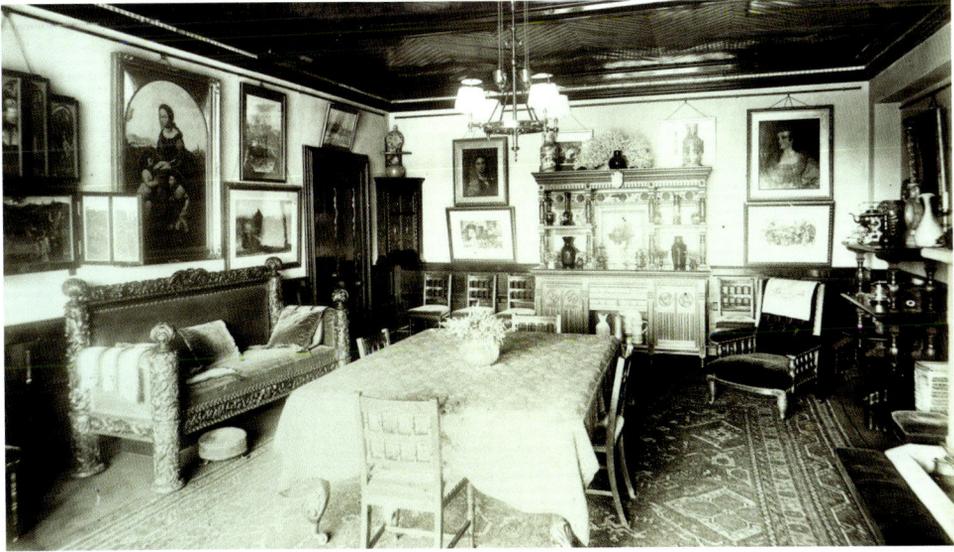

Above: Bensham Grove, Gateshead

Robert Spence Watson commissioned this photograph of his Gateshead home in 1886. Born in 1837, Watson became one of the region's most renowned intellectuals. A committed Quaker, he was a lawyer, an influential lecturer and a strong advocate of political and educational reform. After his death in 1911, Bensham Grove appropriately became an education and social centre, a role it continues to fulfil. (Historic England Archive)

Below: Axwell Park, Blaydon

Overlooking the picturesque Derwent Valley, Axwell Park was one of County Durham's finest stately homes. Designed by architect James Paine for Sir John Clavering, the Palladian mansion was completed in 1758. It fared badly in more recent times but was rescued and is now about to be converted into apartments. A garden temple by John Dobson (visible on the left in this 1886 image) has not been so fortunate. (Historic England Archive)

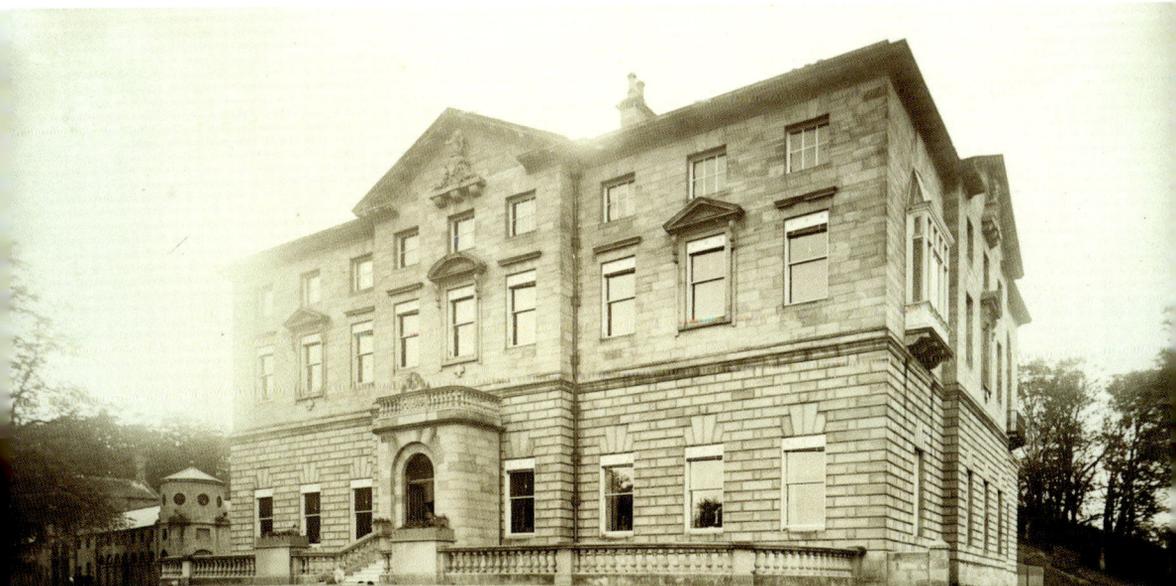

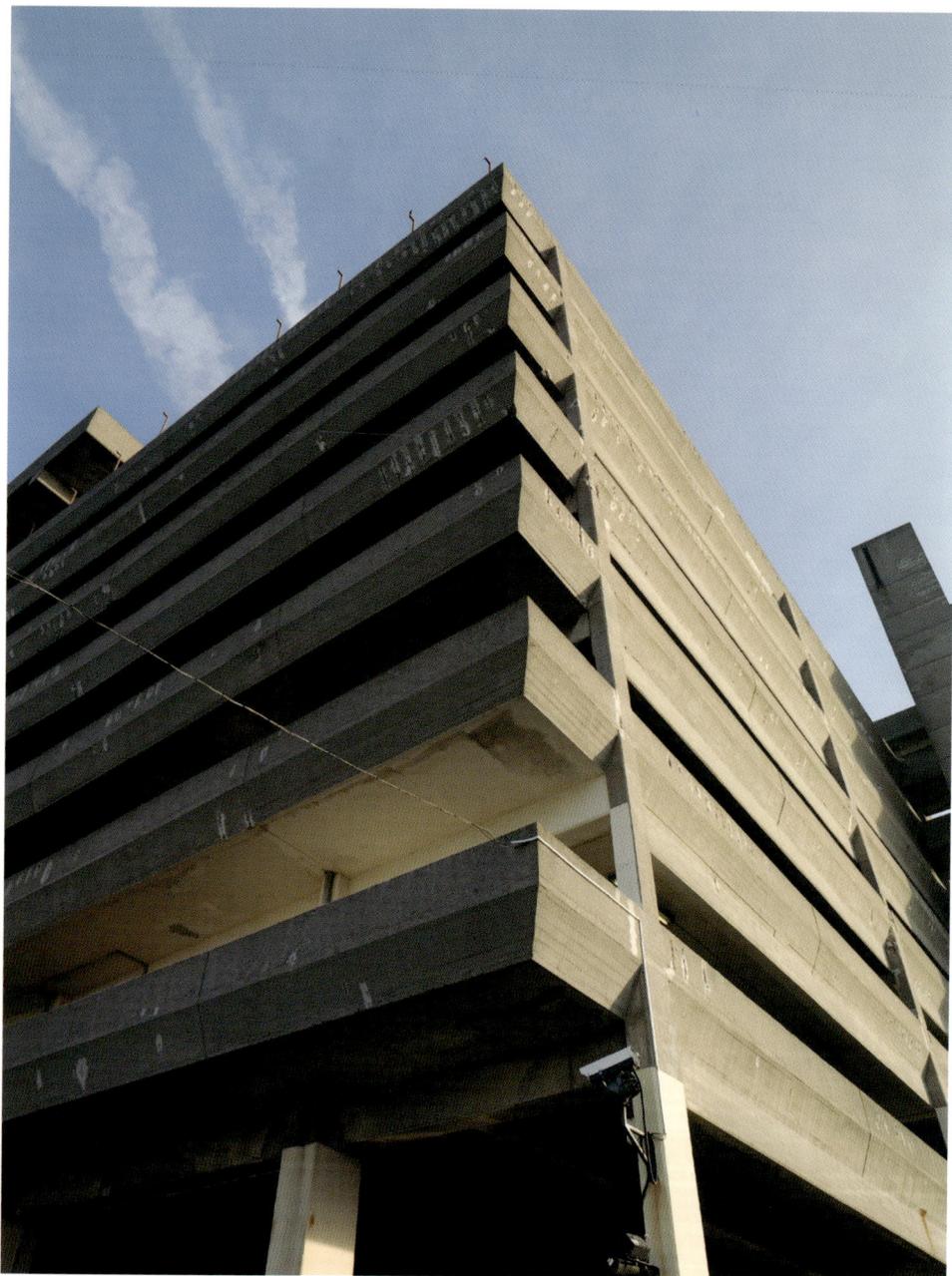

Trinity Square, Gateshead

Gateshead's Trinity Square car park was more loathed than loved. Another brutalist statement from Owen Luder, it was completed in 1969 as part of a new shopping centre 'megastructure'. Initially praised, it fell out of fashion and into disrepair like many structures of that era. Many welcomed its demolition in 2010 but by then it had also achieved cult status as a star of the 1971 film *Get Carter*. (© Historic England Archive)

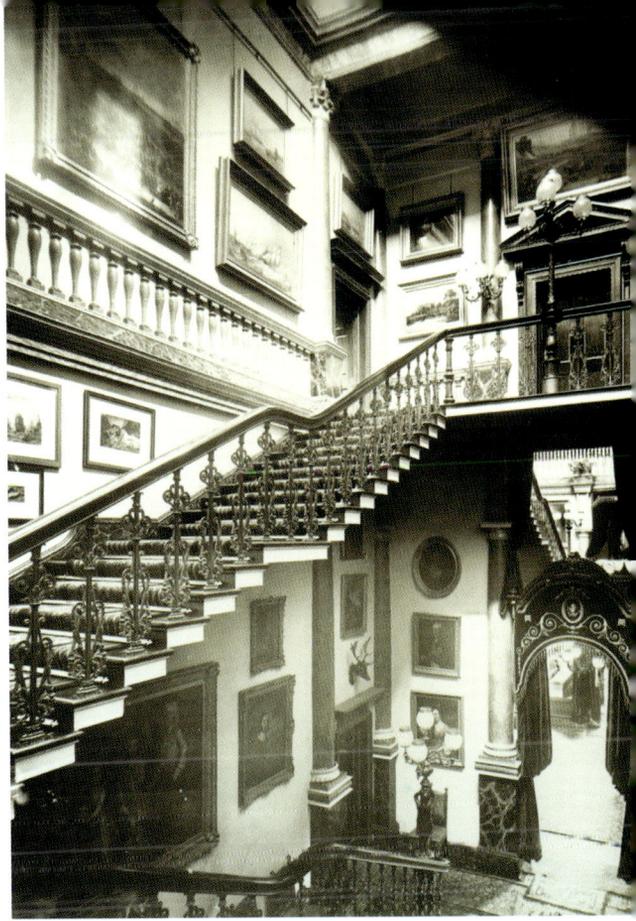

Right: Axwell Hall Interior
Sir Henry Augustus Clavering, who commissioned this Lemere photograph in 1886, was the last baronet to occupy Axwell Hall. After 'Mad Harry', as he was known locally, died in 1893, the fortunes of the Clavering family continued to decline. The hall and its contents were sold off in 1920 and the imperial staircase and surrounding picture gallery were illustrated in the catalogue of auctioneers Anderson and Garland. (Historic England Archive)

Below: Trinity Square, Gateshead
Trinity Square shopping centre was Gateshead's emphatic answer to the dismal old car park and retail area. Opened in 2013 and costing £150 million, the centre was complemented a year later with the addition of high-tech artwork by North East artist Steve Newby. Titled *Halo*, the 27-foot welded ring of 'inflated' stainless steel was engineered by local craftsmen to honour Gateshead's industrial past and anticipate its bright future.

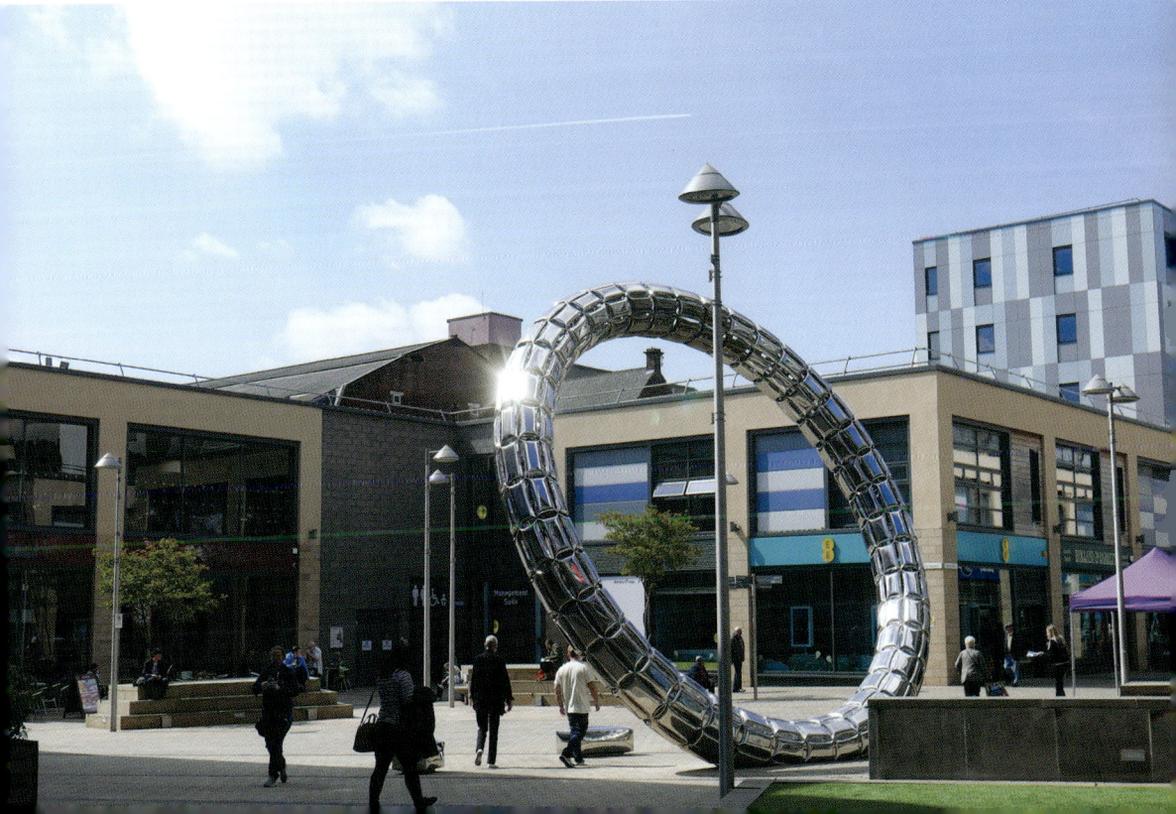

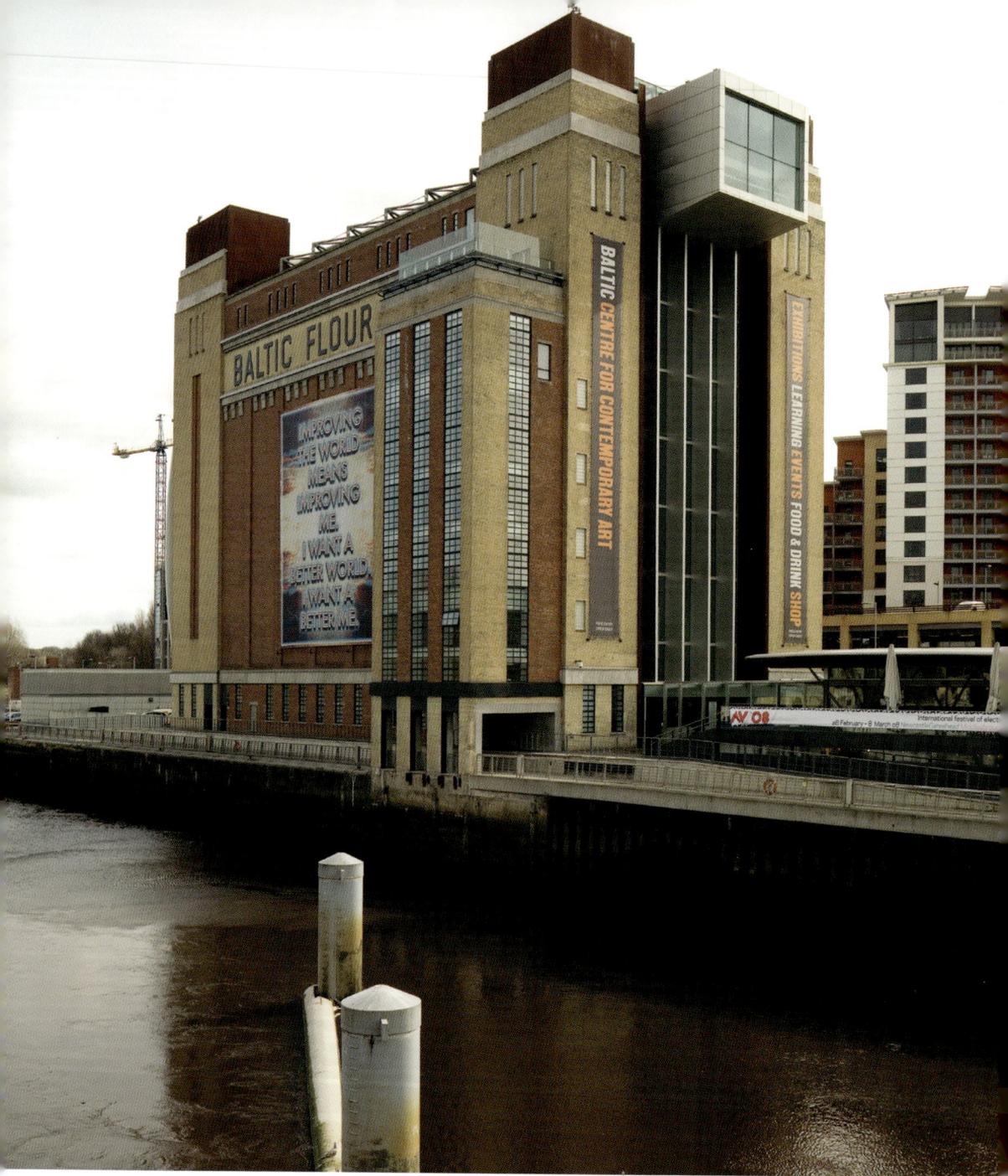

Baltic Centre for Contemporary Art, Gateshead

Gateshead's Baltic Centre for Contemporary Art and the adjacent Sage building are symbols of Tyneside's regeneration. The Baltic was officially opened in 2002 after a decade of planning and construction costing around £50 million. Most critics agree that architect Dominic Williams' conversion of a former flour mill into a cutting-edge art venue has been a huge success. (© Historic England Archive)

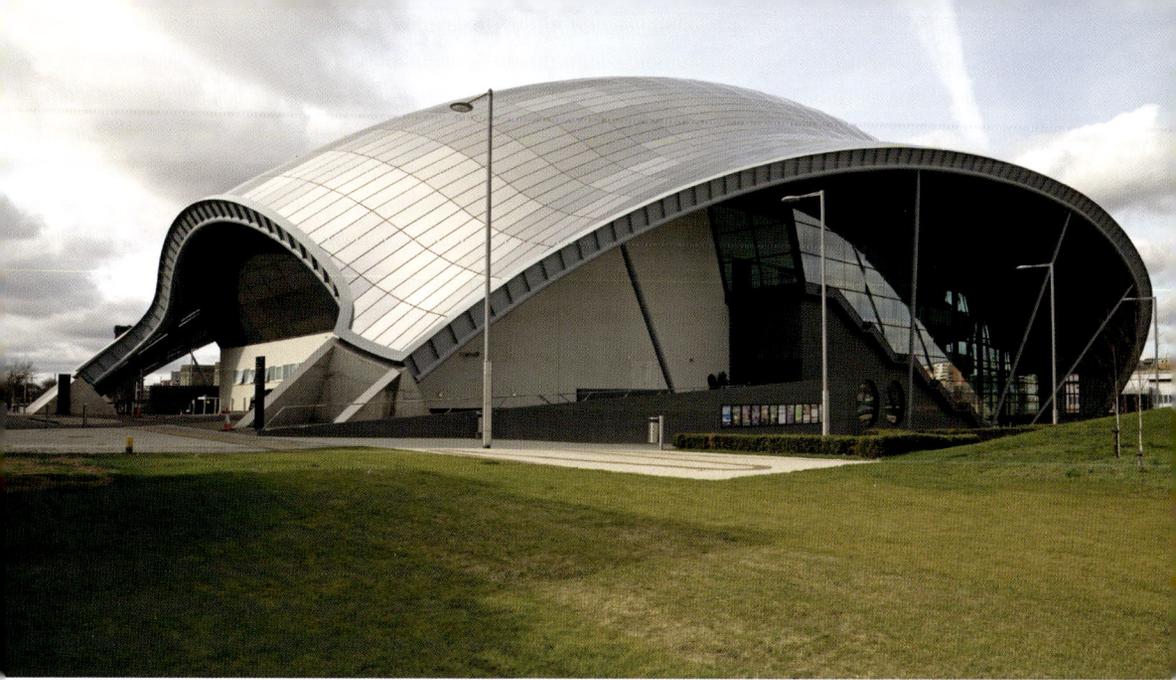

Above: The Sage, Gateshead
Resembling an alien spacecraft, the Sage is seen here from the east in Keith Buck's photograph. Completed in 2004, it was another milestone in the redevelopment of Gateshead's quayside district. The international music centre, designed by award winners Foster & Partners, was built on the site of an old rope works. A huge glass and stainless steel structure, it houses three auditoriums as well as workshops and rehearsal rooms. (© Historic England Archive)

Below: The Sage, Gateshead
Engineered by the Buro Happold Co., this is one of four giant steel arches that underpin the spectacular roof of Gateshead's Music Centre. Spanning over 250 feet, they support the thousands of glass and stainless steel panels that give the Sage its distinctive undulating form. Visitors with a head for heights can apply to take part in the Sage 'roof walk experience' but others climb the stairs from Mill Road.

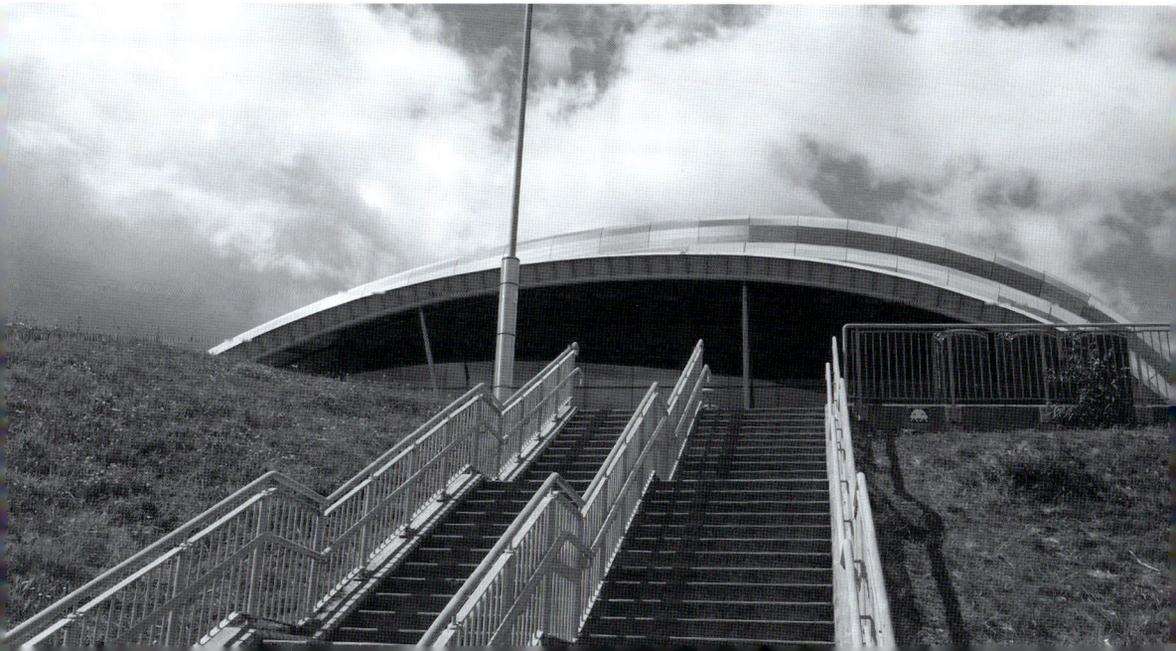

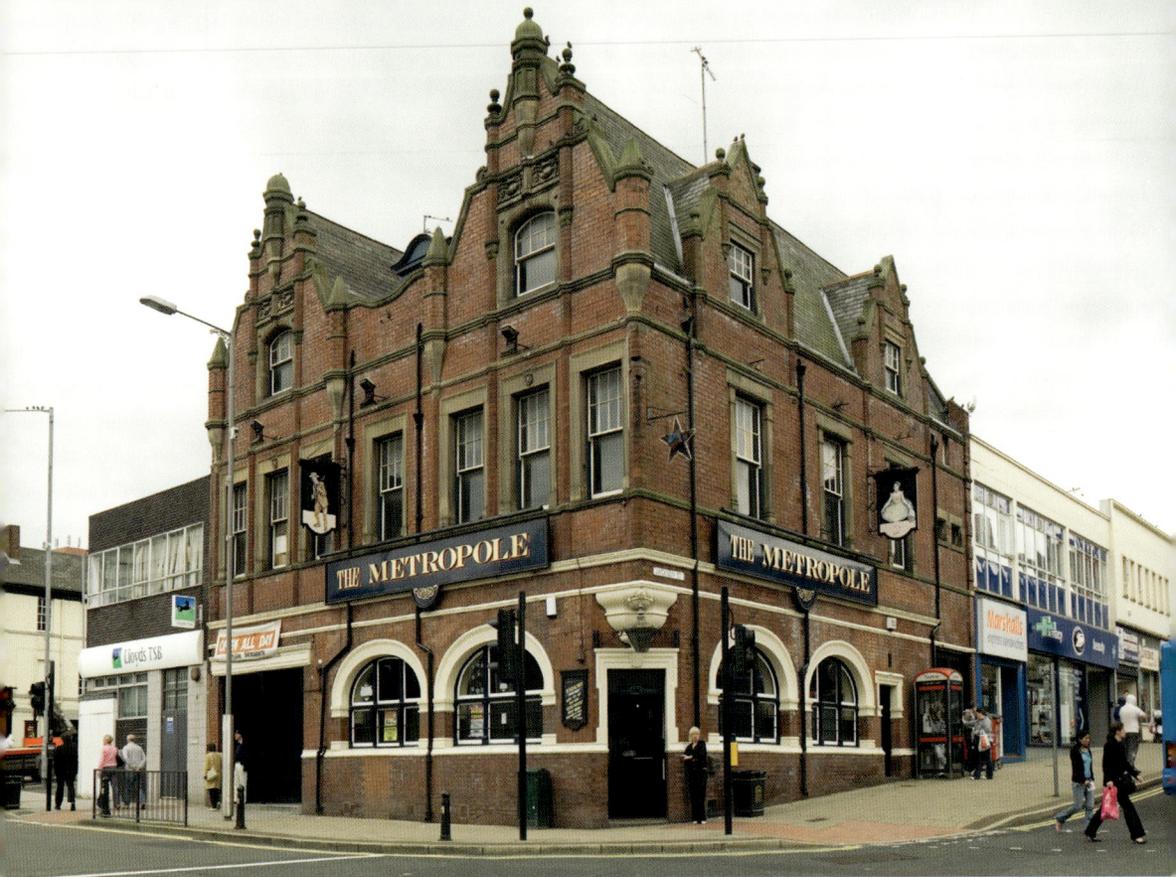

The Metropole, Gateshead

Now squeezed between less charismatic buildings, The Metropole enlivens the corner of Gateshead's High Street and Jackson Street. Red bricked and gabled, the original more extensive building incorporated a hotel and was the work of Newcastle architect William Hope. Opened as the town's biggest theatre in 1896, it became the Scala Cinema in 1919 and was largely demolished in 1960. The Metropole pub is its last remnant. (© Historic England Archive)

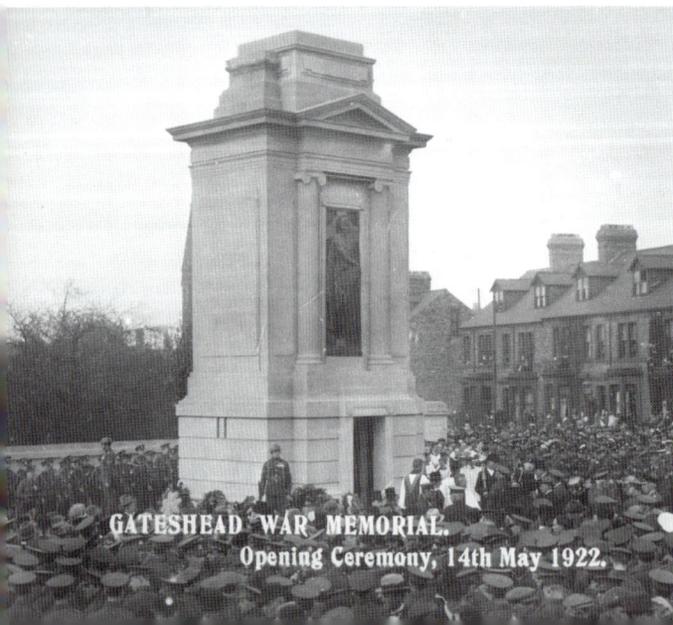

GATESHEAD WAR MEMORIAL.
Opening Ceremony, 14th May 1922.

War Memorial, Gateshead

A huge crowd attended the unveiling of Gateshead's war memorial on Durham Road in May 1922. Built in a classical cenotaph style, the sandstone memorial was designed by Kingston upon Thames architect J. W. Spink. Hand on sword, a giant bronze warrior sculpted by Richard Goulden looks down from the upper storey. Gateshead paid a heavy price in the First World War and a lengthy roll of honour was initially deposited inside the empty tomb. (Historic England Archive)

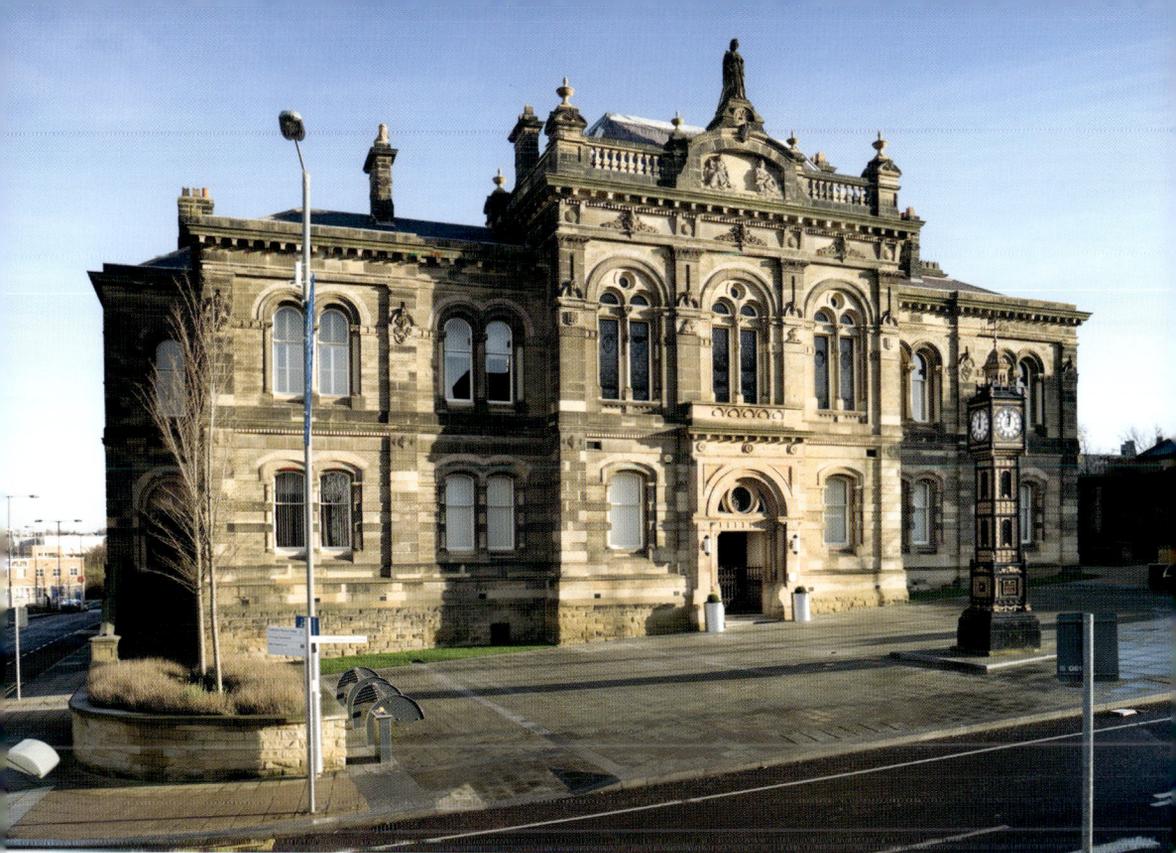

Old Town Hall, Gateshead
Gateshead's old Town Hall still exudes civic pride. In an eye-catching position, the Italianate-style building was designed by John Johnson and opened in 1870. Erected for £12,000, it was constructed from ashlar masonry, topped with reliefs representing Industry, Commerce and Justice and crowned unsurprisingly by the figure of Queen Victoria. Redundant in 1986, it is now for sale. (© Historic England Archive)

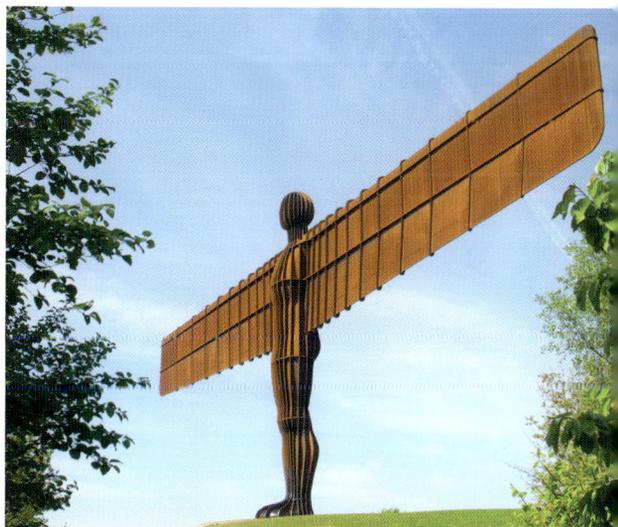

The Angel of the North, Gateshead
The Angel of the North has become a regional icon. Erected in 1998, the 66-foot-tall statue stands high on Eighton Banks, reaching out over routes in and out of Gateshead. Created by artist Antony Gormley and based on the proportions of his own body, the 200-ton figure was made from Cor-Ten all-weather steel and fabricated in Hartlepool. (© Historic England Archive)

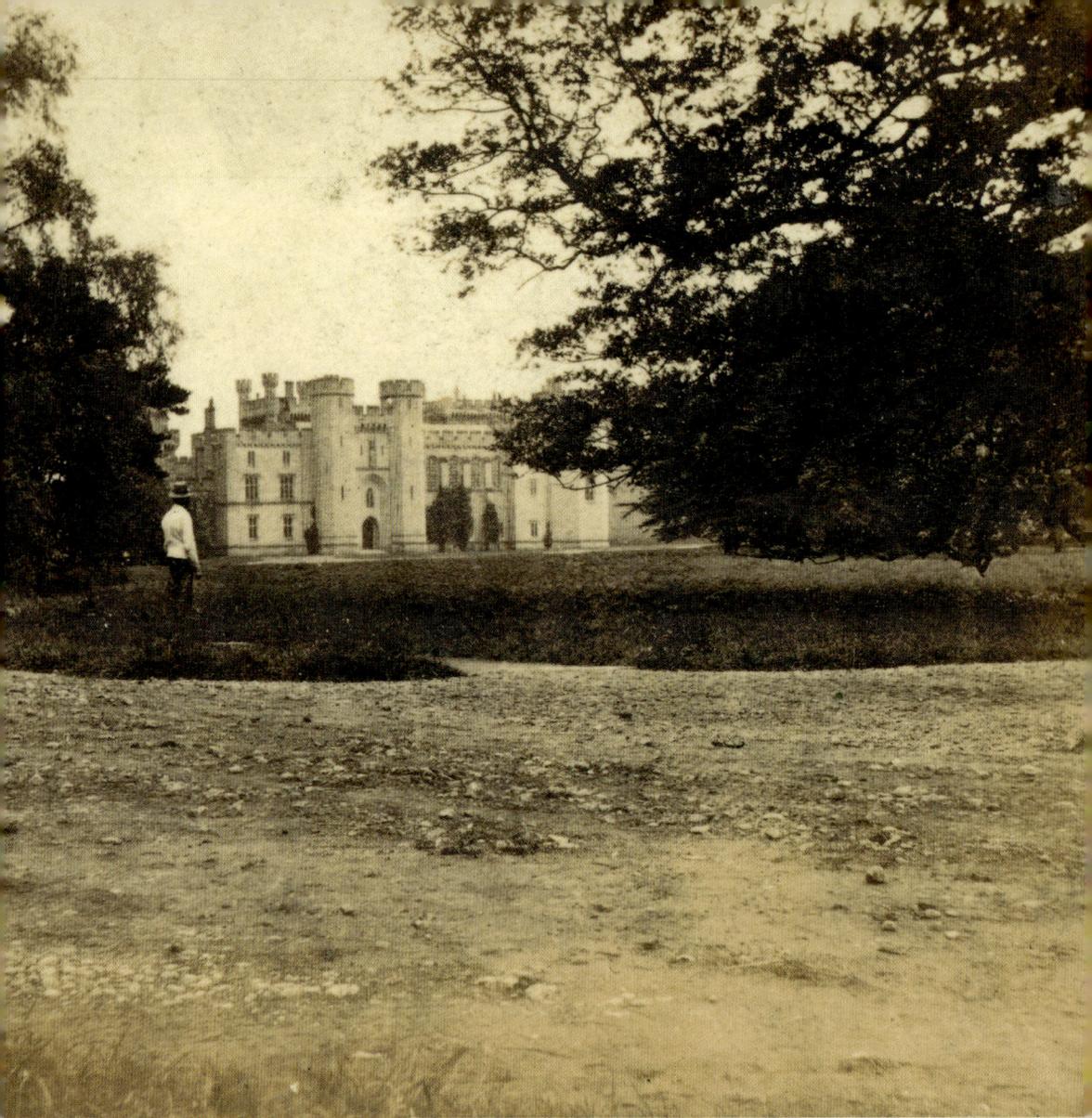

Above: Ravensworth Castle, Gateshead
A charming nineteenth-century stereoscopic image illustrates Ravensworth Castle in its prime. Originally medieval, the castle was altered by Newcastle merchant Thomas Liddell after 1607 and then rebuilt by subsequent Liddell generations. The vast Gothic palace glimpsed here was completed for another Liddell, the 2nd Lord Ravensworth, in the 1840s. Mostly demolished just over a century later, it remains a sad ruin of a once noble estate. (Historic England Archive)

Opposite above: Saltwell Towers, Gateshead
Newcastle businessman William Wailes had Saltwell Towers built between 1860 and 1871. His artistic skill as a stained-glass manufacturer was reflected in the design and furnishing of his new mansion. A quirky mixture of exotic turrets and gaudy brickwork made Saltwell Towers an extraordinary building. Under threat in the late twentieth century, it was rescued by Gateshead Council and restored to its idiosyncratic best. (Historic England Archive)

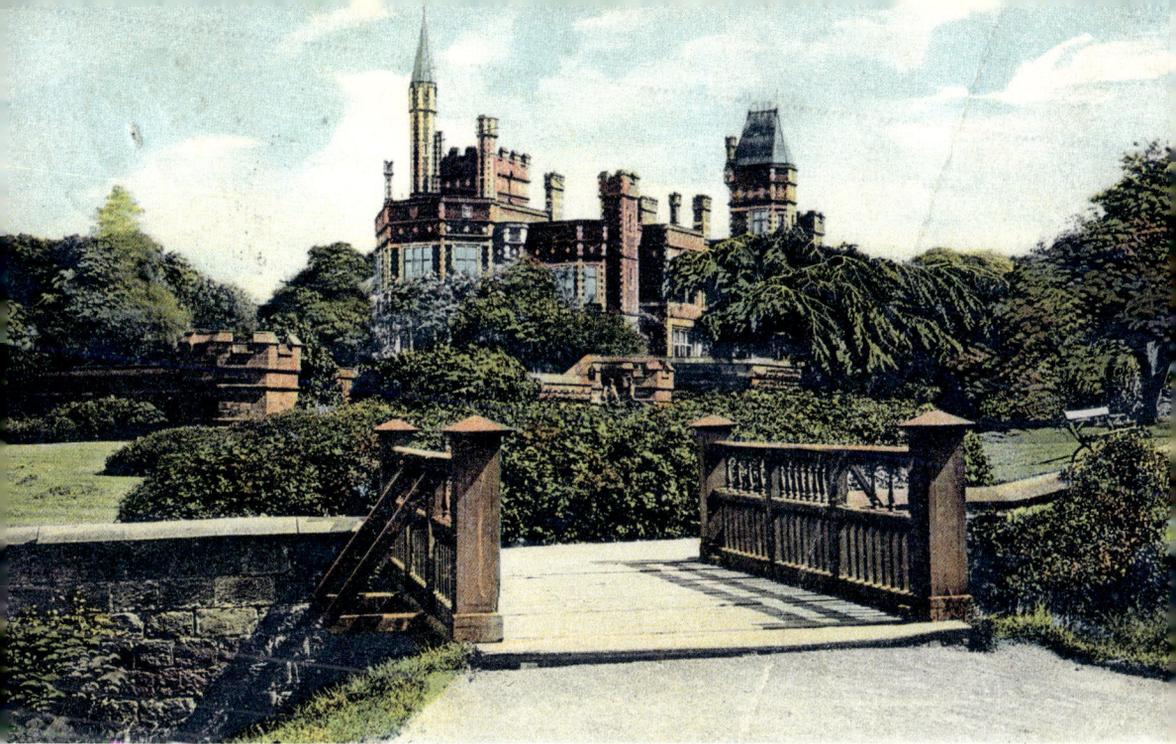

Below: Saltwell Park, Gateshead

Saltwell Park was opened in 1876 on land purchased from William Wailes. Its picturesque location was fully exploited by noted landscape architect Edward Kemp. In this WHSmith postcard of the park's promenade or 'Broad Walk', the Lucas memorial looks across Team Valley towards Lobley Hill. Brickmaker John Lucas became the mayor of Gateshead in 1888 and was a major supporter of what has always been known as 'The People's Park'. (Historic England Archive)

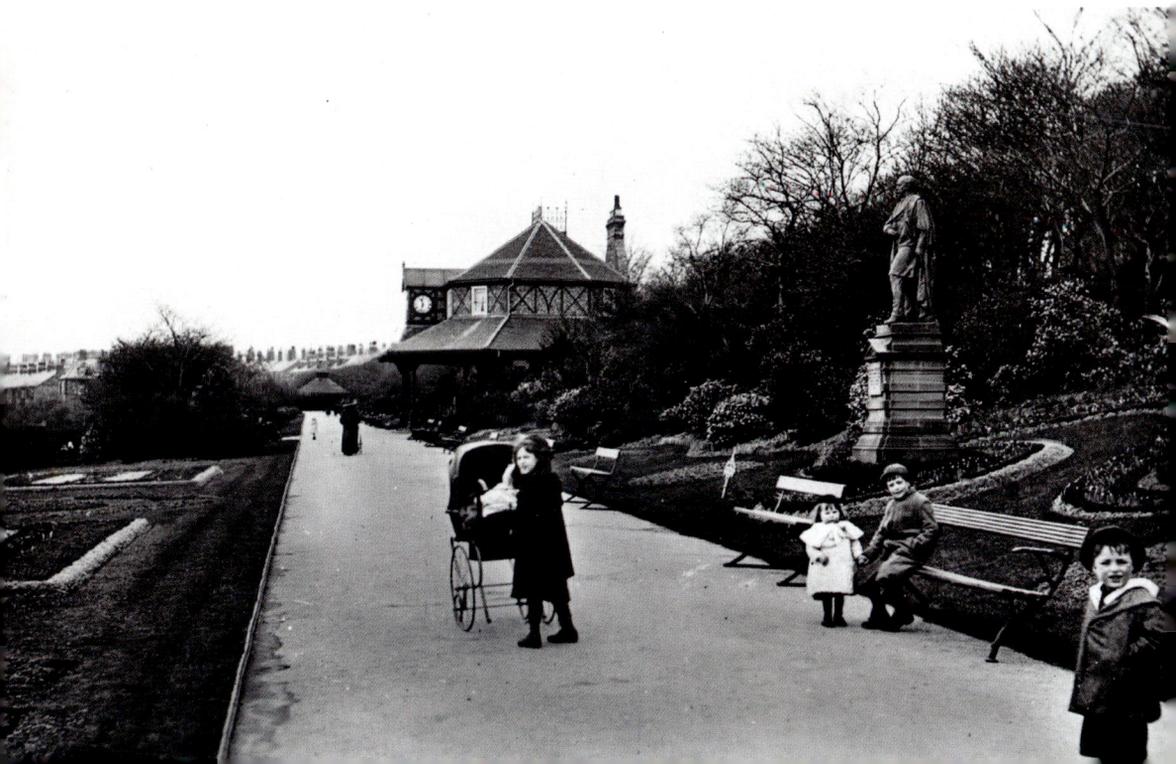

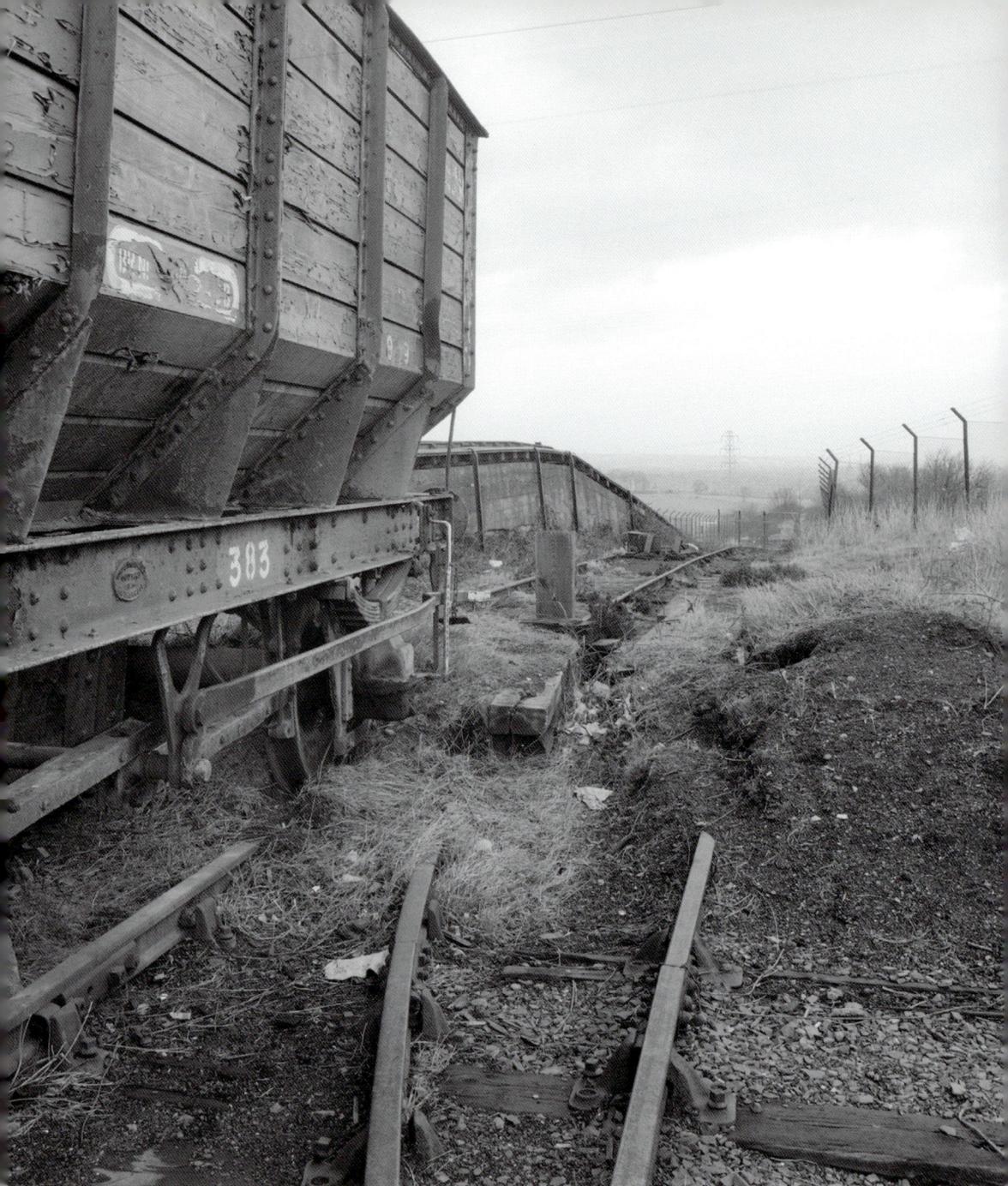

Bowes Railway at Springwell

The Bowes Railway was developed in the first half of the nineteenth century to carry coal from County Durham's north-west collieries to the River Tyne. Springwell's line to Jarrow staiths led the way, engineered in 1826 by George Stephenson. After closure in 1974, the Springwell site near Gateshead was saved as a Scheduled Ancient Monument, a unique example of a rope-hauled and inclined plane railway system. Taken in 1993, this Bob Skingle photograph looks down the slope from the south-west. (© Crown copyright. Historic England Archive)

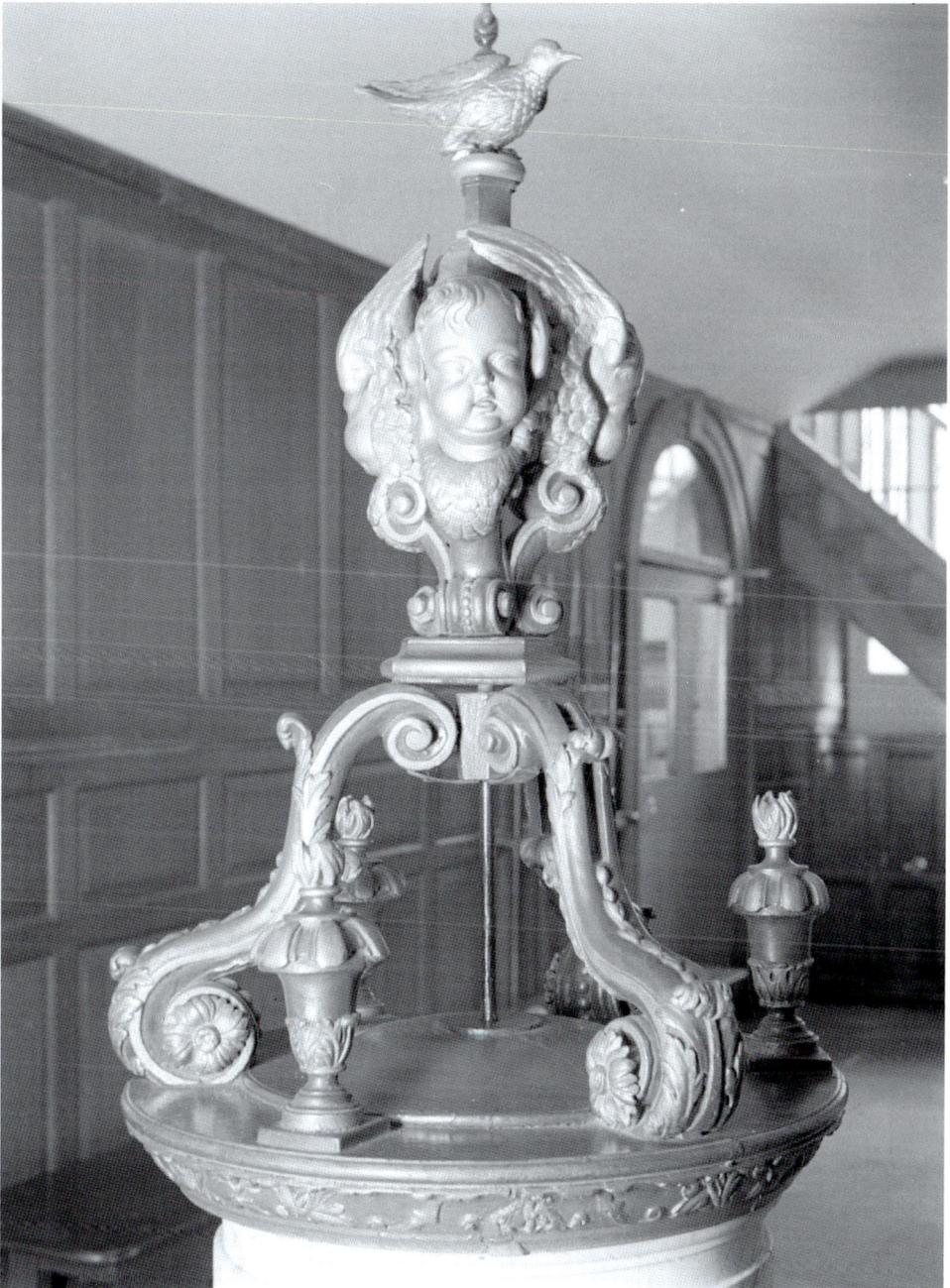

Holy Trinity Church, Sunderland
Photographed by Eric de Mare, this detailed image shows the font cover from Sunderland's Holy Trinity Church. Elaborately carved, it features cherub heads and is topped with a dove. Although presumed to be contemporary with the church building, the cover's style suggests an earlier period. (Historic England Archive)

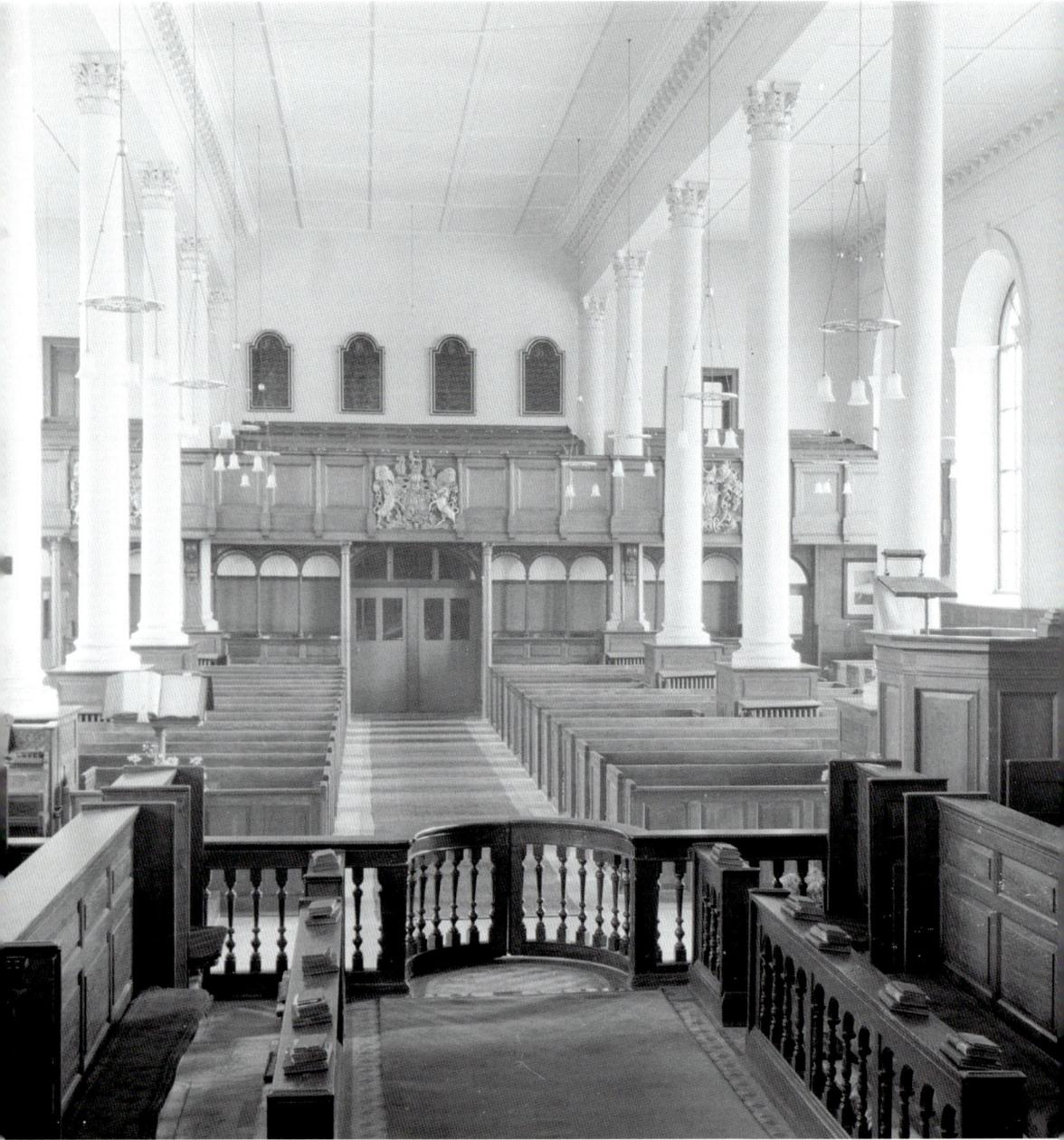

Holy Trinity Church, Sunderland

Consecrated in 1719, and later extended, Holy Trinity Church was built in the newly formed parish of Sunderland. Attributed to Yorkshire architect William Etty, the building contained meeting rooms and a library and its elegant interior is noteworthy for the tall Corinthian columns seen above and classical plasterwork by Isaac Mansfield. Burdened by shrinking congregations and hefty restoration costs, the parish church closed in 1988. It is now cared for by the Churches Conservation Trust. (Historic England Archive)

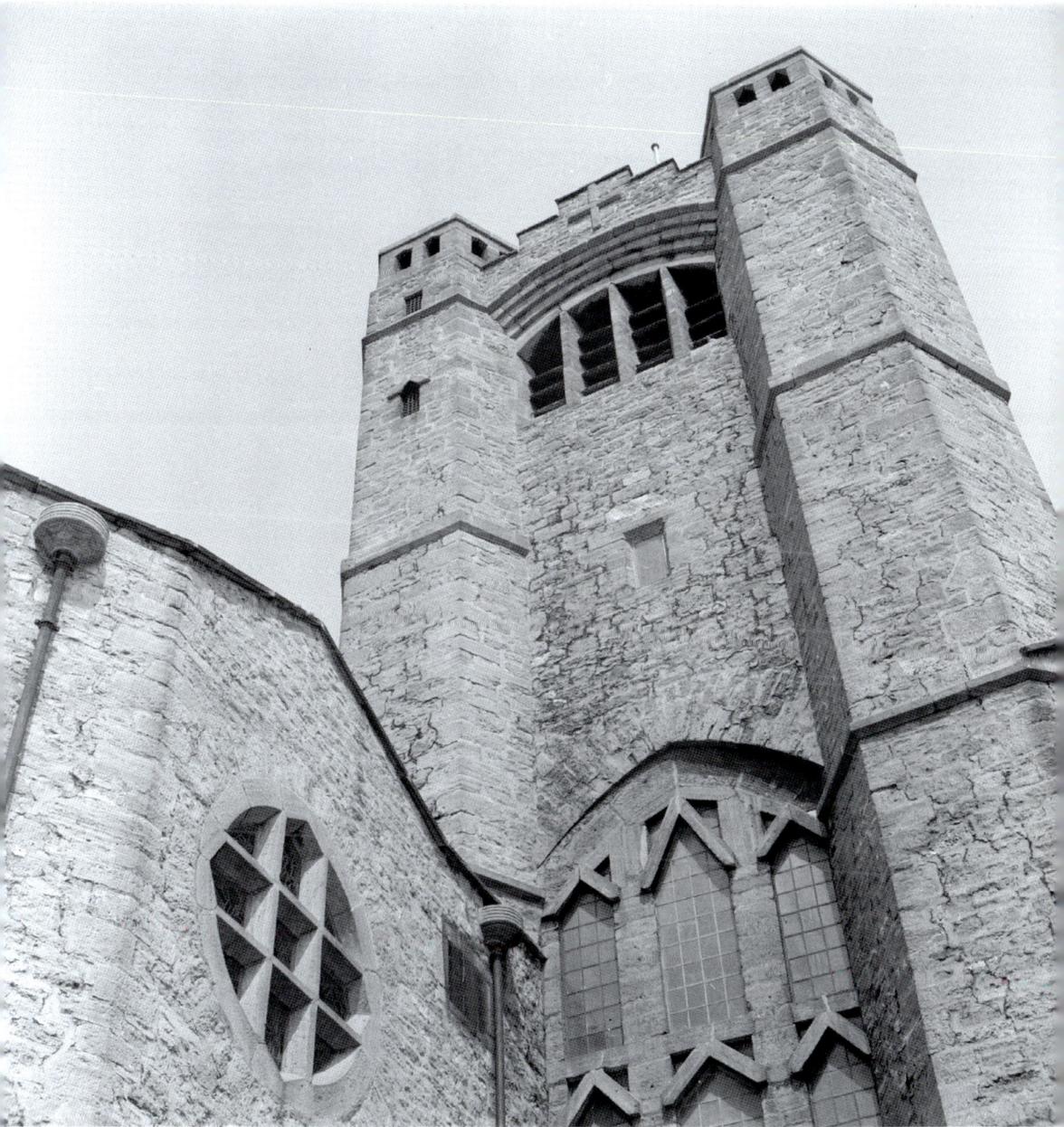

St Andrew's Church, Sunderland
St Andrew's tall tower looks out across the sea from the church in Roker. The nautical motif, repeated inside, is appropriate. Clad in coastal limestone and completed in 1907, the neo-Gothic structure was financially indebted to local shipbuilder John Priestman and designed by Edward Prior, a powerful force in Britain's Arts and Crafts style. Unsurprisingly, his Sunderland masterwork has been called 'the Cathedral of the Arts and Crafts Movement'. (Historic England Archive)

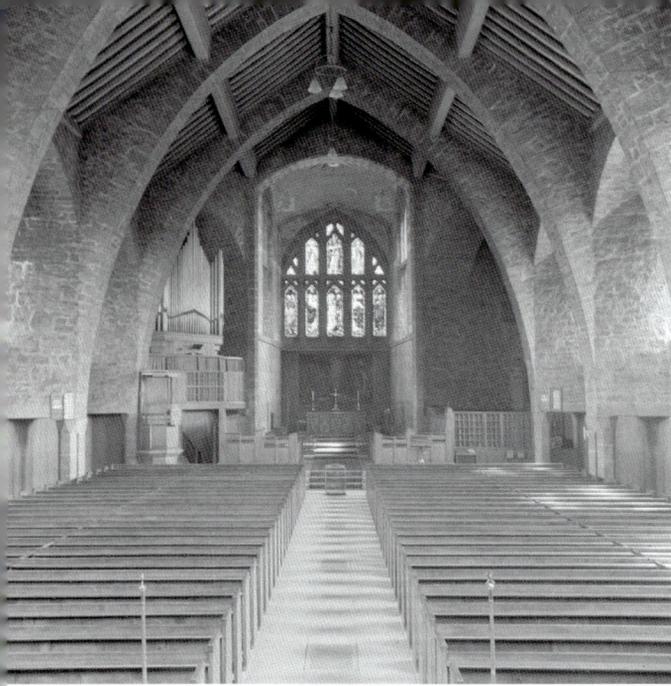

St Andrew's Nave, Sunderland
Resembling the ribs of an overturned boat, the nave of St Andrew's is pictured here. Its arches of reinforced concrete faced with stone were typical of Edward Prior, an architect never afraid of experimentation. Interior decorations by artists such as Burne-Jones and the William Morris Co. continue this Arts and Crafts tour de force and combine to make St Andrew's a building of international significance. (Historic England Archive)

South Pier Lighthouse, Sunderland
Sunderland's old south pier lighthouse now stands on the seafront at Roker, some distance from its original position. Designed by Thomas Meik, this fine cast and wrought-iron construction was erected in 1856 on the original south pier. When the pier was shortened in 1983, the 50-foot-high lighthouse was rebuilt further north in Cliffe Park and restored in 2016. (© Crown copyright. Historic England Archive)

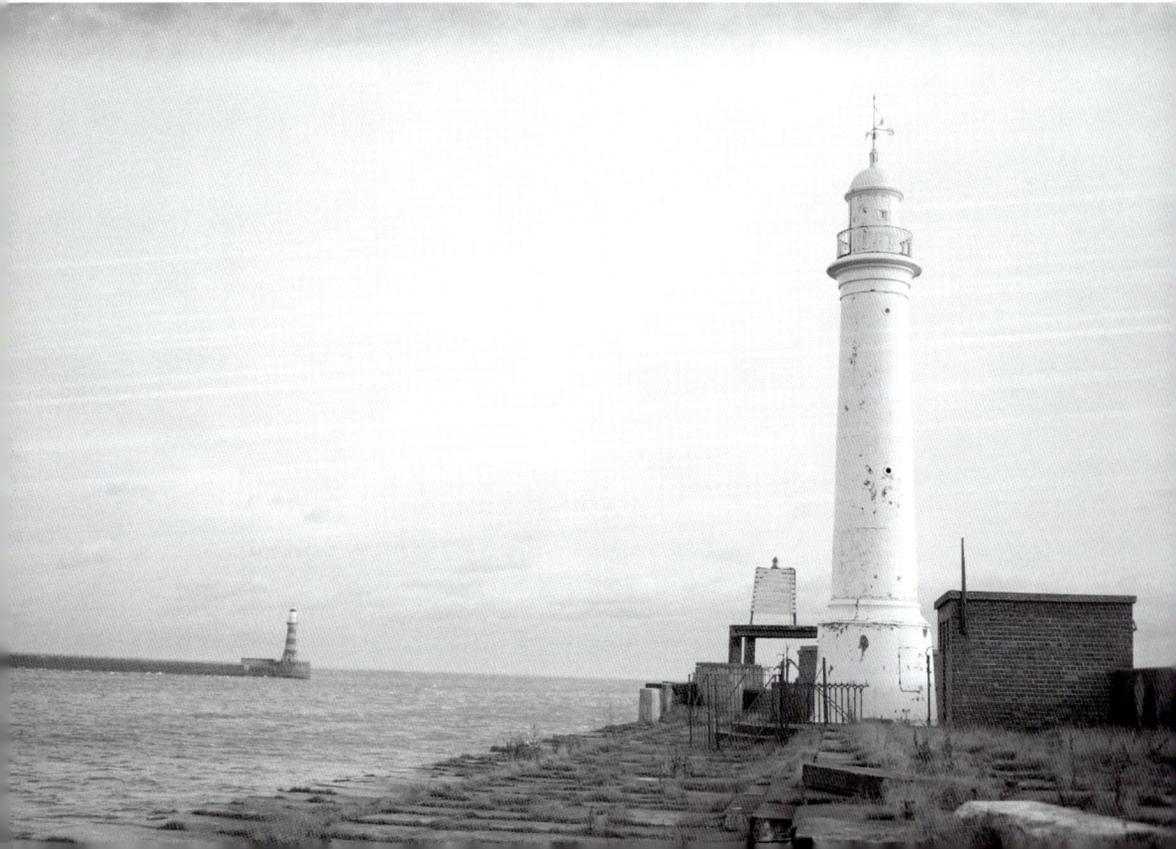

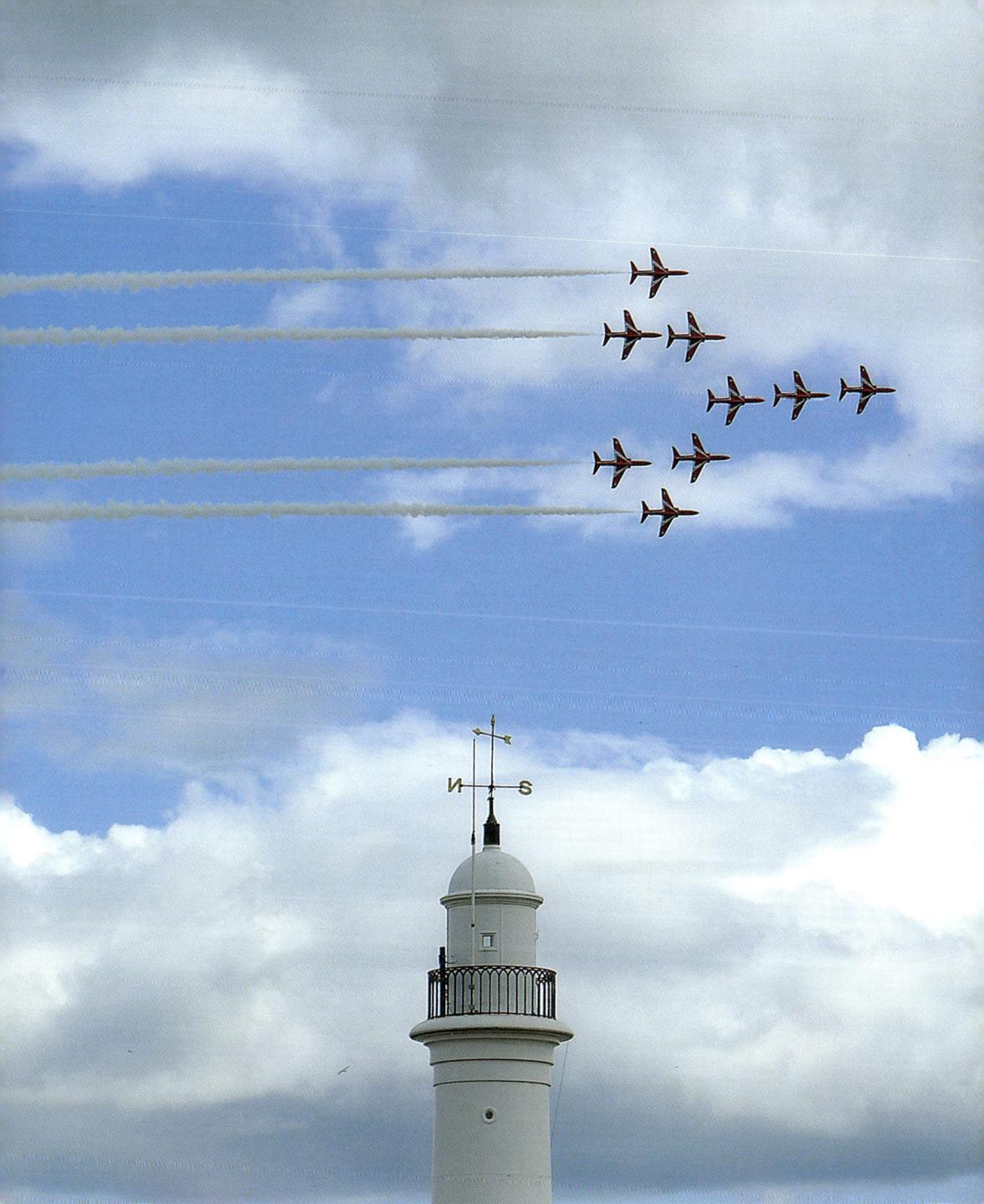

Cliffe Park Lighthouse

Since it was moved to Cliffe Park in 1983, Meik's lighthouse has become an even more familiar Sunderland landmark. During the annual air show, the Tuscan-style column acts as a focal point for spectators as well as a navigation aid for aircraft displays. Photographed here in 2014, the Red Arrows formation team fly past the lighthouse dome.

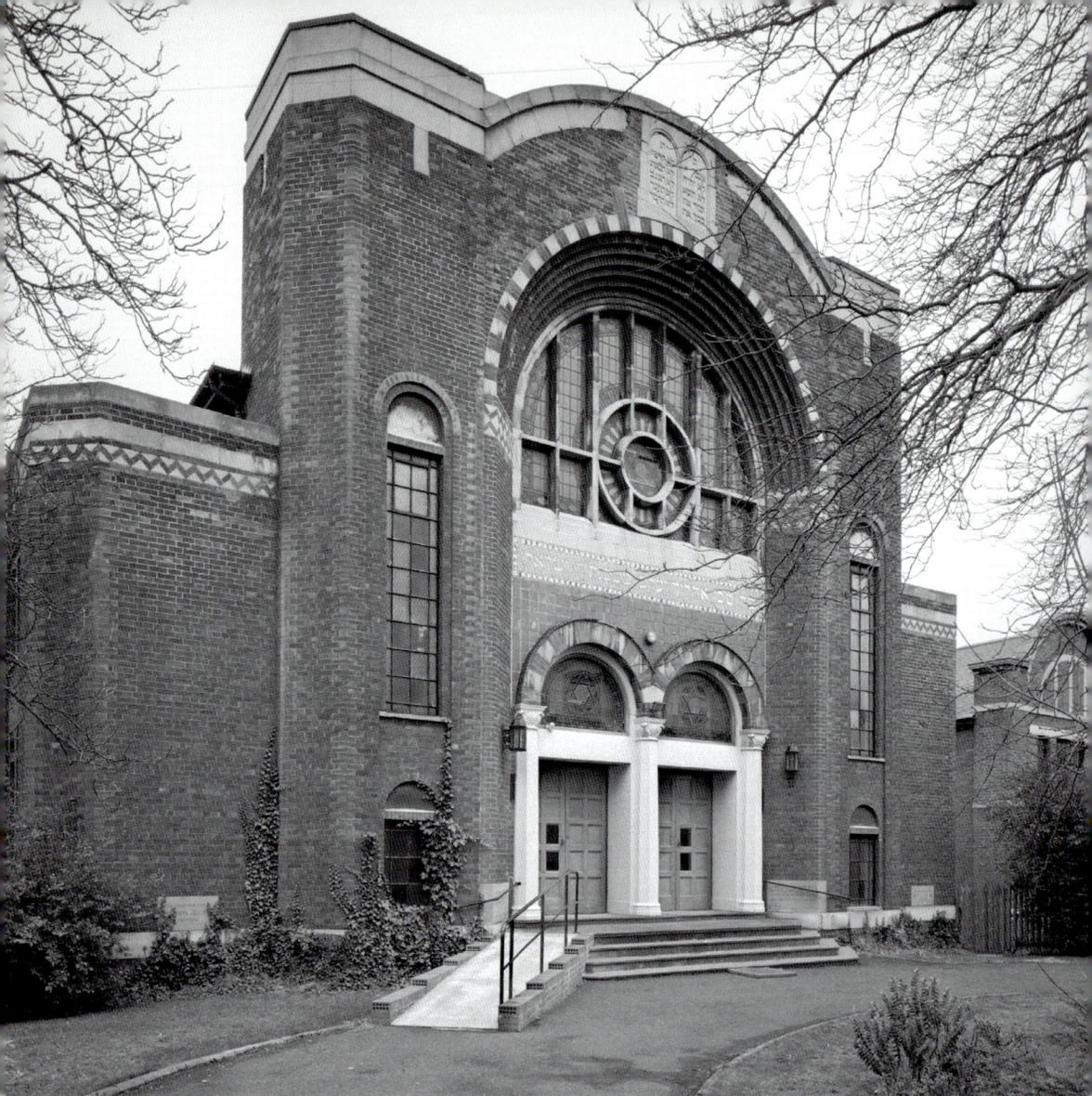

Above: Synagogue, Sunderland

Sunderland's Jewish community, in existence since the eighteenth century, moved its centre of worship from Moor Street to Ryhope in 1928. The new synagogue, pictured here in 1999, was designed by Marcus Glass. His design was a bold fusion of Byzantine and art deco styling enclosing a jewel-like interior (now badly damaged). Closed in 2006 and subsequently sold off, the building has acquired listed status but faces an uncertain future. (© Crown copyright. Historic England Archive)

Opposite above: Hylton Castle, Sunderland

Only the strong outer walls of Hylton Castle remain. It was built around 1400 by William de Hylton on ancestral land reputably owned since the Norman Conquest. Constructed as a rectangular gatehouse tower, the castle was originally of four storeys with the great hall on the second floor. This photograph dates from 1965 but today, after centuries of alteration and decay, restoration of this impressive monument is poised to begin. (Historic England Archive)

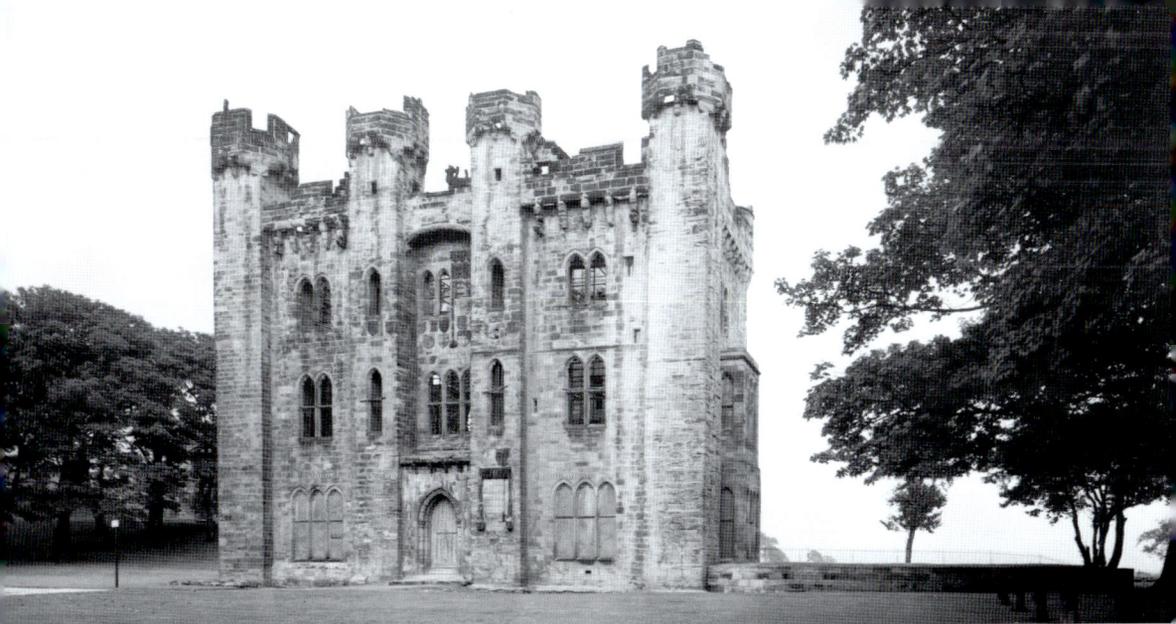

Below: Hylton Castle, Sunderland

Sir William de Hilton was rich, powerful and apparently well connected. Although many are badly weathered, carved displays of Hilton family prestige can still be seen on the castle walls. England's elite are also represented, including Henry IV and Henry 'Hotspur' Percy. Bob Skingle's west front image from 2008 shows the Hylton banner and above that the crest of Walter Skirlaw, 25th Bishop of Durham. (© Historic England Archive)

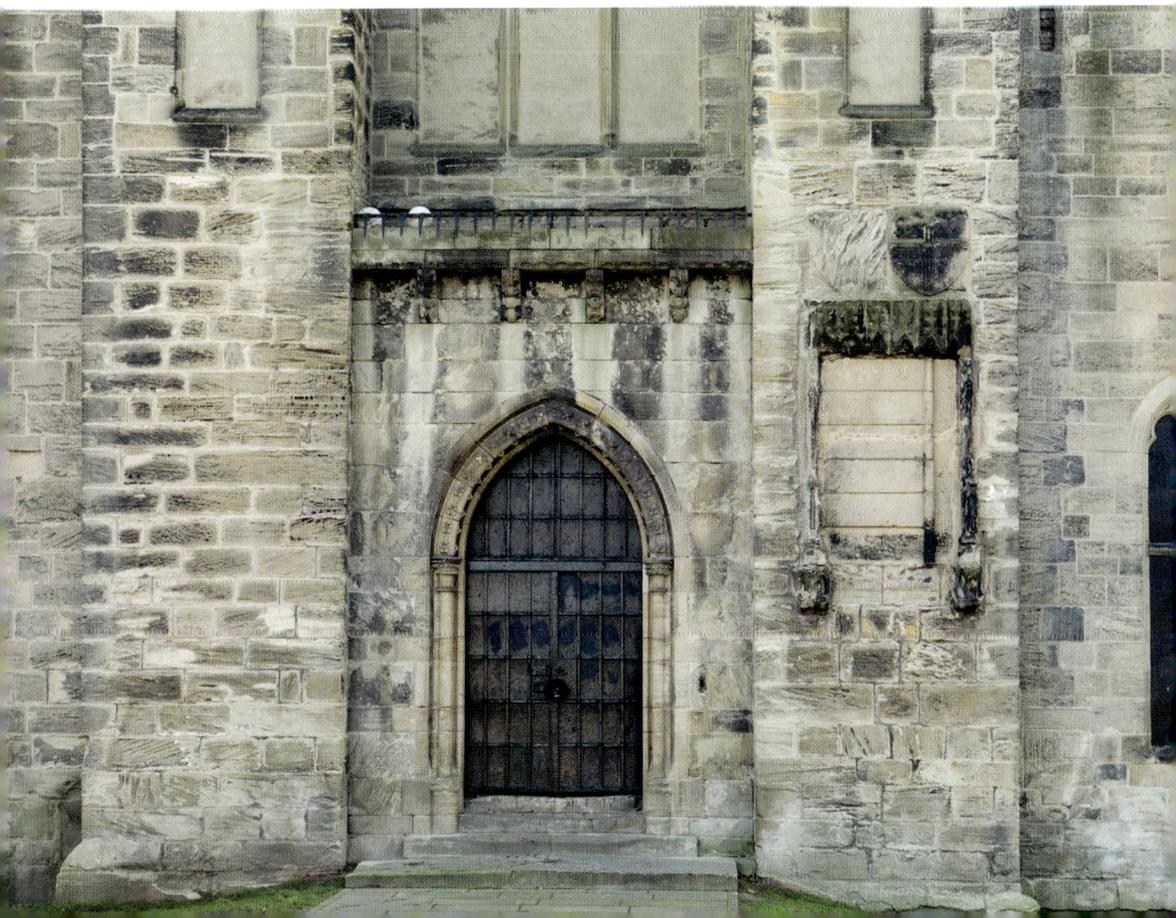

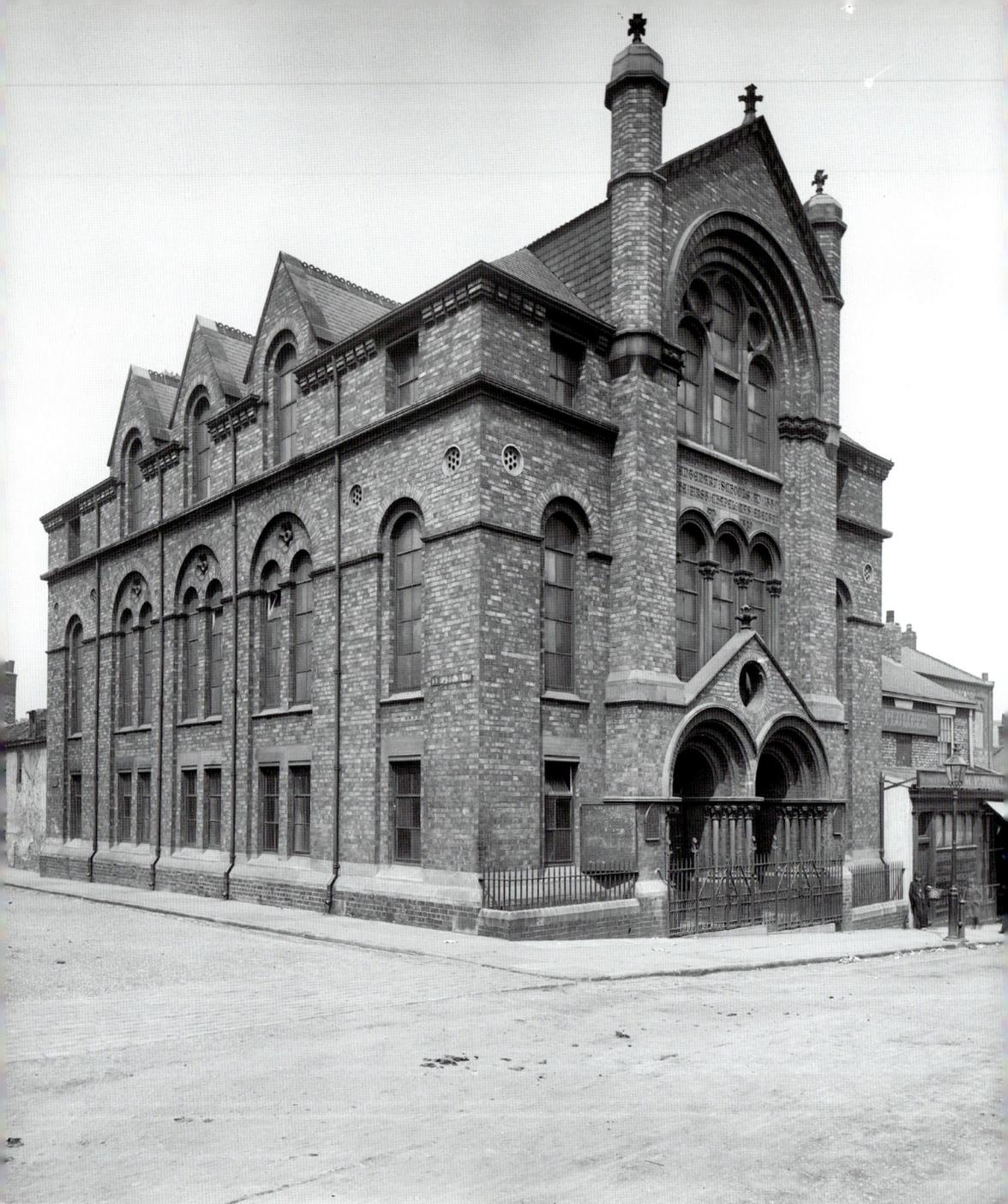

Sunderland Primitive Methodist Chapel

Pictured in July 1891, almost a decade after opening, is the Williamson Terrace Primitive Methodist Chapel. Erected on the junction of Charles Street, the new building cost £3,000, had a schoolhouse attached and was the second chapel on that site. Working-class converts in particular were attracted to the zeal and passion of the Primitive Methodist faith. The chapel was bomb damaged in 1943 and later demolished. (Historic England Archive)

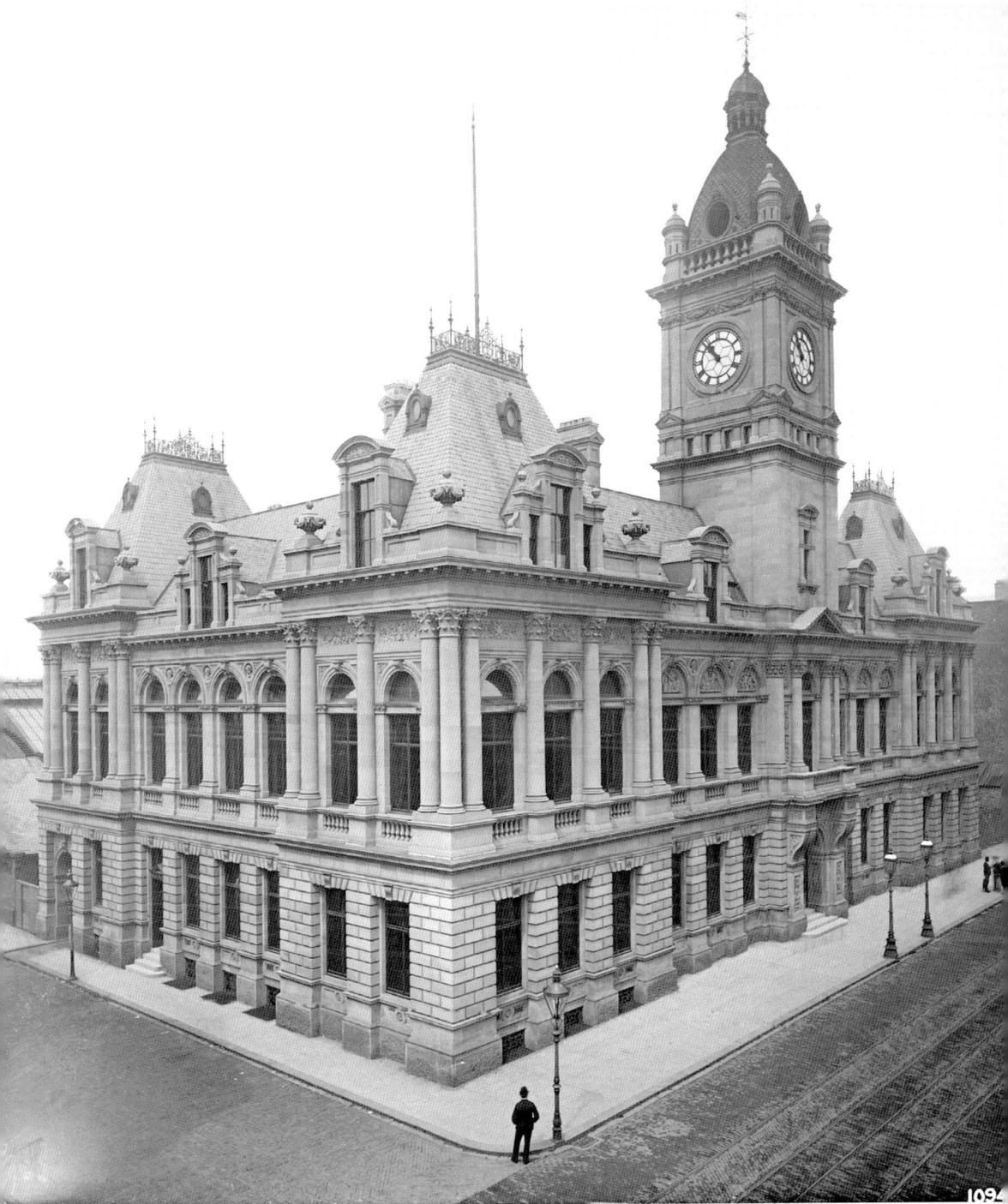

Old Town Hall, Sunderland
An imposing demonstration of civic confidence and pride, Sunderland's Town Hall on Fawcett Street is the subject of this 1891 view. The continental-styled building, designed by Ipswich architect Brightwen Binyon, opened in the previous year. Yet despite the general popularity of its distinguished appearance, it proved impractical for modern council use and was demolished in 1971. (Historic England Archive)

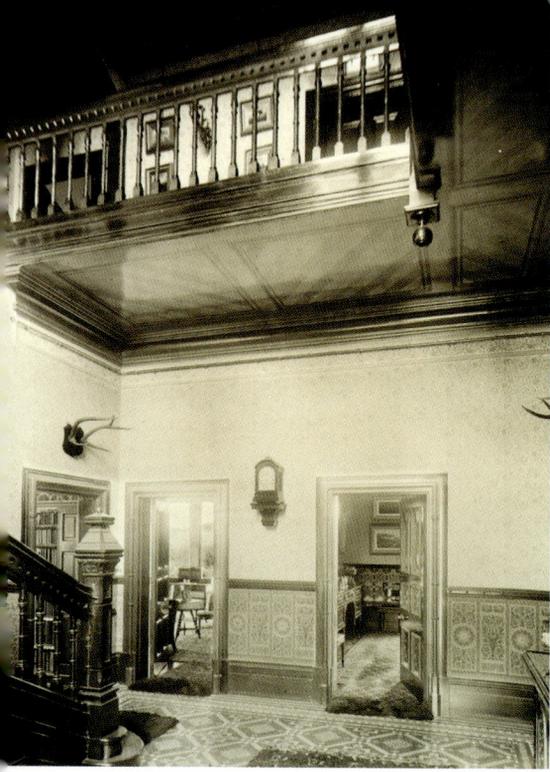

Left: The Laurels, Sunderland
Apart from its name, little is known about this house in Sunderland. Photographed by Bedford Lemere & Co. in 1886, The Laurels appears to have been a substantial property. Judging by the grand staircase and tastefully furnished interior, the owner must have been prosperous. Doors are deliberately left open to display a well-stocked library and there are glimpses of quality furniture in other rooms. (Historic England Archive)

Below: Town Hall Interior, Sunderland
Sunderland's old Town Hall was impressive inside and out. In another promotional image by Henry Bedford Lemere, the symmetry of the landing can only hint at the regal staircase that waited beyond it. Splendid decorative plasterwork is also on show. All this was destroyed in what an expert has recently judged to be 'Sunderland's greatest architectural tragedy'. (Historic England Archive)

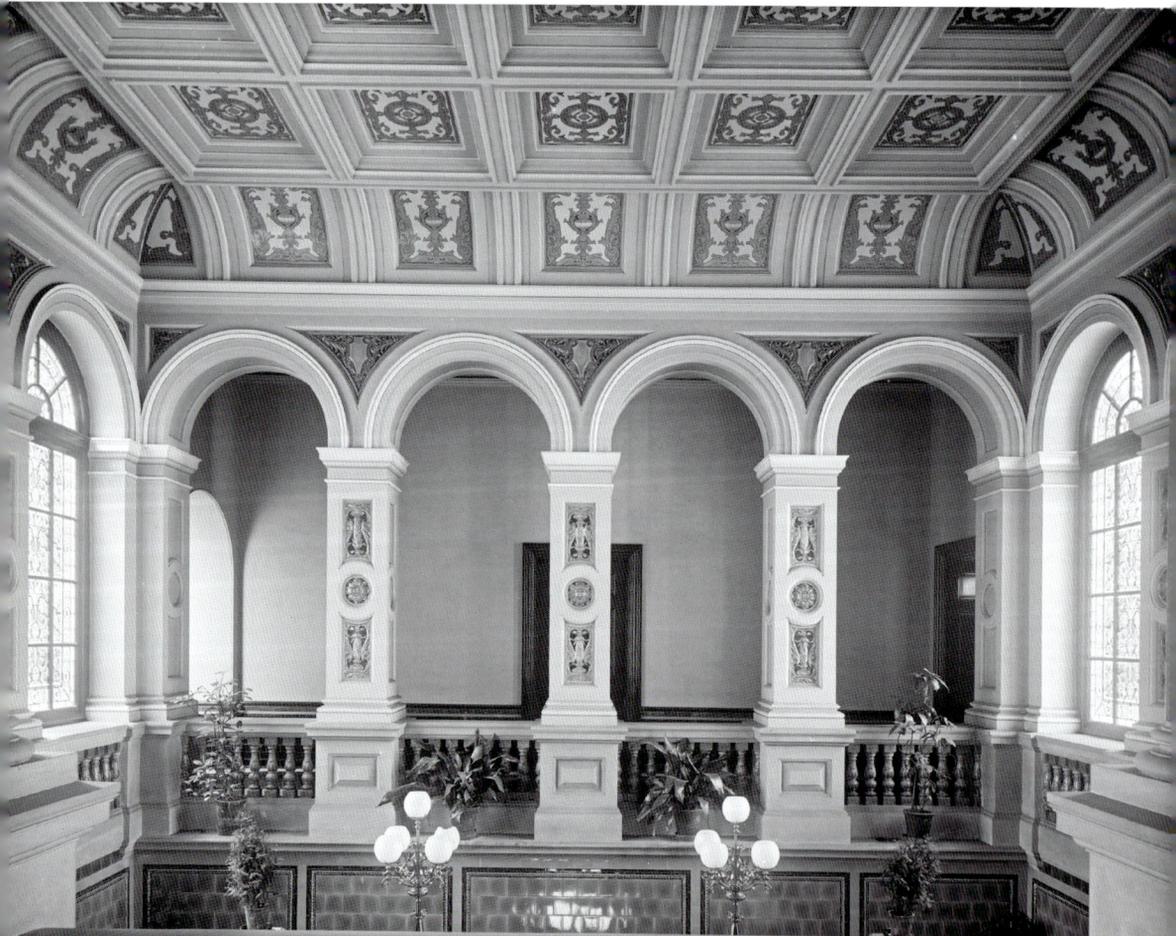

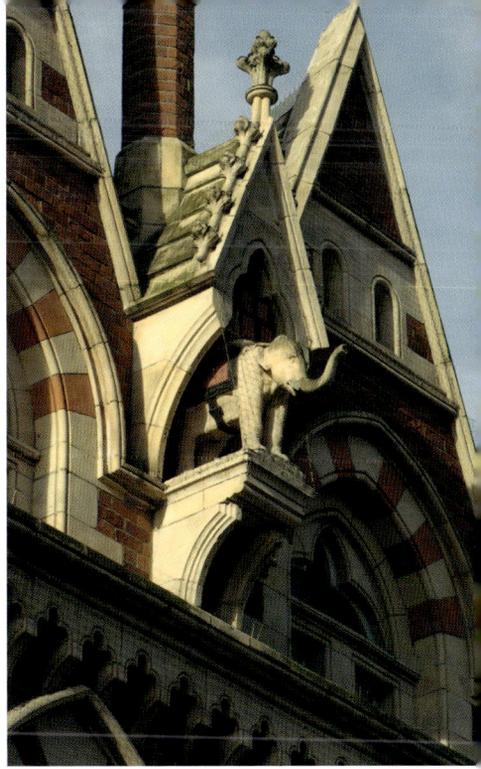

Right: Tearooms, Sunderland
Frank Caws' Elephant Tea House is the architectural high spot of Fawcett Street, if not the whole town. Sunderland architect Caws produced this remarkable structure between 1873 and 1877 and indeed had plans to develop the rest of Fawcett Street in what he termed 'Hindoo Gothic' style. Now a bank, the former tearooms are renowned for their outlandish upper levels where elephant gargoyles have tea chests strapped to their backs. (© Historic England Archive)

Below: Villiers Street, Sunderland
Villiers Street was one of old Sunderland's most prestigious thoroughfares. Building began in the 1790s on land owned by William Henry Lambton and the new street was named to honour his wife, Lady Ann Villiers. This wide street was home to well-heeled Sunderland residents for more than half a century. Nos 29 and 30, photographed here, are fortunate survivors from an elegant Georgian past. (© Historic England Archive)

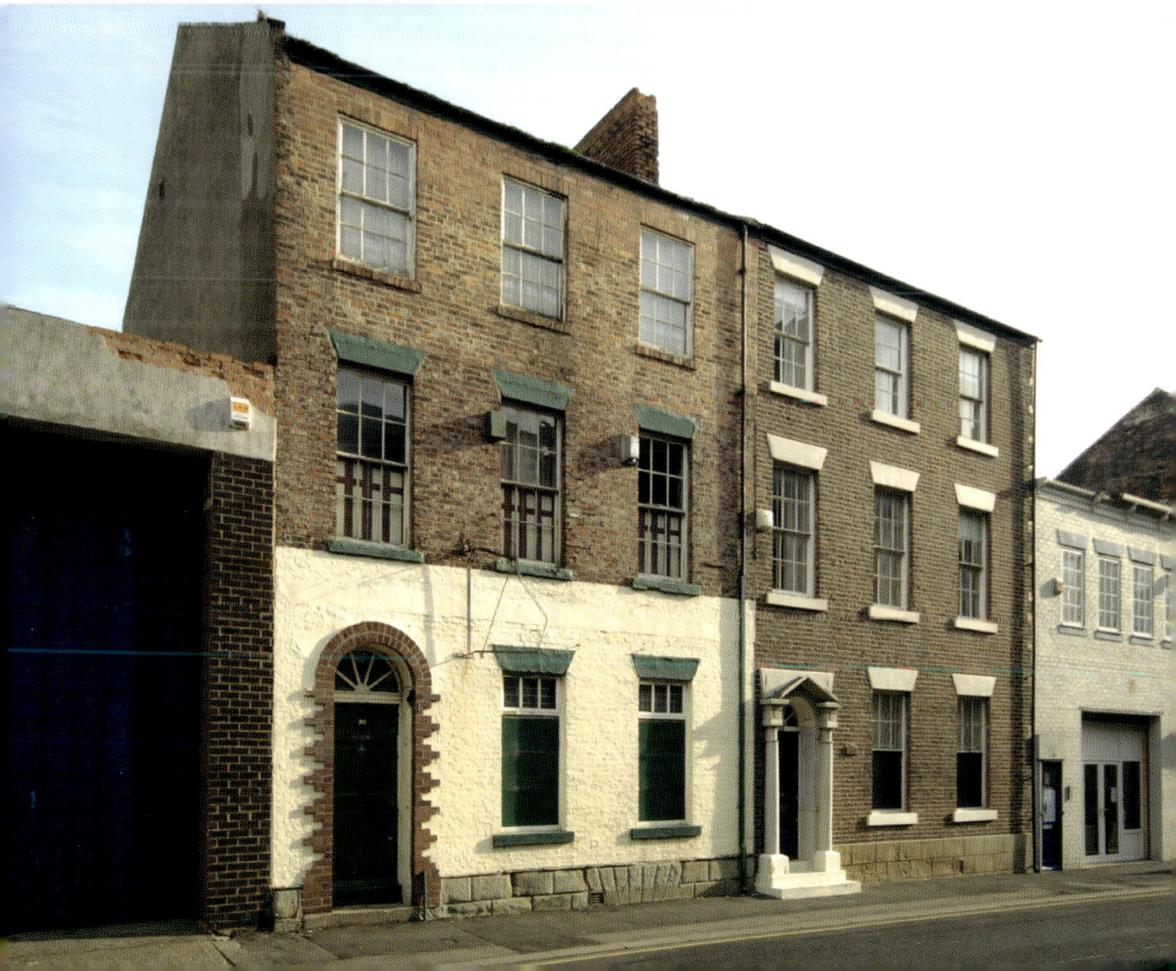

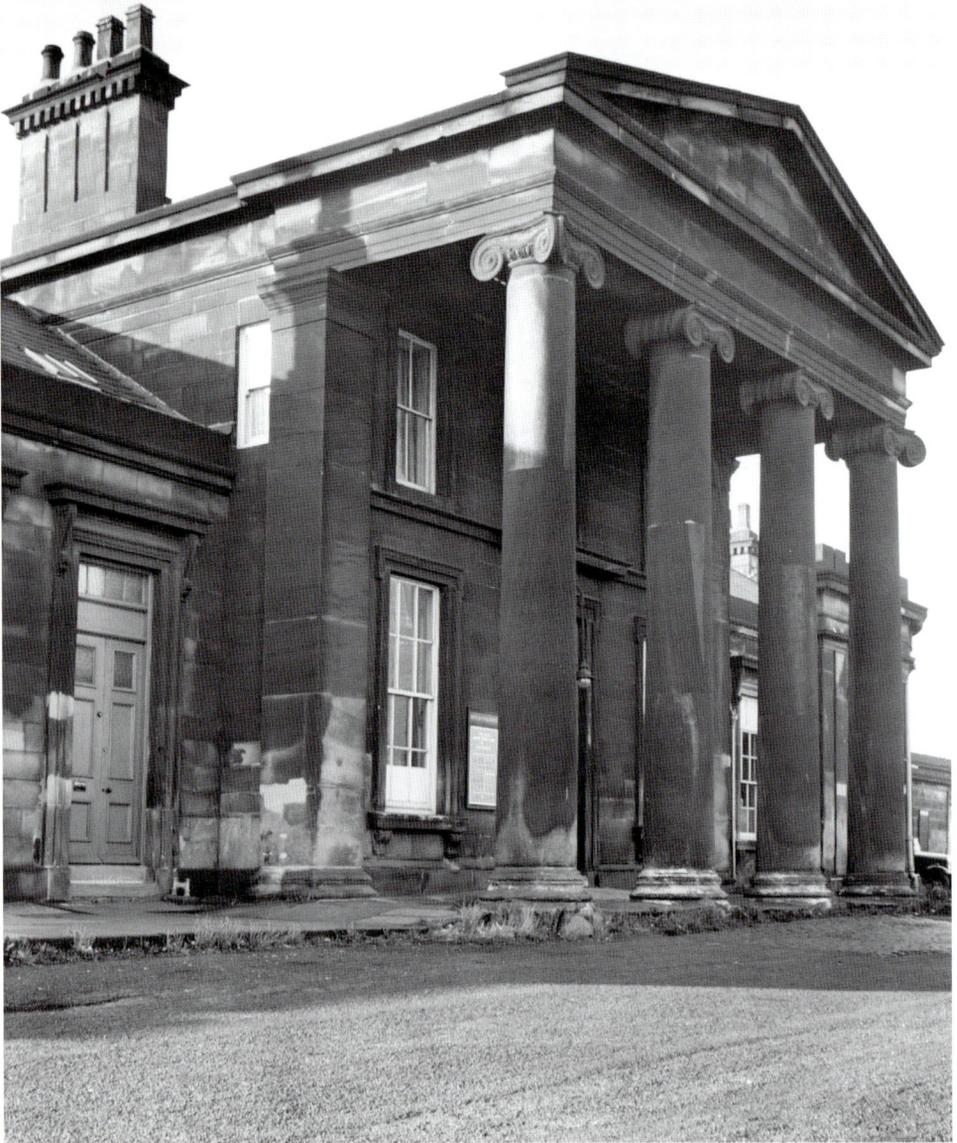

Monkwearmouth Station, Sunderland
Coated with a century of soot and grime, Monkwearmouth Station's majestic portico was photographed by the Ministry of Works for a 1950s survey. Built for roguish Sunderland MP George Hudson, the station opened in 1848, serving as a passenger terminus for his Brandling Junction Railway. Strongly influenced by ancient Greek designs, it was created by local architect Thomas Moore. His Railway Age Temple closed in 1970 and became a museum. (Historic England Archive)

Right: Almshouses, Sunderland

These almshouses for needy former seamen were opened at Hendon in 1840. Fittingly named, the Trafalgar Square Almshouses were probably the work of William Drysdale, built from the proceeds of a charitable fund established in 1747. Still in use, the listed buildings are a tribute not only to the port of Sunderland's significant maritime heritage, but also to the many North East seafarers who participated in England's greatest naval victory.

Below: St Peter's Church, Sunderland

Sunderland's most venerable church, one of the earliest such stone buildings in England, dates from the late fifth century AD. Little remains of the original Saxon foundations of St Peter's, but clearly it became an important monastic settlement, particularly renowned for its scholarship and association with Saint Bede. Sunderland University campus has replaced the shipyards, houses and factories that once surrounded this historic church. (© Historic England Archive)

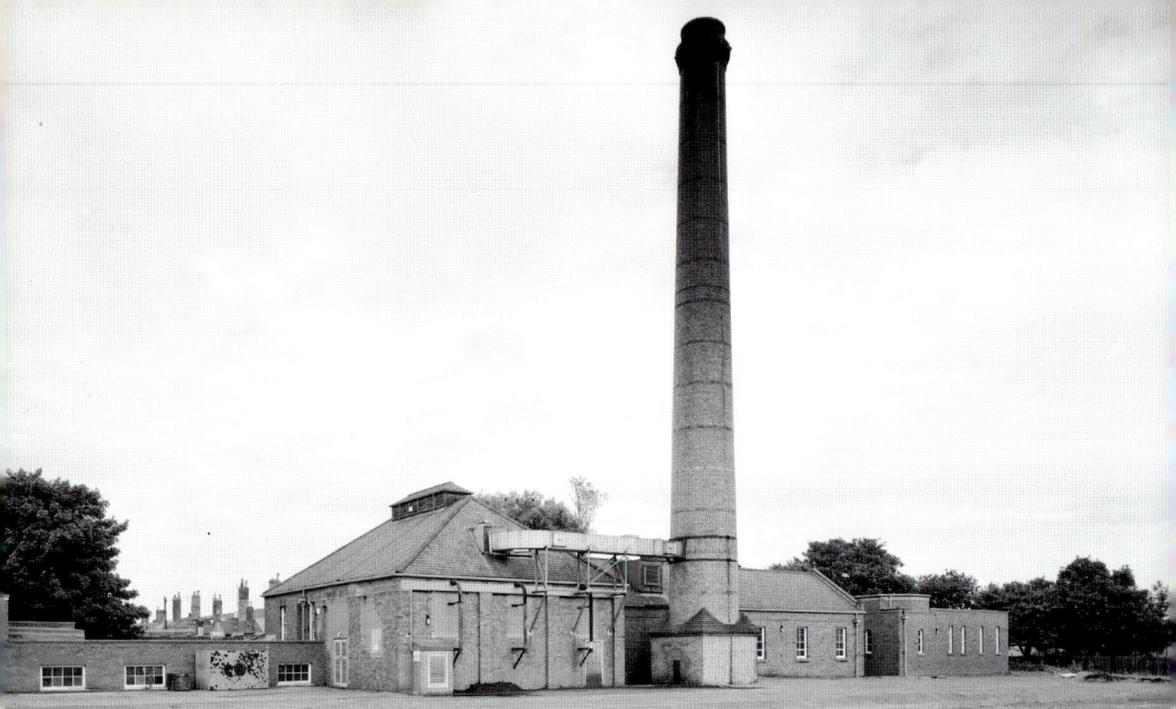

Below: Monkwearmouth Hospital, Sunderland

Monkwearmouth Hospital's boiler house and chimney is pictured here in 1993; since then there has been extensive modernisation on the Newcastle Road site. Opened in July 1932, the hospital replaced a building of the same name on Roker Avenue. Wearside businessman and philanthropist Sir John Priestman was a driving force behind the new hospital and made a substantial contribution to its funding. (© Crown copyright. Historic England Archive)

Penshaw Hill, Sunderland

Penshaw monument has been a landmark since its completion in 1844. Built as a memorial to John Lambton, the 1st Earl of Durham who died in 1840, this version of an Athenian antiquity was designed by father and son architects John and Benjamin Green. 'Radical Jack' Lambton would be delighted that it has remained in the public eye. Below Penshaw Hill are former National Coal Board workshops. (© Crown copyright. Historic England Archive)

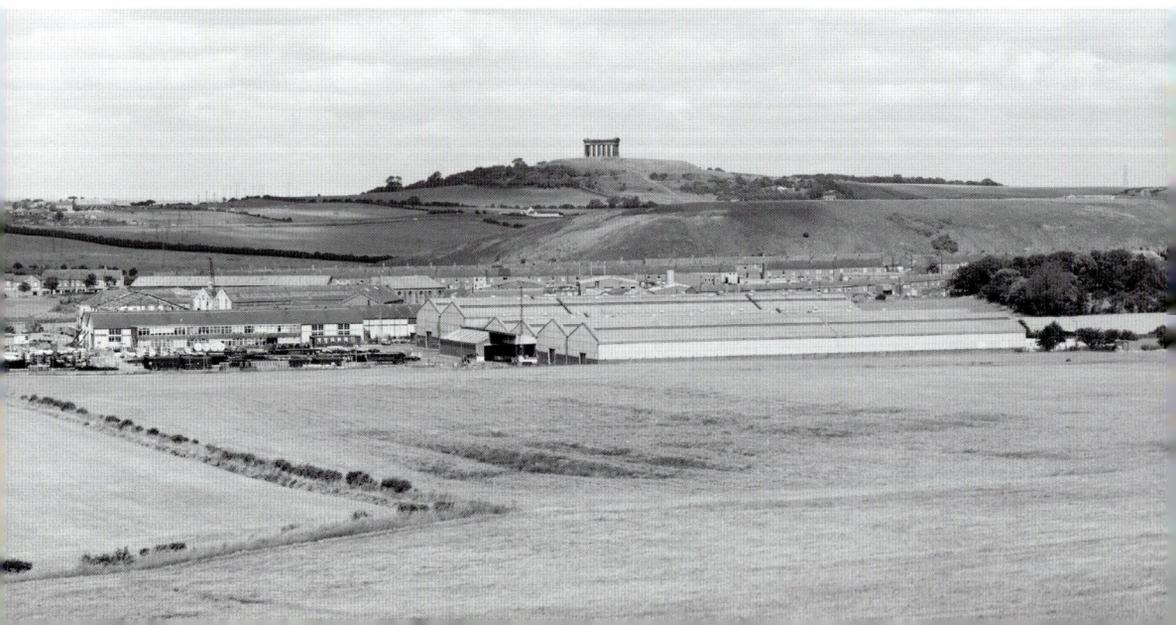

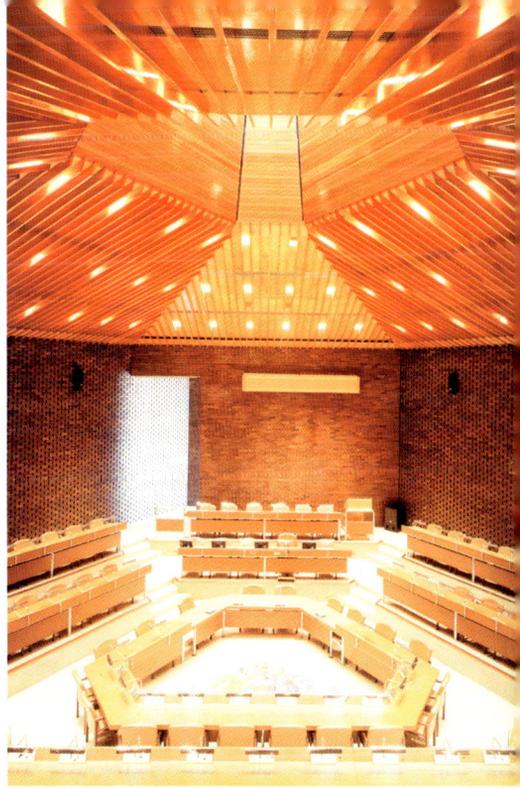

Right: Civic Centre Council Chamber, Sunderland
James O. Davies' image illustrates the Civic Centre's vivid council chamber. Light floods in through a hexagonal skylight, a geometric figure repeated throughout a building, which cost over £3 million. Architect Jack Bonnington was largely responsible and while his design has received critical acclaim, its stark modernity has never generated much enthusiasm among the townspeople of Sunderland. (Historic England Archive)

Below: Civic Centre, Sunderland
Old and new Sunderland are focused on in this image from December 1969. Approaching completion, the bold new Civic Centre on Burdon Road forms a backdrop to the statue of boy sailor Jack Crawford. He was celebrated for his heroic actions at the Battle of Camperdown in 1797 and his dramatic granite and bronze monument, designed by Percy Wood, was erected in Mowbray Park in 1890. (© Historic England Archive. John Laing Collection)

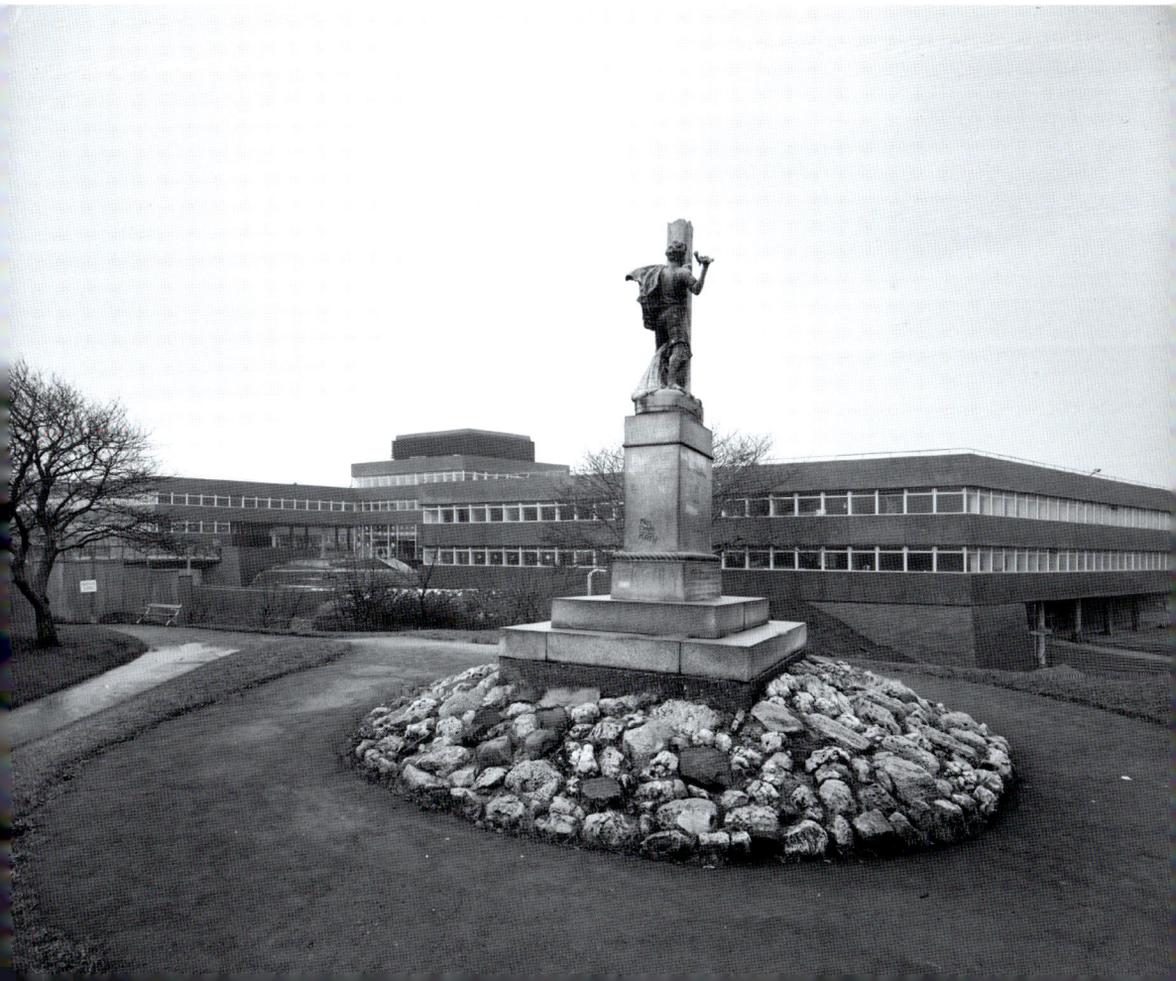

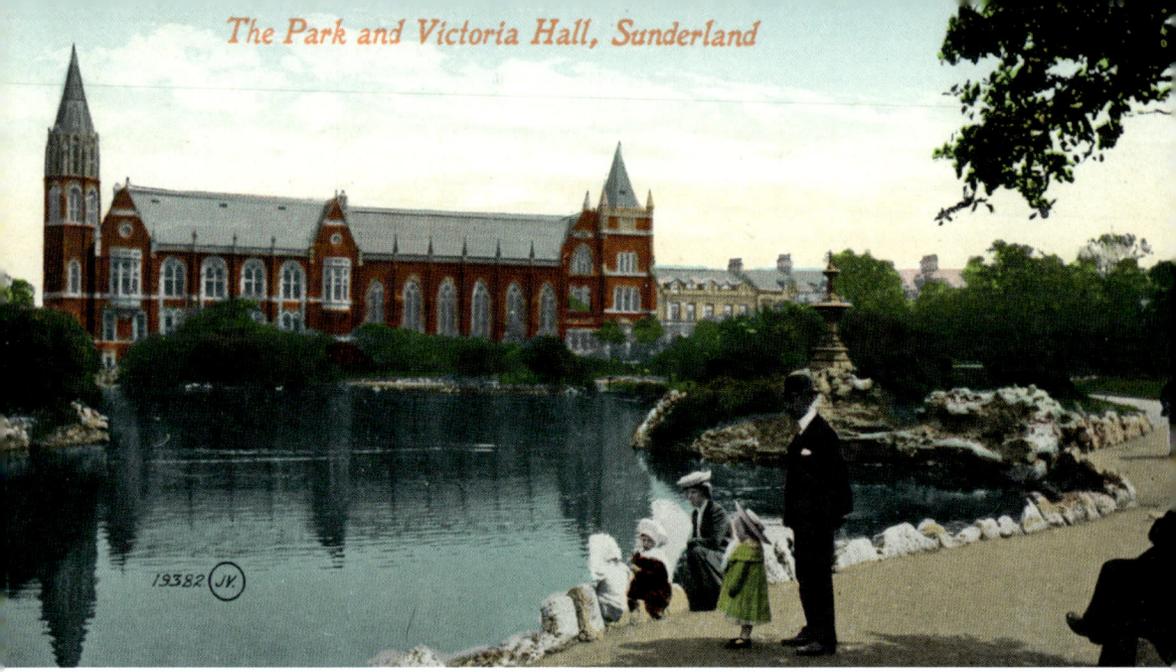

The Park and Victoria Hall, Sunderland

Above: Victoria Hall, Sunderland

A colour postcard shows Sunderland's ill-fated Victoria Hall around 1910. Opened in 1872, the Gothic building was designed as a concert venue by G. G. Hoskins and erected on a site facing Mowbray Park. Victoria Hall is mainly remembered for the 1883 tragedy when 183 children were crushed to death against an inward-opening door. Extended in 1906, the hall was destroyed by a German bomb in 1941. (Historic England Archive)

Below: Roker Park, Sunderland

Roker's new municipal park boosted the popularity of Sunderland's seaside resorts. It was opened in 1882 on land provided largely by Sir Hedworth Williamson, who resided at nearby Whitburn Hall. The model boating lake, seen in this postcard view, was a particular attraction. It remains in use and along with a listed bandstand, drinking fountain and the curious 'Spottie's Cave' (named after an eighteenth-century shipwrecked sailor) helps to keep this Victorian park alive. (Historic England Archive)

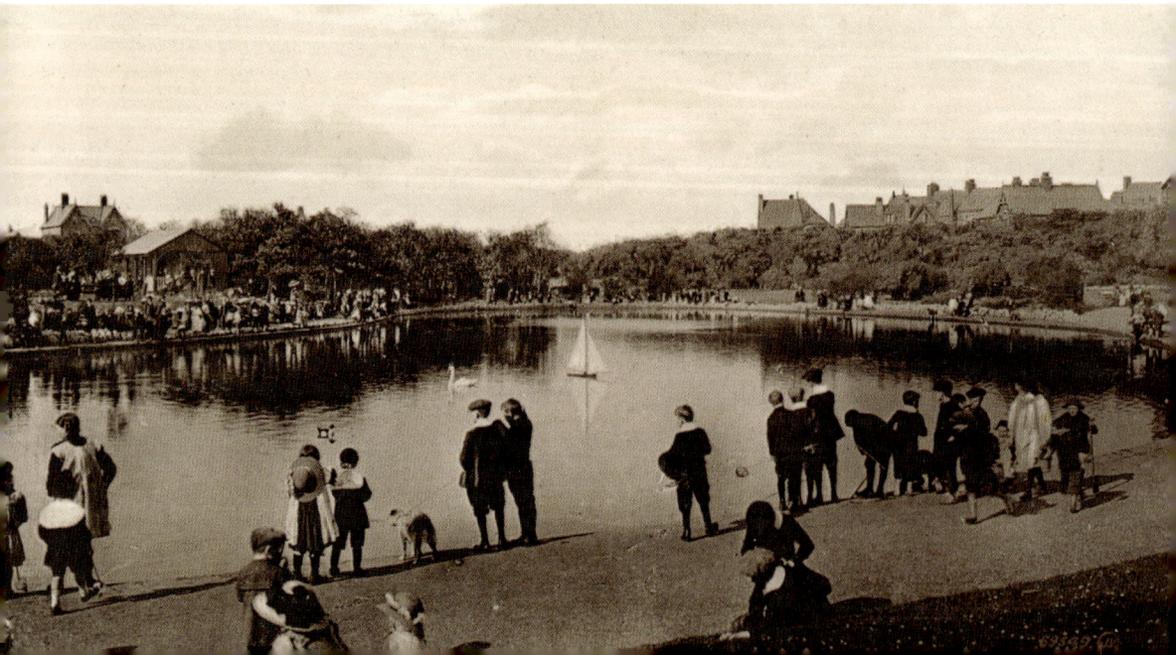

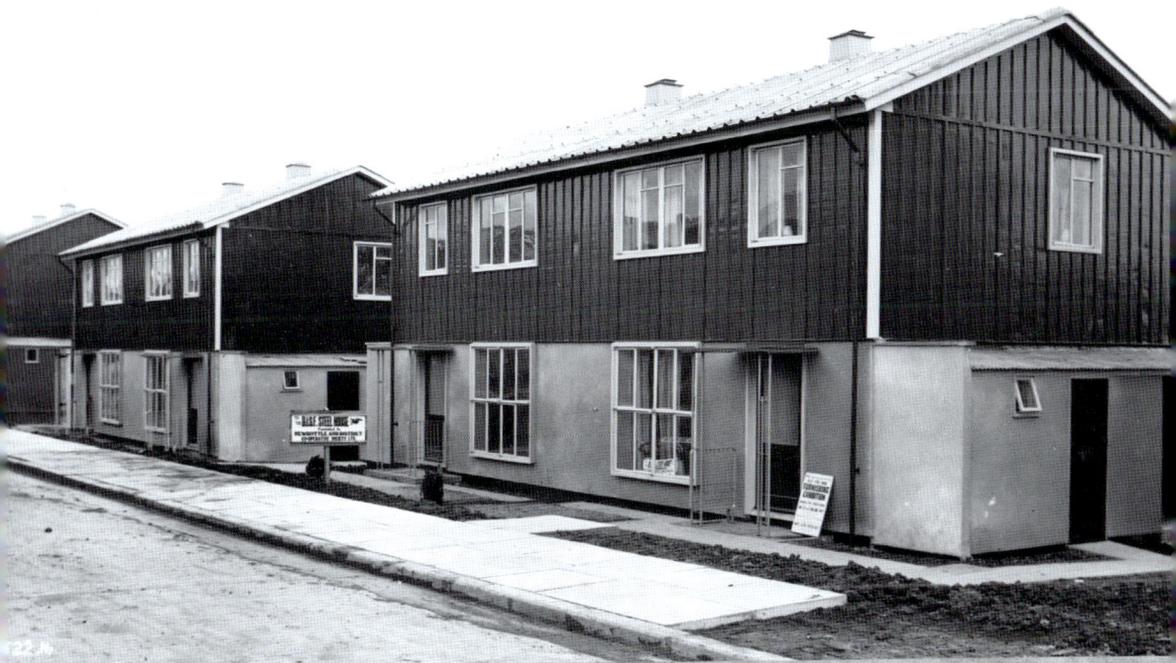

Sunderland Prefabs

Prefabs were generally intended to temporarily ease Britain's chronic housing shortage following the Second World War. Sometimes manufactured from scrap materials, they were relatively cheap and speedily assembled. The examples illustrated above, however, erected in the Sunderland area, were steel-framed show houses produced by the John Laing Co. for the British Iron and Steel Federation (BISF) and built as permanent homes, many of which are still occupied today. (© Historic England Archive. John Laing Collection)

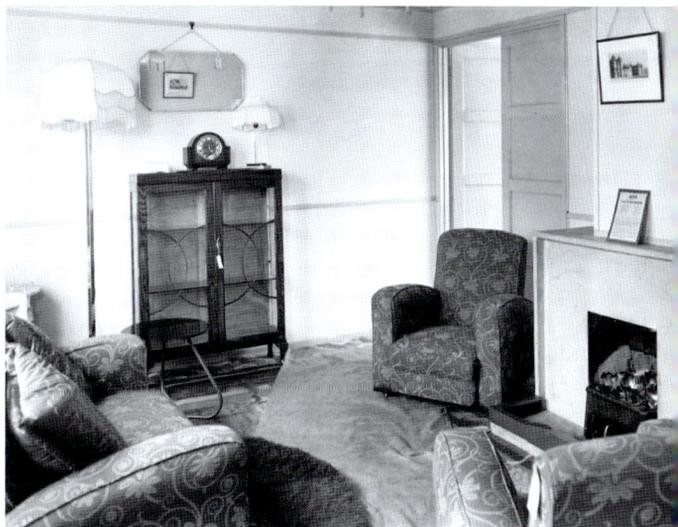

Sunderland Prefabs

'Homes fit for Heroes' built for returning servicemen after 1945 were expected to be furnished accordingly. The cosy sitting room of this BISF show house was provided by courtesy of the Newbottle and District Co-operative Society Ltd. (© Historic England Archive. John Laing Collection)

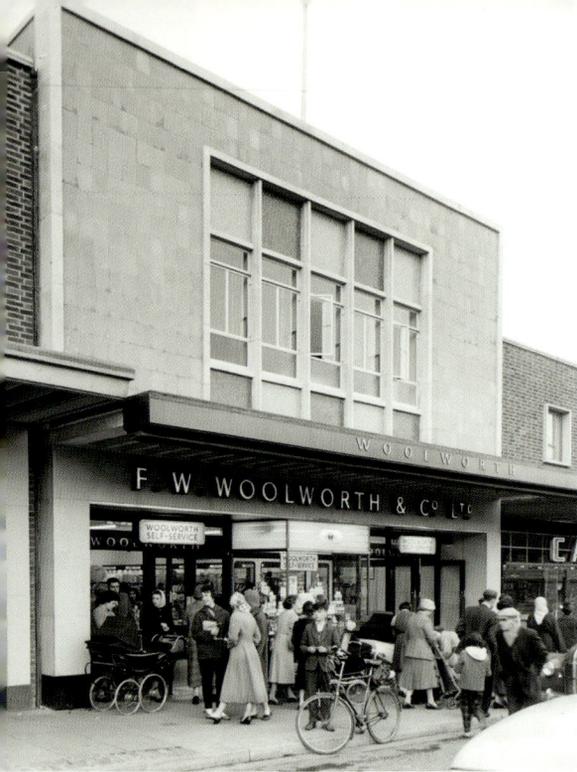

Washington New Town

Woolworth's was a shopper's favourite in post-war Britain. From American origins in 1878, it grew to become the largest retailer in the world. This bustling scene was captured in Washington New Town outside the Victoria Road 'Woolies' following its opening in 1959. Originally self-service, the Arndale House store suffered after the opening of a huge 'Woolco' supermarket at the nearby Washington Galleries shopping centre and closed in 1984. (Historic England Archive)

Coach Road, Washington

What had been a scattering of farm and mining communities west of Sunderland became one of Britain's New Towns in 1964. Houses, schools and supporting infrastructure were built within a complex road network that attempted to draw them all together. With its long established pit, Usworth was one of the area's original villages and innovative change came in the shape of chalet-style bungalows like these, on Washington's Coach Road Estate. (© Historic England Archive)

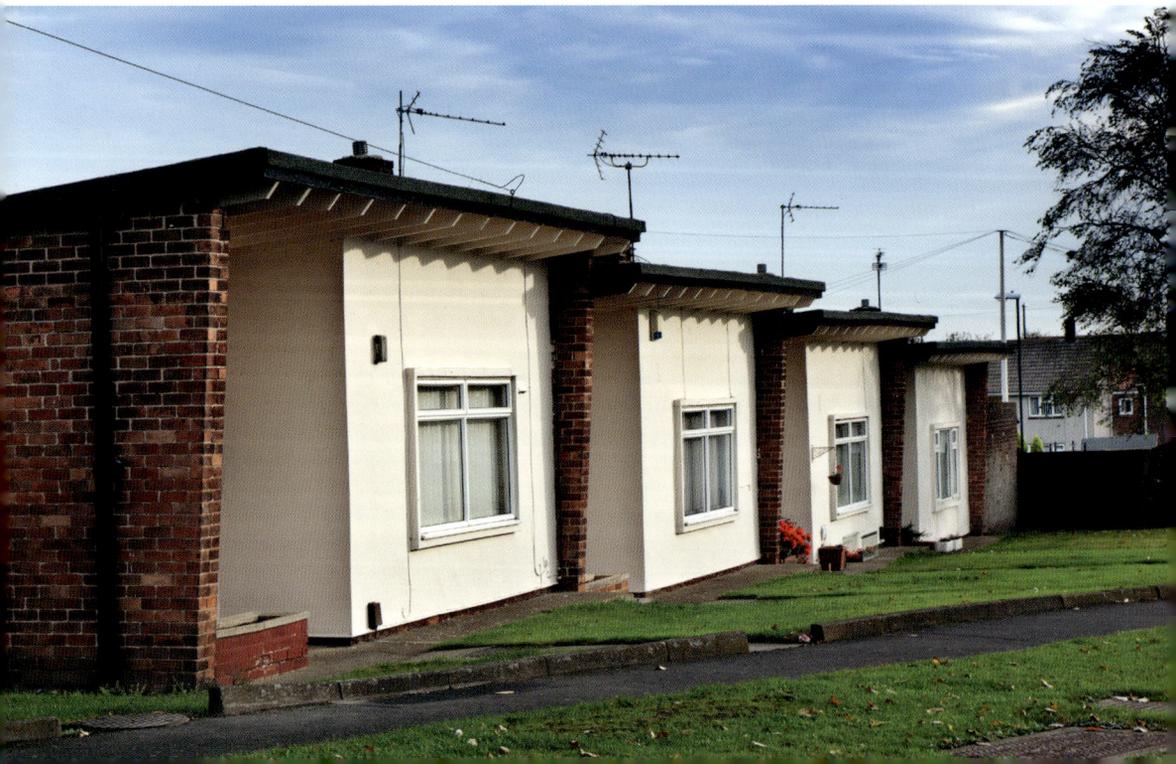

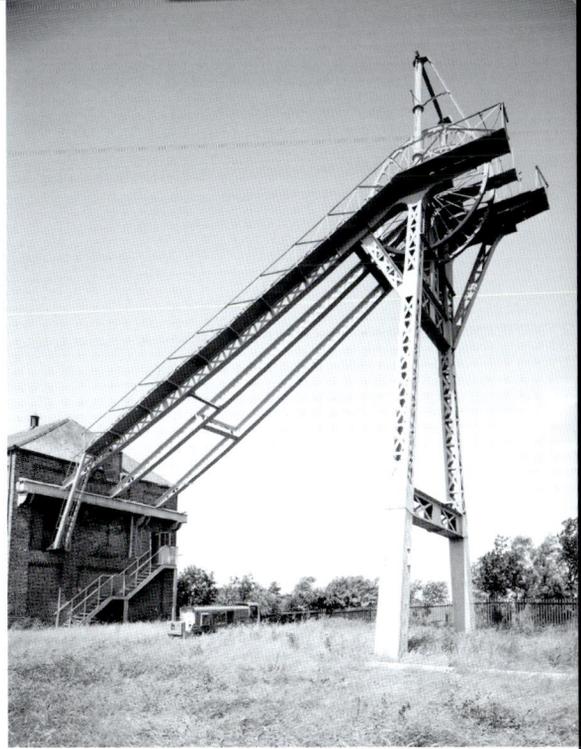

F Pit, Washington

One of a series of coal mines around Washington, 'F' pit began operations in 1777. Despite twentieth-century modernisation, the pit was closed in 1968 and in 1976 reopened as a museum. The engine house with its 1888 twin-cylinder steam winder remains alongside the headstock's gaunt steel latticework (seen here minus winding wheel in July 1993). Occasionally open to the public, this historic relic gives a rare insight into a tough and dangerous trade. (© Crown copyright. Historic England Archive)

Washington New Town Flats

Originally a product of post-war brutalist architecture, these apartment blocks and garages appear to be rather less forbidding after their refurbishment by Sunderland Council in 1981. Completed in 1961 by the Napper architectural partnership and now known as Collingwood Court, they are found in Washington's Sulgrave district, named because of ancestral connections between Washington Old Hall and Sulgrave Manor in Northamptonshire. (© Historic England Archive)

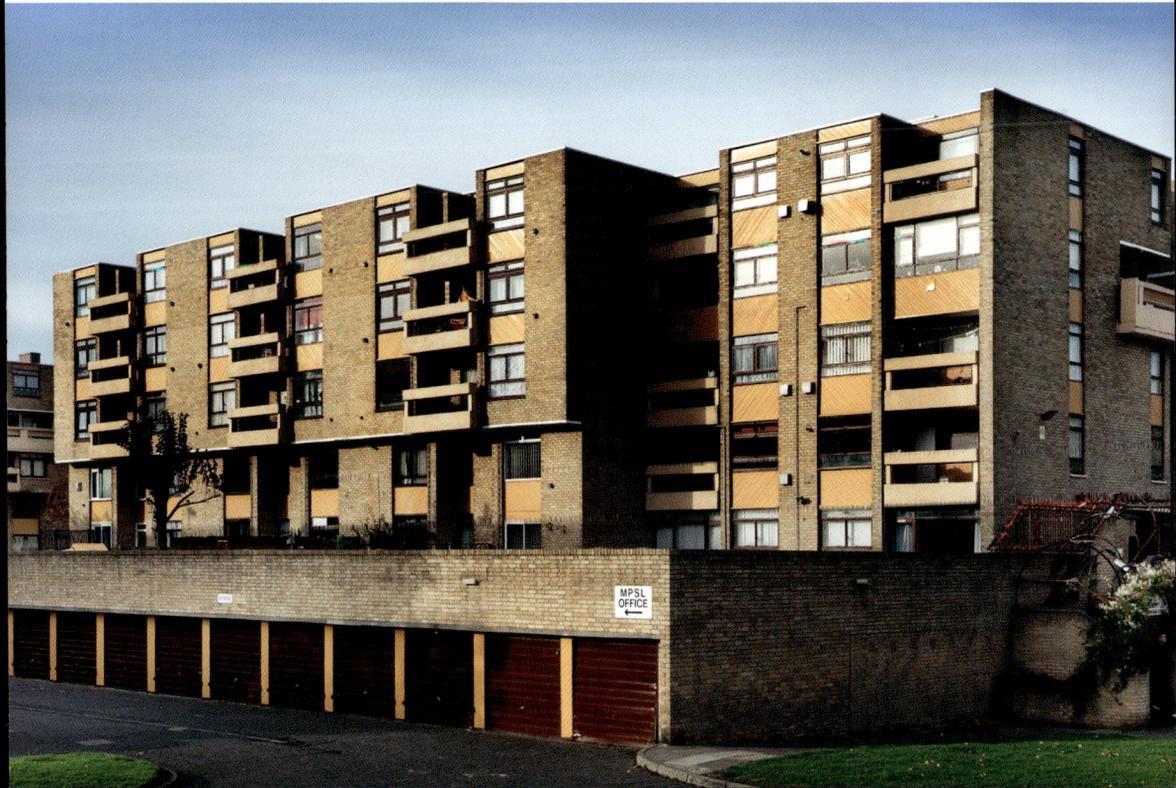

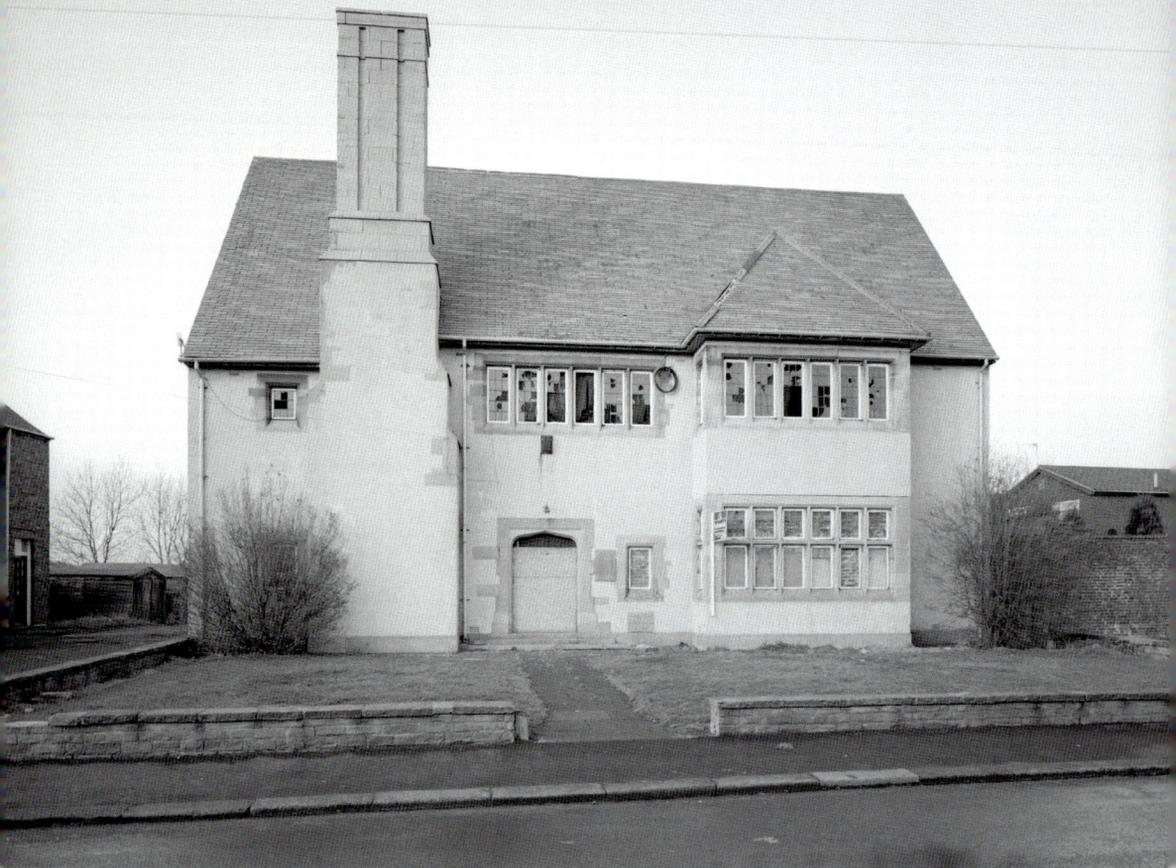

Above: Kibblesworth's Institute
Miners' institutes were once widespread in County Durham. Primarily intended for adult education, they also contained games and meeting rooms and were usually run by combined committees of colliery managers and workmen. Costing £3,500, Kibblesworth's Institute was opened on Barrack Terrace in June 1937. The distinctive building soldiered on as a community hall after the village pit closed in 1974, but was dilapidated by 1993 and subsequently demolished. (© Crown copyright. Historic England Archive)

Opposite above: St Michael's Church, Houghton-le-Spring
A place of worship for over 1,000 years, St Michael and All Angels' Church in Houghton-le-Spring is renowned for Bernard Gilpin, rector there between 1557 and 1583. Alongside his normal duties in what was then one of the largest and richest parishes in Durham, Gilpin sometimes journeyed much further afield to preach. 'The Apostle of the North', as he became known, is buried in an outsized tomb within his ancient parish church. (© Historic England Archive)

Opposite below: Joicey Aged Miners' Homes, Shiney Row.
Campaigning to house retired miners began in the late nineteenth century, largely inspired by Gateshead pitman and preacher Joseph Hopper, who became the first secretary of the Durham Aged Mineworkers' Association. Between 1910 and 1957 they built 1,600 homes across the county, which until the mid-1960s were rent-free to miners and their wives. This single-storey terrace in Shiney Row near Houghton-le-Spring, opened in 1906, is a Grade II-listed example. (© Crown copyright. Historic England Archive)

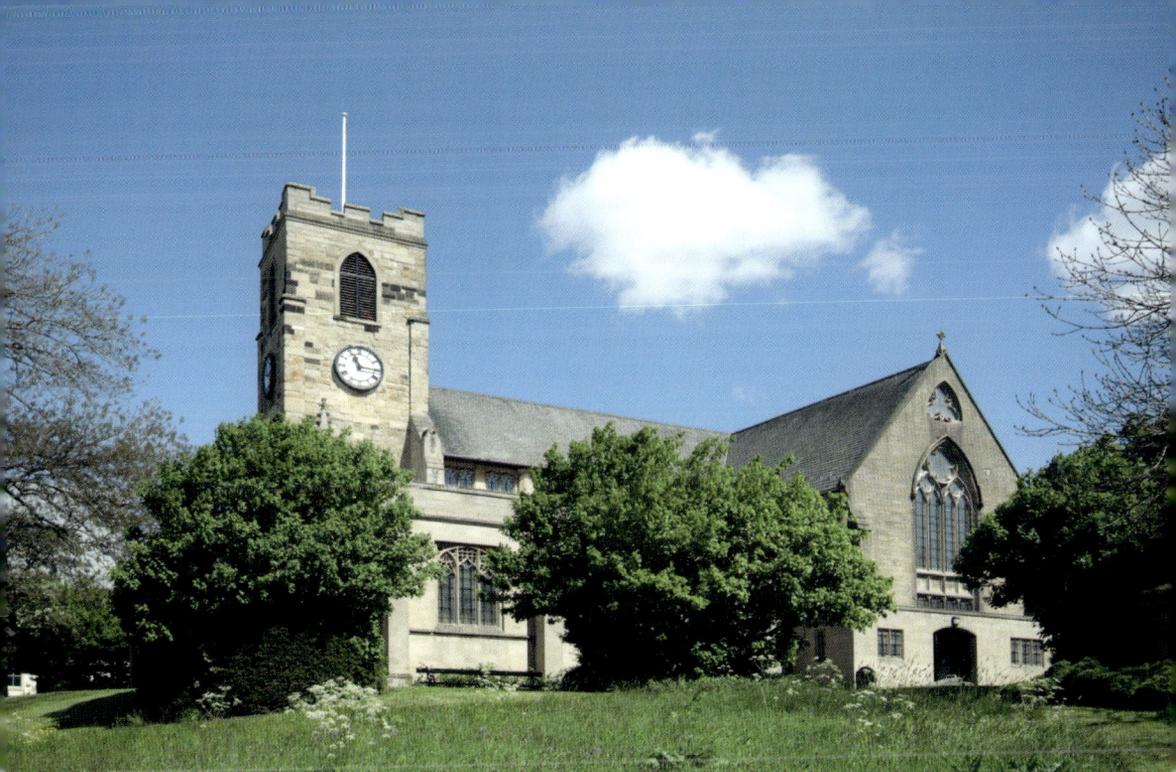

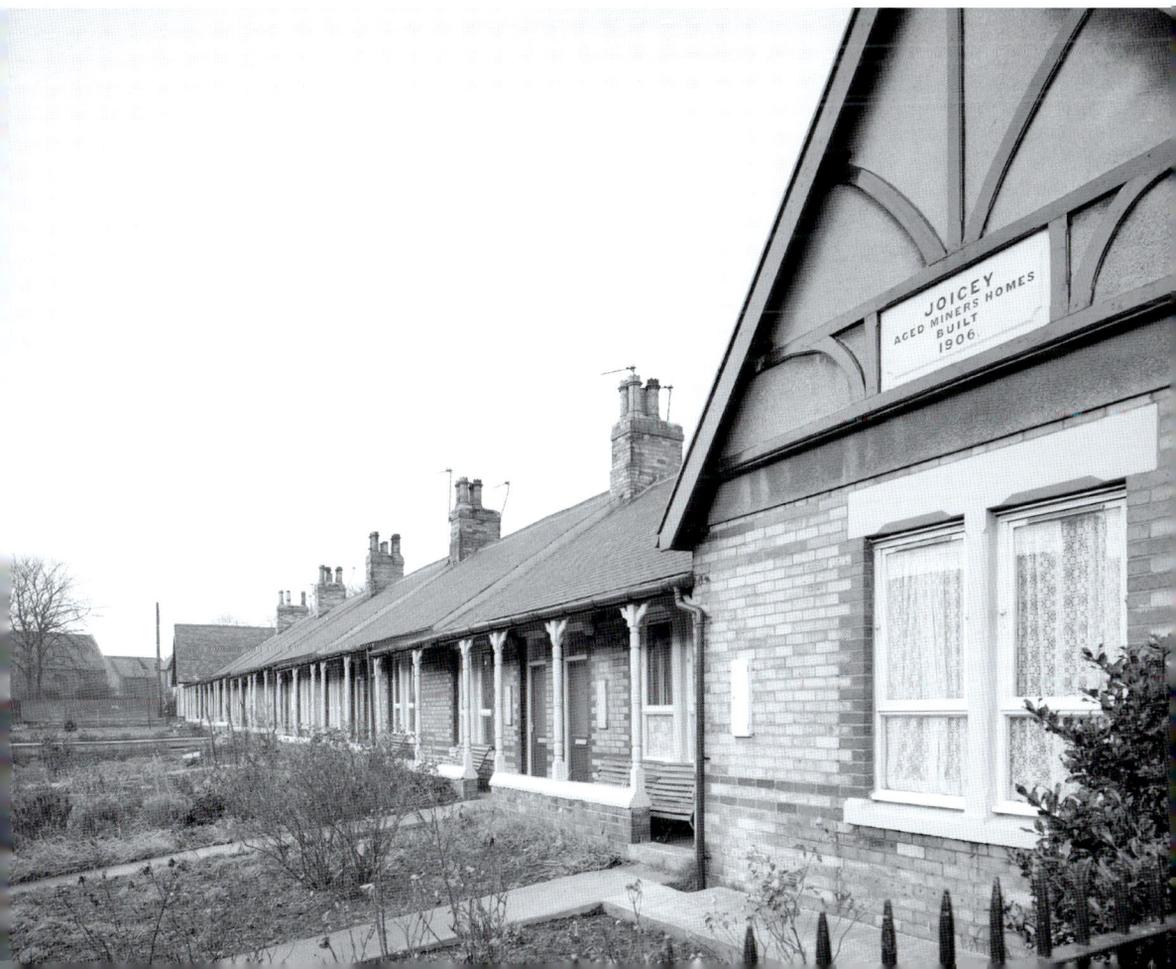

Teeside

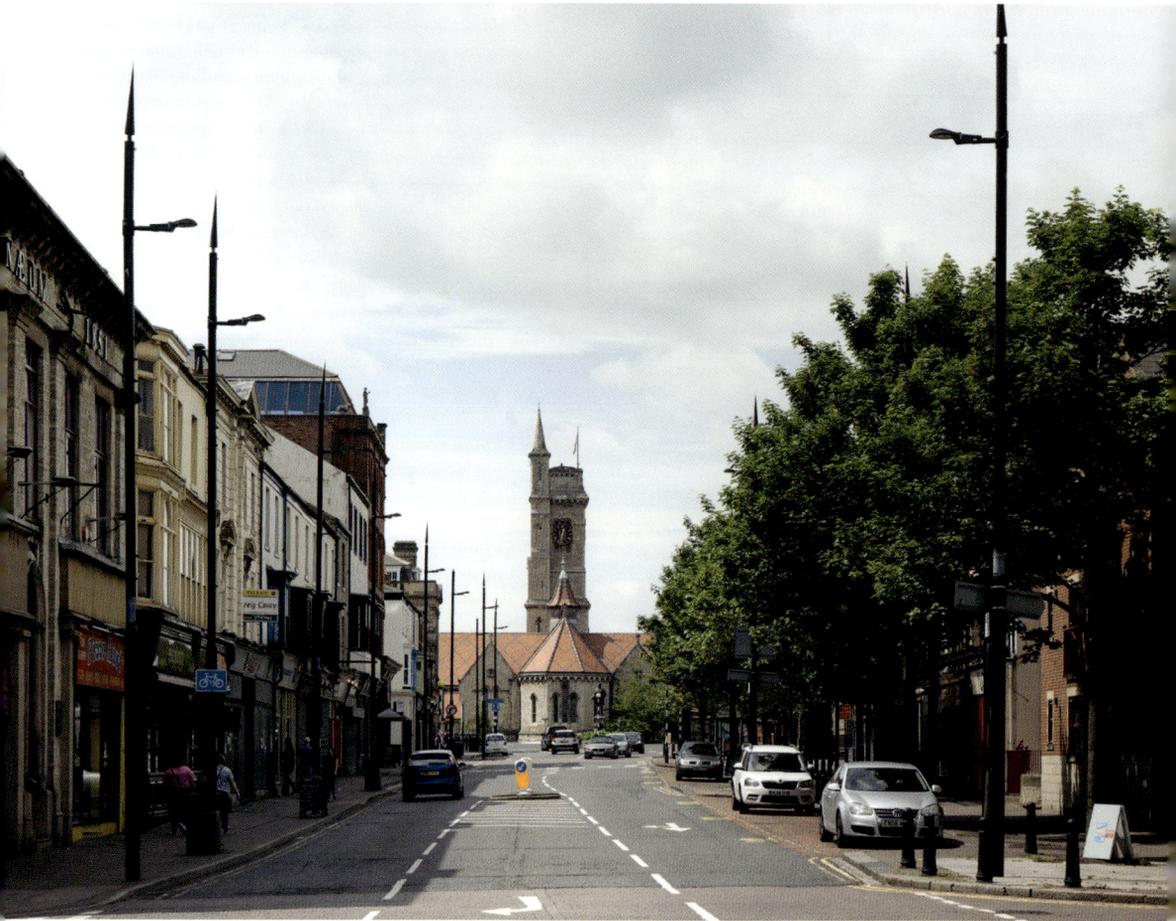

Above: Church Street, Hartlepool

Patricia Payne's 2015 image provides an illuminating contrast to the older archive view of Church Street. Once a business and shopping centre, the thoroughfare has sadly declined like many other High Street areas. Though faded in grandeur, fine old buildings survive. Just in view on the far left is the Athenaeum, erected in 1851, which has served many purposes including a public hall, library, schoolroom and presently a social and snooker club. (© Historic England Archive)

Opposite above: St Hilda's Church, Hartlepool

St Hilda's stands proud on Old Hartlepool's Headland peninsula. Built in the late twelfth century, this church has much deeper roots. It was sited alongside a monastery where the Northumbrian saint and nun Hild was abbess between AD 648 and 658. Few traces of her abbey survive, but over the centuries the structure that now bears her name has been rebuilt and enlarged to become a substantial and dignified parish church. (© Historic England Archive)

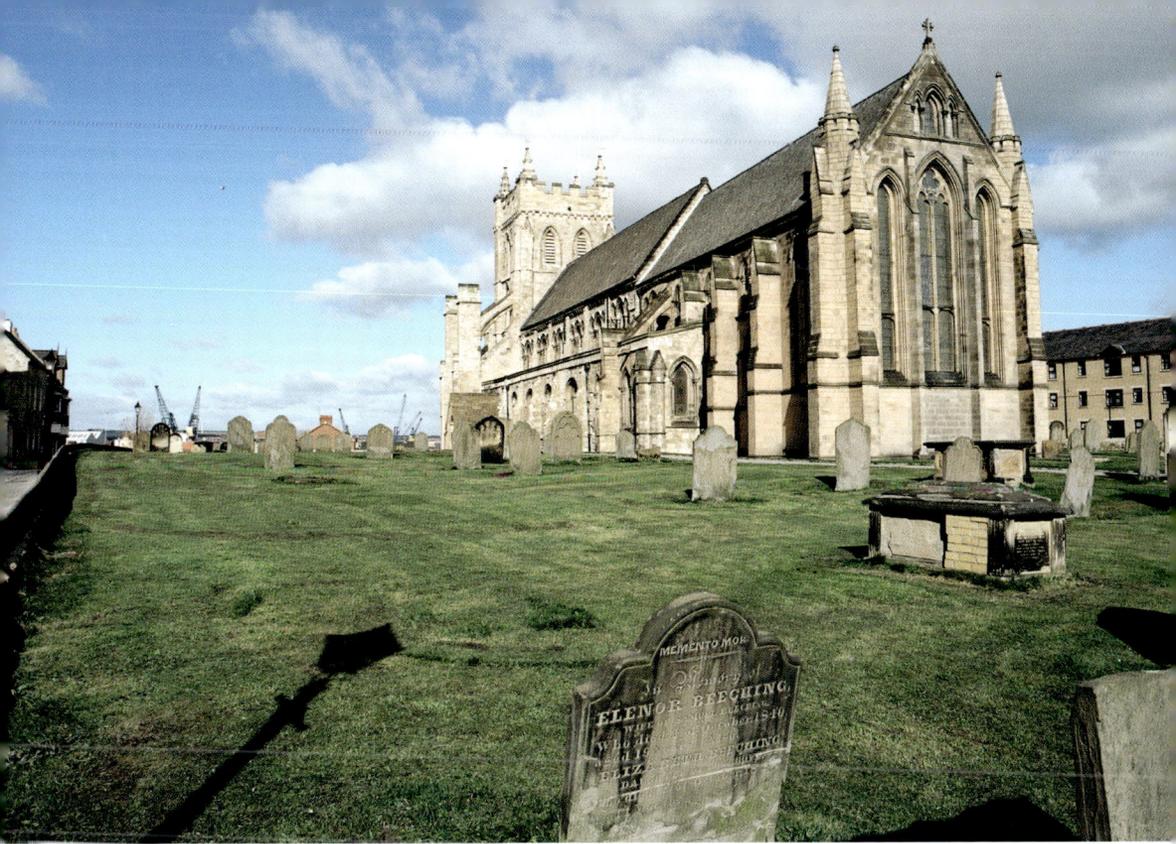

Below: Hartlepool Hospital

What remained of St Hilda's Hospital was semi-derelict when this photograph was taken on the Headland in April 2006. Originally built as a Franciscan friary around 1240, it became the Friarage Manor House after the Dissolution of the Monasteries in the sixteenth century. Afterwards used as a workhouse, it then became part of a local hospital. Plans to convert the unusual listed building into apartments have so far made little progress. (© Historic England Archive)

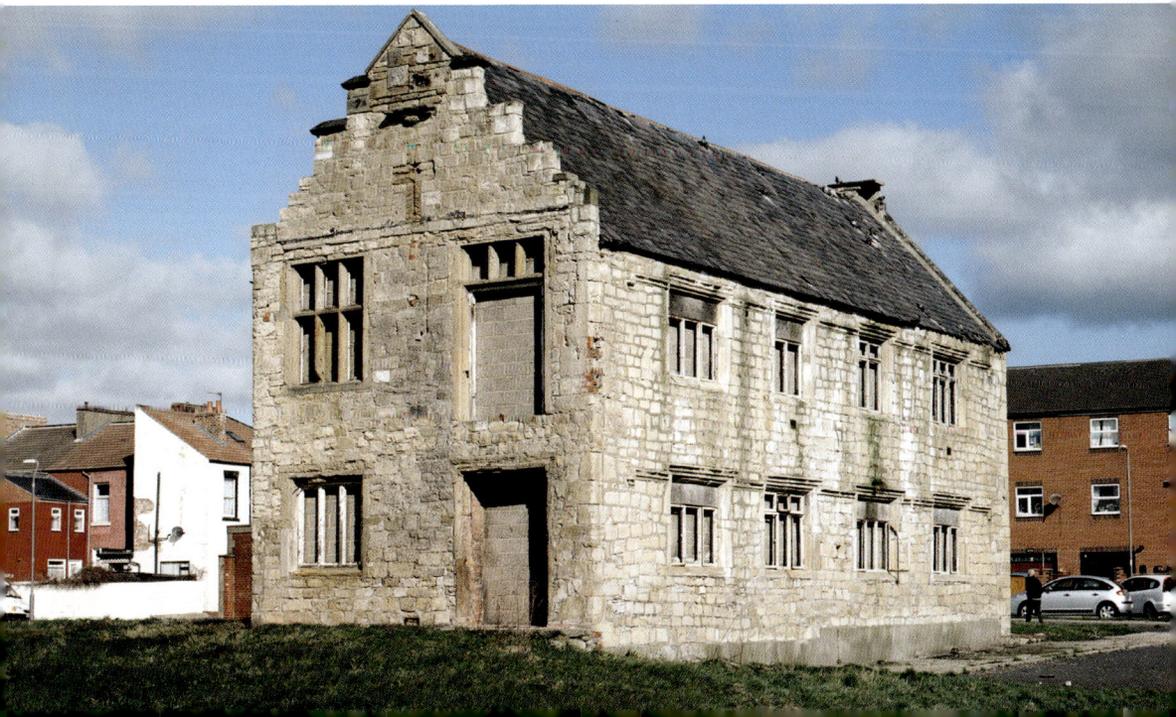

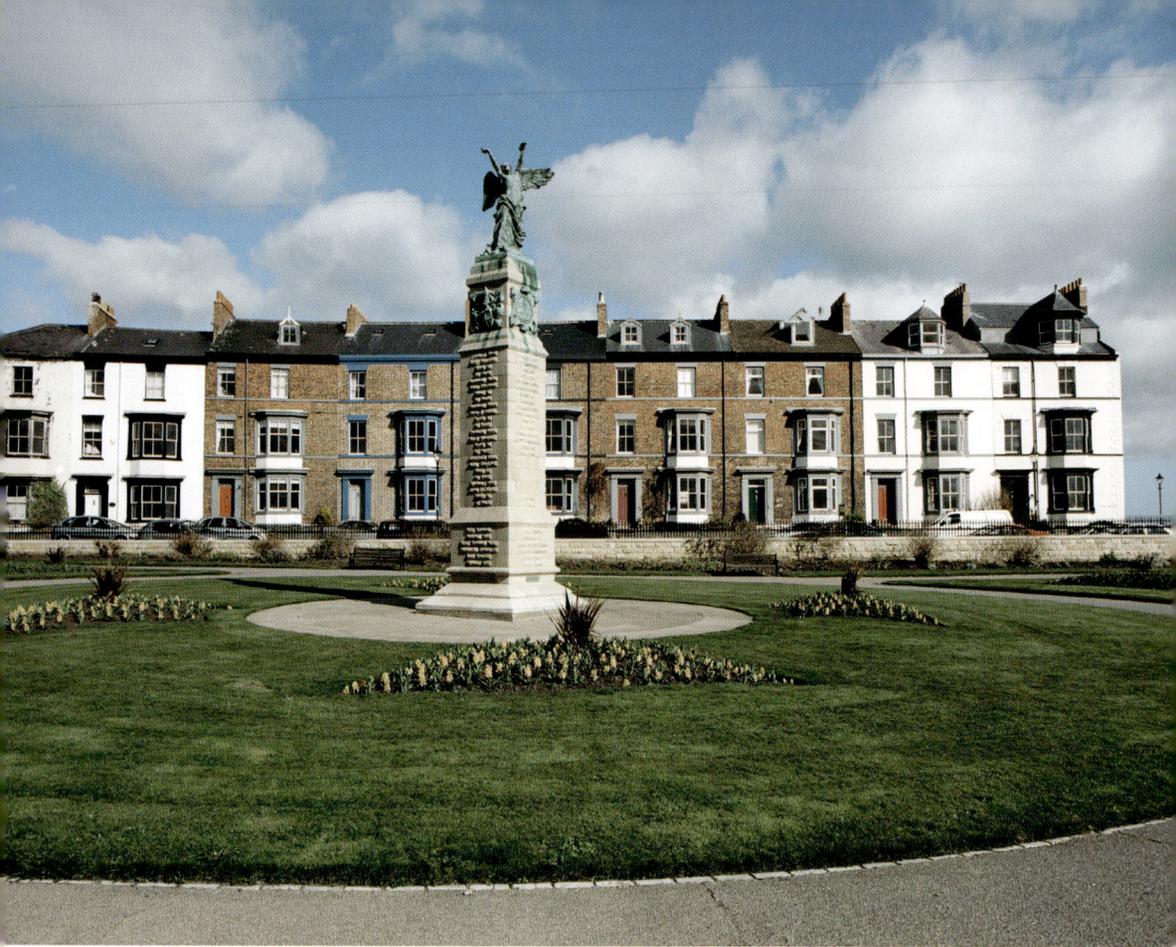

Cliff Terrace, Hartlepool

A German naval force bombarded the Headland in December 1914. Heavy damage was inflicted, particularly on Cliff Terrace, which still bears shell splinter scars. A fittingly placed First World War memorial in Redheugh Gardens also commemorates the 114 Hartlepool civilians (mostly women and children) thought to have been killed in the attack. Designed by Philip Bennison, the limestone monument is capped by a bronze statue of 'Triumphant Youth' and was unveiled in 1921. (© Historic England Archive)

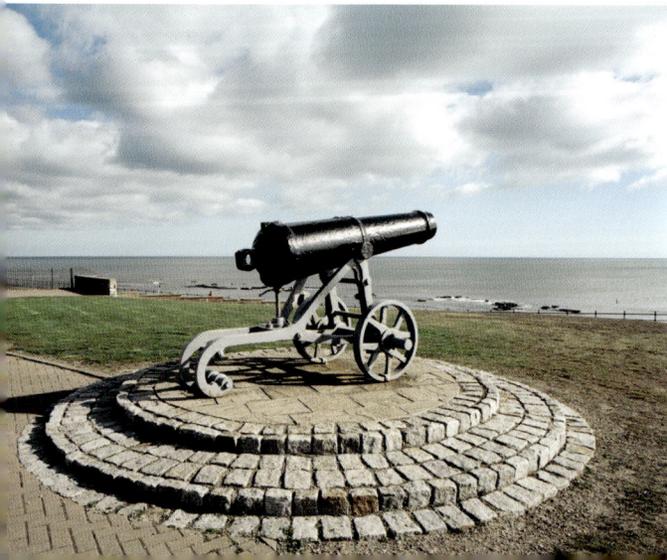

Headland Cannon

This Crimean War trophy arrived in Hartlepool in 1858. Captured at the Battle of Sebastopol, the cannon is sited on the Headland, near the Heugh battery, a gun emplacement built during the Napoleonic Wars. Strengthened during the nineteenth century, the battery's finest hour came in 1914 when it accurately returned fire on German naval attackers. (© Historic England Archive)

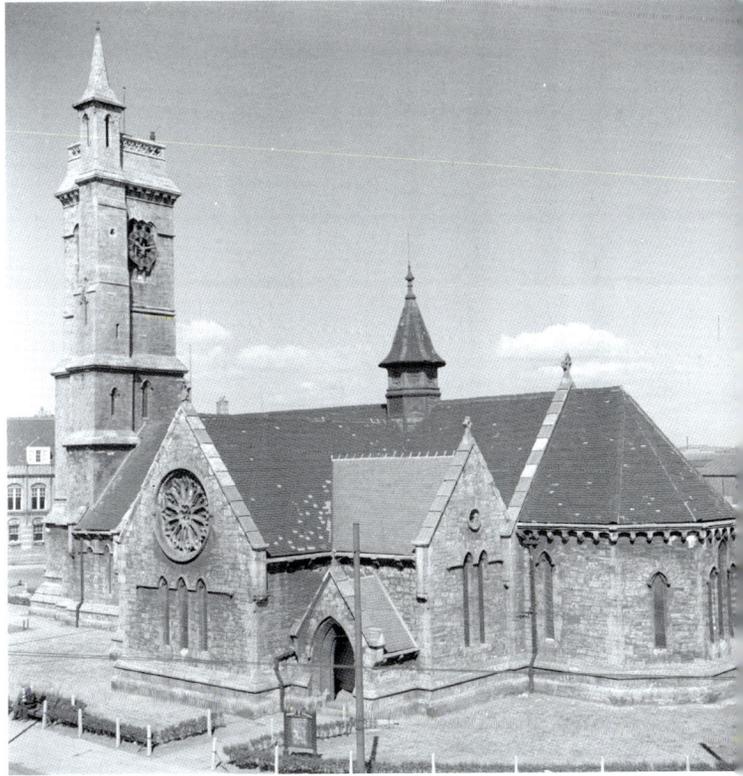

Christ Church, Hartlepool
Ralph Ward Jackson had Christ Church built between 1852 and 1854. Industrialist Jackson was the driving force behind the creation of the port and town of West Hartlepool. The town was known as 'Jackson Town' and its new Anglican place of worship was 'Jackson's Church.' Architect E. B. Lamb produced an eccentrically low building with an outrageously tall tower. Redundant in 1973, the church became a tourist information centre. Fortunately Christ Church has remained, although it was once threatened with demolition. (© Crown copyright. Historic England Archive)

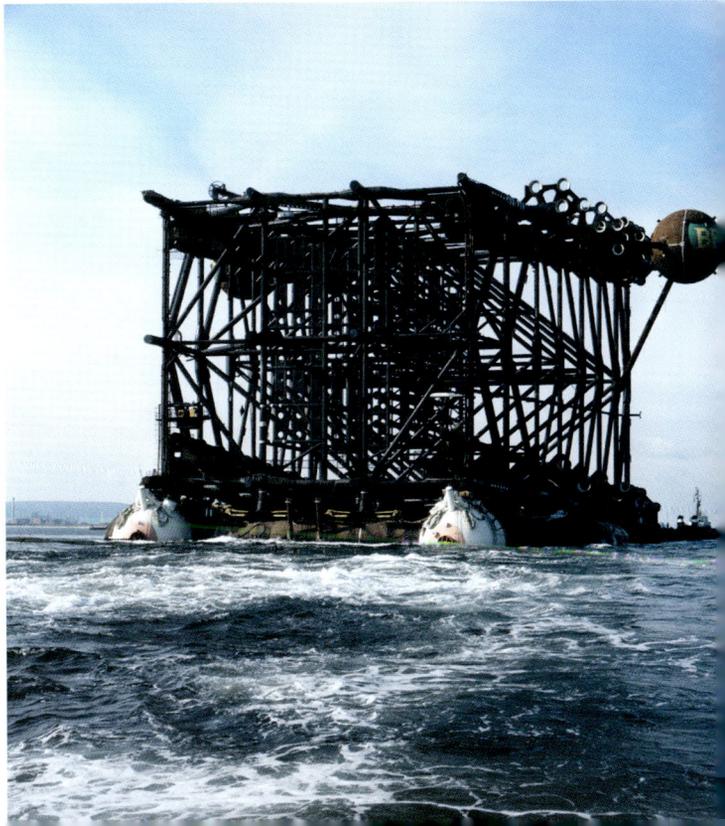

Oil Rig, Hartlepool
The Graythorp II oil platform floats majestically into the River Tees in June 1974. After acquiring Gray's former shipyard near Hartlepool in 1969, Laing Offshore built a series of massive rigs to exploit the North Sea oil boom. Extensive redevelopment of the old yard, including the construction of permanent dock gates, was carried out. History has turned full circle and oil rigs are now being dismantled on the same site. (© Historic England Archive. John Laing Collection)

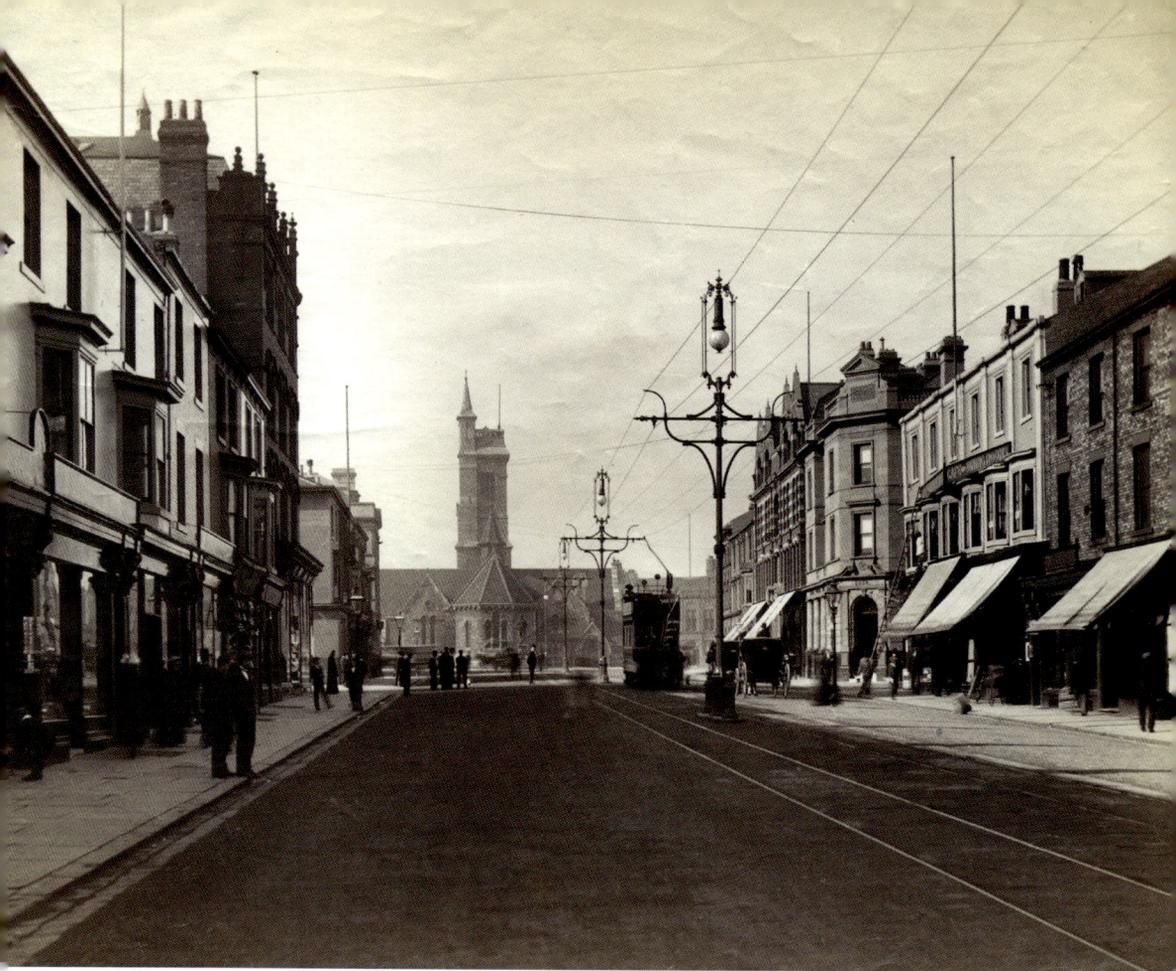

Above: Church Street, Hartlepool

Pictured here around 1910, Church Street was the main thoroughfare in Ward Jackson's new town of West Hartlepool. Laid out in the 1850s, it became a wide avenue lined with shops and imposing buildings, beginning at Christ Church's grand tower and leading to once thriving docks. Seen on the right is a tramcar owned by the Hartlepool Electric Tramways Co., which commenced services in 1896. (Historic England Archive)

Opposite above: Victoria Terrace, Hartlepool

A sailing ship appears in this old image of Victoria Terrace. Part of Jackson's West Hartlepool masterplan, the terrace was adjacent to new docks, which by 1860 made the town a premier North Sea port. Mostly demolished just over a century later, the area was swallowed by Hartlepool's ambitious waterside regeneration. Built in 1911, the Customs House and distinctive clock tower have remained a reassuring presence in a sea of change. (Historic England Archive)

Opposite below: Victoria Terrace, Hartlepool

Masts and rigging can still be seen behind the now restored Customs buildings on Victoria Terrace. Built of teak and launched at Bombay in 1817, HMS *Trincomalee* was too late for action in the Napoleonic War but patrolled British colonial waters before becoming a training ship in the 1860s. Brought from Portsmouth to Jackson Dock in 1987, the Leda class frigate has become the focus of Hartlepool's Historic Quay Museum.

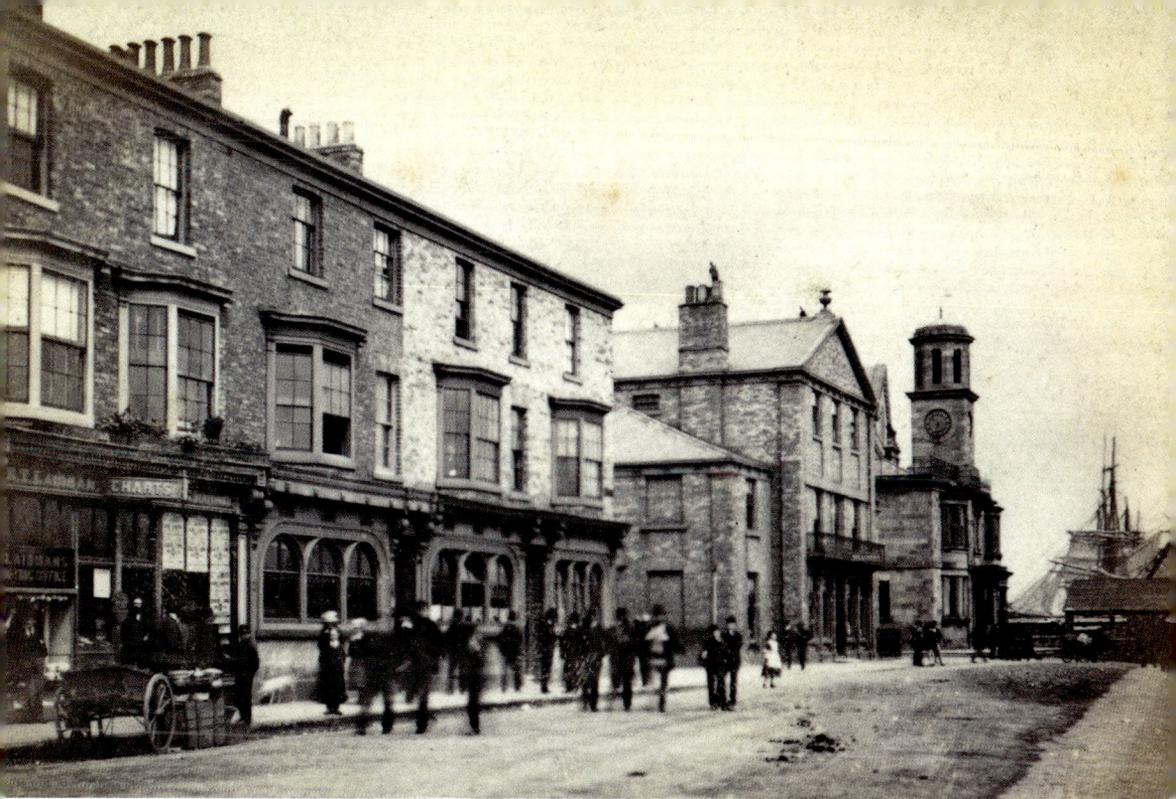

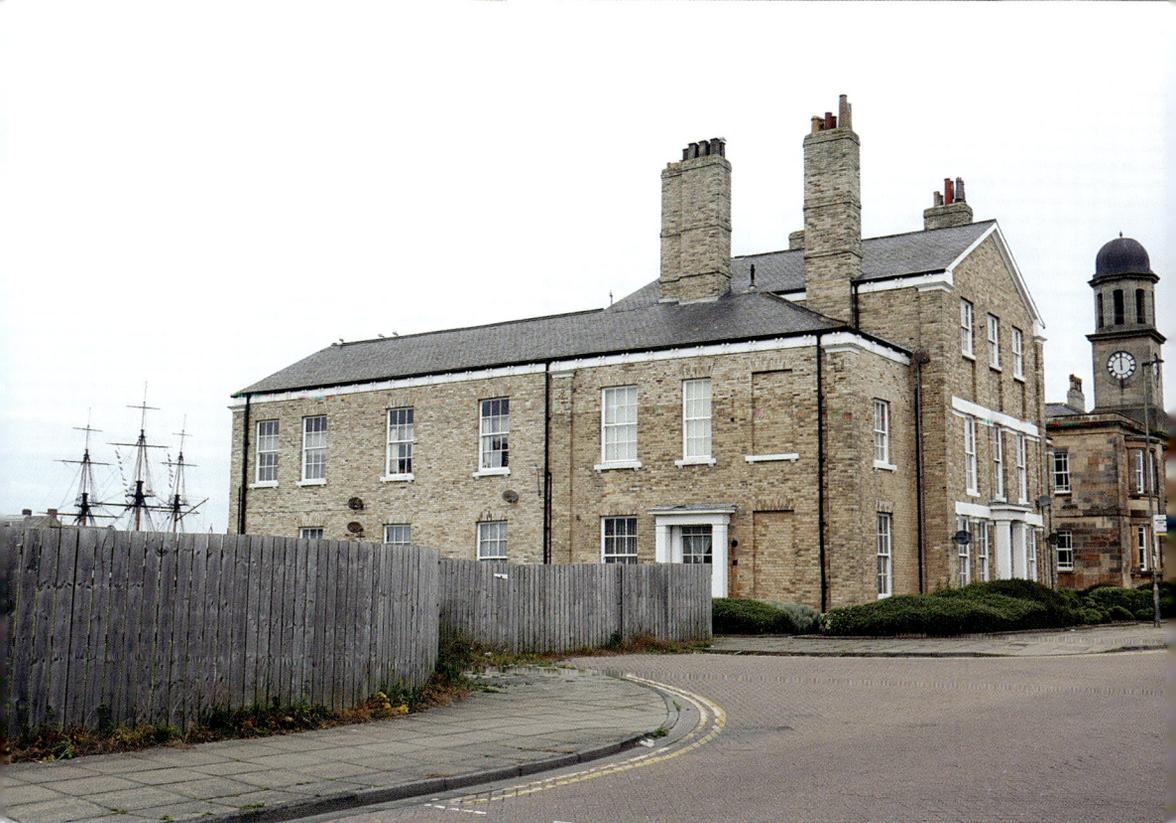

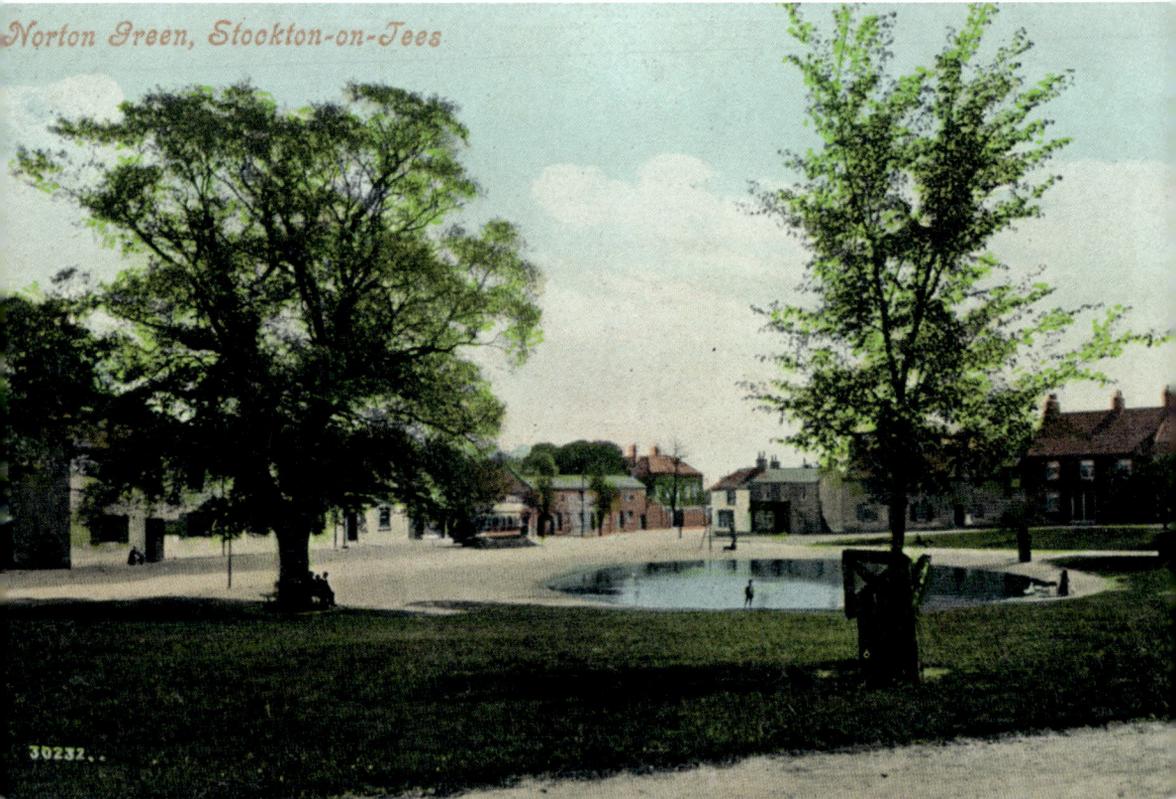

Norton Green, Stockton-on-Tees

30232

Norton Green

Traces of ancient County Durham linger on its village greens. Early settlements, particularly on more fertile land east and south of the River Wear, often gathered around central spaces for communal security. Of Saxon origins, the village of Norton, pictured here in a Valentine postcard, is a good example. Despite its proximity to the bustling towns of Stockton and Billingham, Norton has kept its green and its tranquil charm. (Historic England Archive)

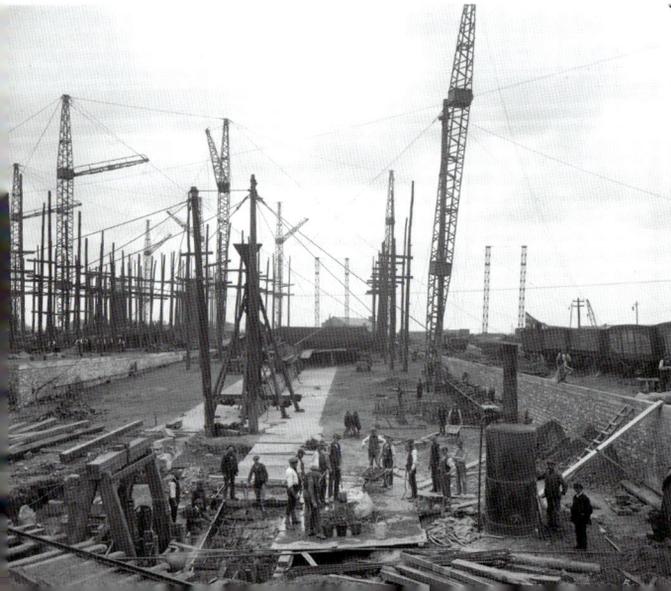

Furness Shipbuilders

Work progresses on the Furness shipbuilding yard in this 1917 image. As British merchant fleet losses increased in the First World War, shipbuilding and repair became an urgent priority. Haverton Hill on Teesside was rushed into service and the first ship, appropriately named *War Energy*, was launched in early 1919. Owned originally by Furness and Withey but known as the Furness Yard, it produced many vessel types until closure in 1979. (Historic England Archive)

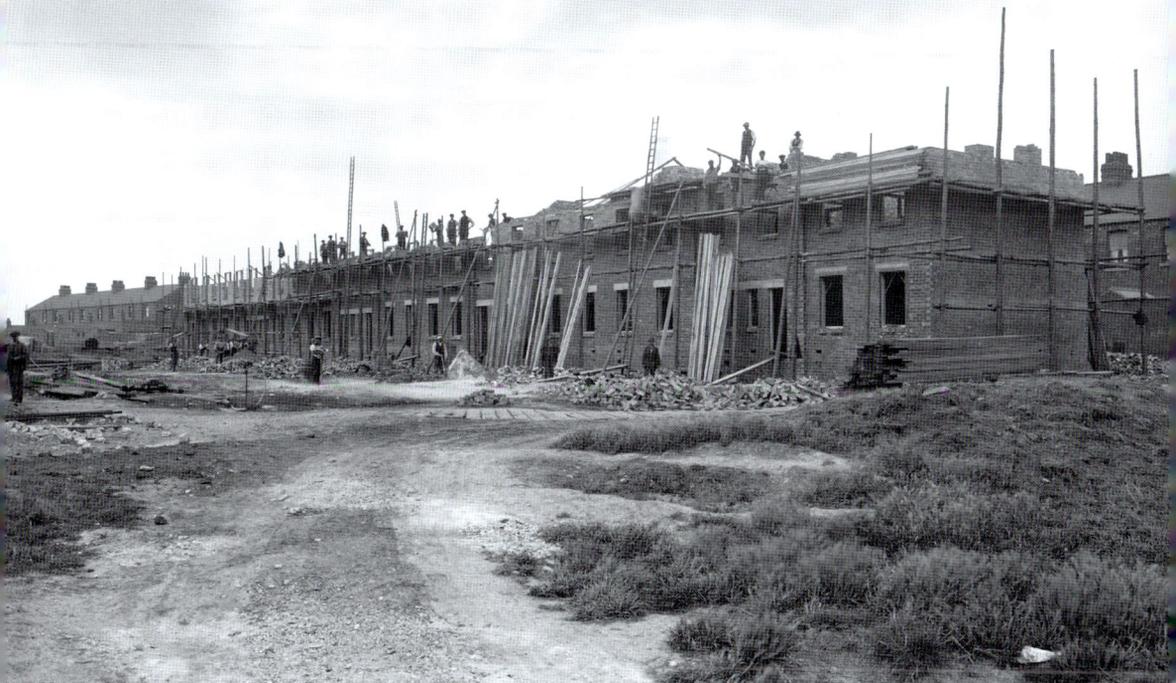

Furness Village

At the end of the First World War, the Furness Co. constructed over 500 houses for their Haverton Hill shipyard workers. Named after a local hamlet, 'Belasis Garden City' was influenced by housing schemes provided by industrialists like Joseph Rowntree of York. With relatively large rooms, gardens and allotment space, Belasis was initially popular with tenants but eventually became uninhabitable due to pollution from neighbouring chemical works. It was demolished in the 1960s and '70s. (Historic England Archive)

Stockton & Darlington Railway Office

Photographed in 1990, this simple cottage (built as a train weigh house) was claimed to be an internationally significant piece of railway heritage. Opened in 1825, the Stockton–Darlington line was the world's first public steam railway and passengers were once believed to have purchased tickets from the Stockton Bridge Road office seen here. Were that absolutely true, then it did indeed witness, as the now removed wall plaque states, an 'epoch in the history of mankind'. (© Crown copyright. Historic England Archive)

91

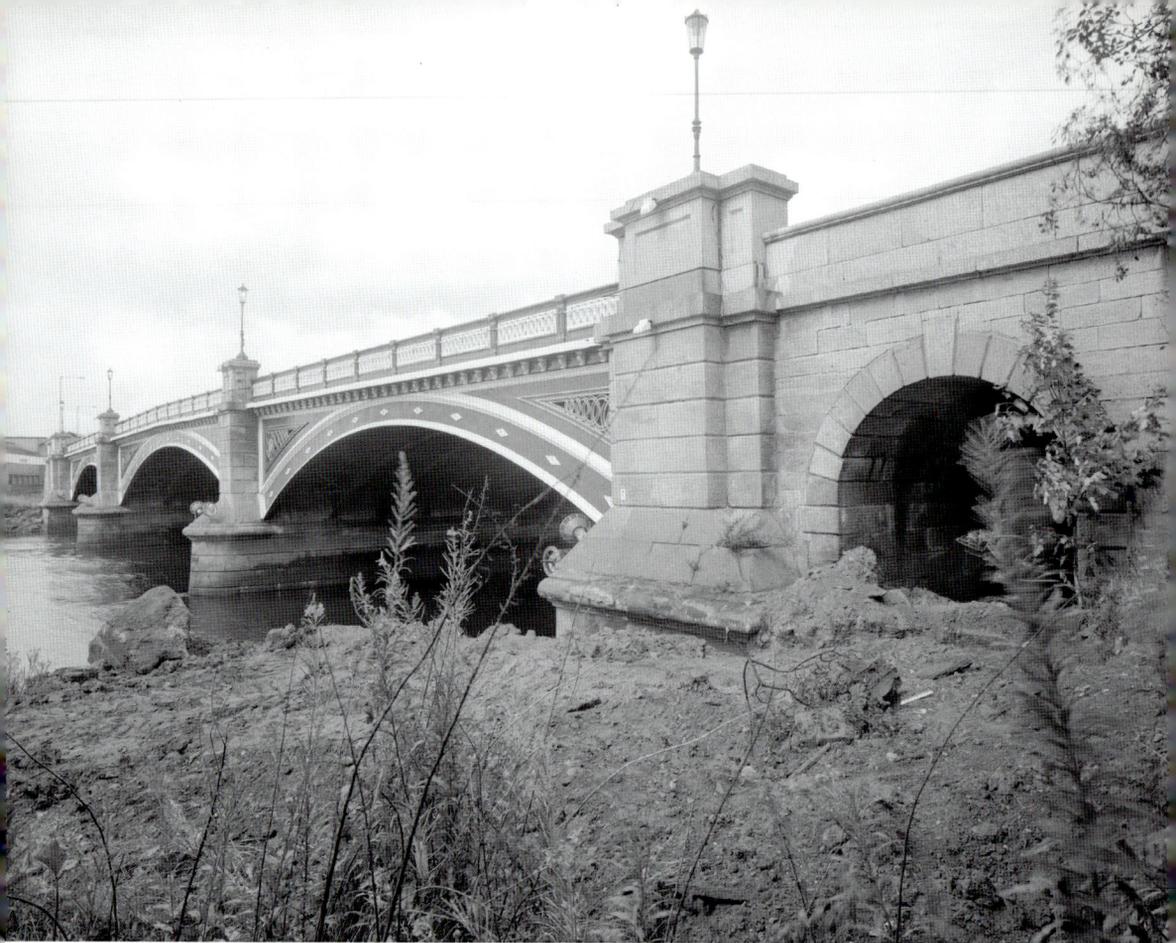

Victoria Bridge, Stockton
Opening in June 1887, the Victoria Bridge was the second to span the River Tees at this location between Stockton and Thornaby. A graceful iron and stone structure, it was engineered by Charles Neate and Harrison Haytor and built by a Leeds company at a cost of £69,000. Visible on the right is one of the road bridge's land arches, constructed to allow the passage of horse-drawn barges. (© Crown copyright. Historic England Archive)

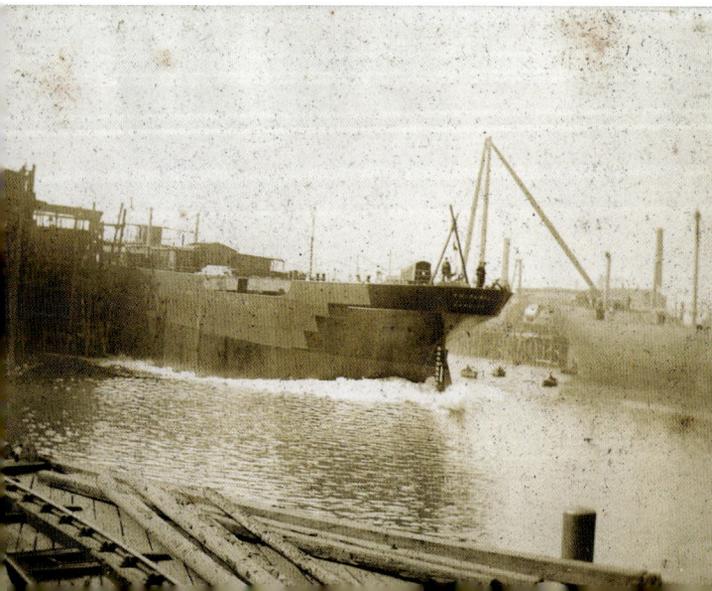

Stockton Launch
Stockton's shipbuilding dates from the fifteenth century, but the Teeside industry was entering a final phase when this photo was taken in 1906. A few years later only three major yards remained, including Richardson Duck & Co. portrayed here. Established in 1852, their shipyard closed in 1925 and was demolished in 1933. Entering the water is the SS *Thirlwell*, one of hundreds of tramp steamers built by the company. (Historic England Archive)

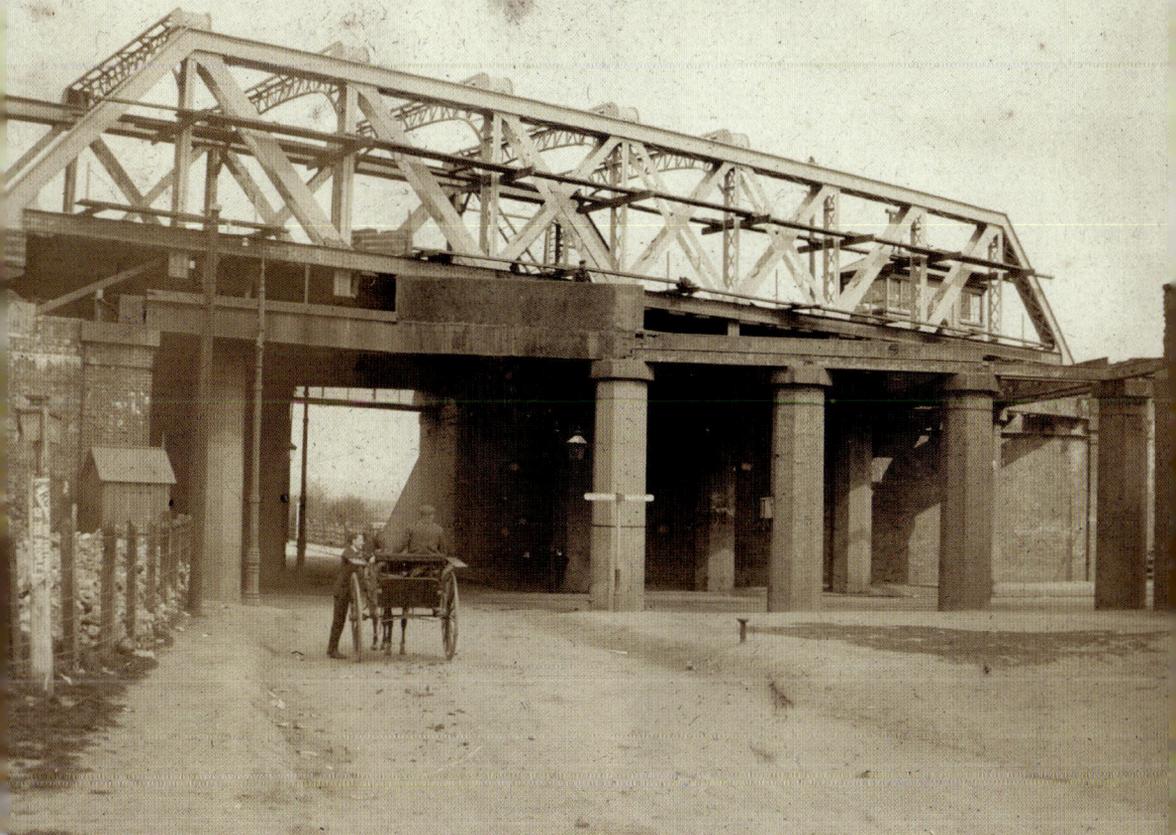

Head Wrightsons, Stockton

Iron and steel were the backbone of Teesside. Iron ore discovered in the Cleveland Hills in the mid-nineteenth century accelerated the area's industrial growth and firms such as Head Wrightsons were major beneficiaries. Formed in 1865, the company made a multitude of iron and steel products from boilers to bridges, employing 1,200 workers by 1892. This bridge in Hanwell (West London) was built for the GWR in 1906 by Wrightsons Stockton Ironworks. (Historic England Archive)

Paradise Row, Stockton

A few Georgian town houses remain in Stockton's old town centre on Church Road. Once known as Paradise Row, it has been occupied at various times by manufacturers, members of the legal profession and 'gentlemen'. Branching off from the town's famously wide High Street, Church Road has an exuberantly fashioned door case at No. 16. It faces the red-bricked parish church, built between 1710 and 1712 in a style reminiscent of Sir Christopher Wren's work. (© Crown copyright. Historic England Archive)

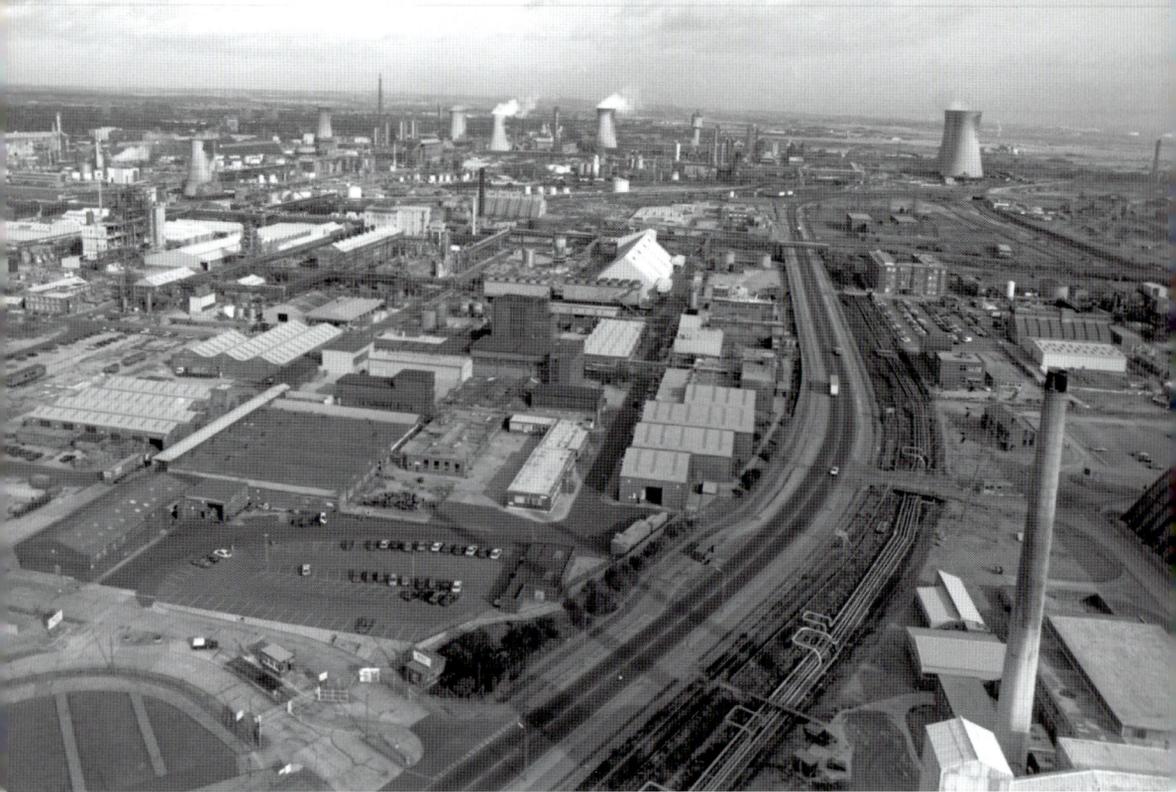

ICI, Billingham

A part of ICI's vast Billingham complex is captured in this 1991 aerial image. Chemical manufacture gradually shifted from Tyneside to the Tees estuary after the discovery of extensive salt reserves there in the 1860s, and after forming in 1926, ICI (Imperial Chemical Industries) expanded the Billingham site. Despite ICI being broken up and restructured in the 1990s, their sprawling former works remains a major chemical manufacturing site and a vital source of local employment. (© Crown copyright. Historic England Archive)

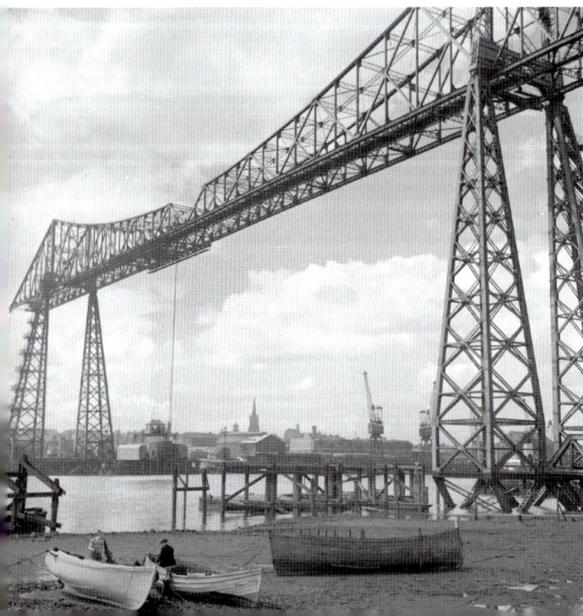

Transporter Bridge

Half ferry, half bridge, the iconic Transporter Bridge has been carrying passengers and vehicles quickly and serenely across the Tees since 1911. Constructed by Cleveland Bridge Engineering Co. of Darlington, it was designed to allow the largest ships under it and bridged the gap between the booming industrial town of Middlesbrough and Port Clarence on the river's County Durham bank. Recently refurbished, it now carries heritage tourists as well as commuters. (© Crown copyright. Historic England Archive)

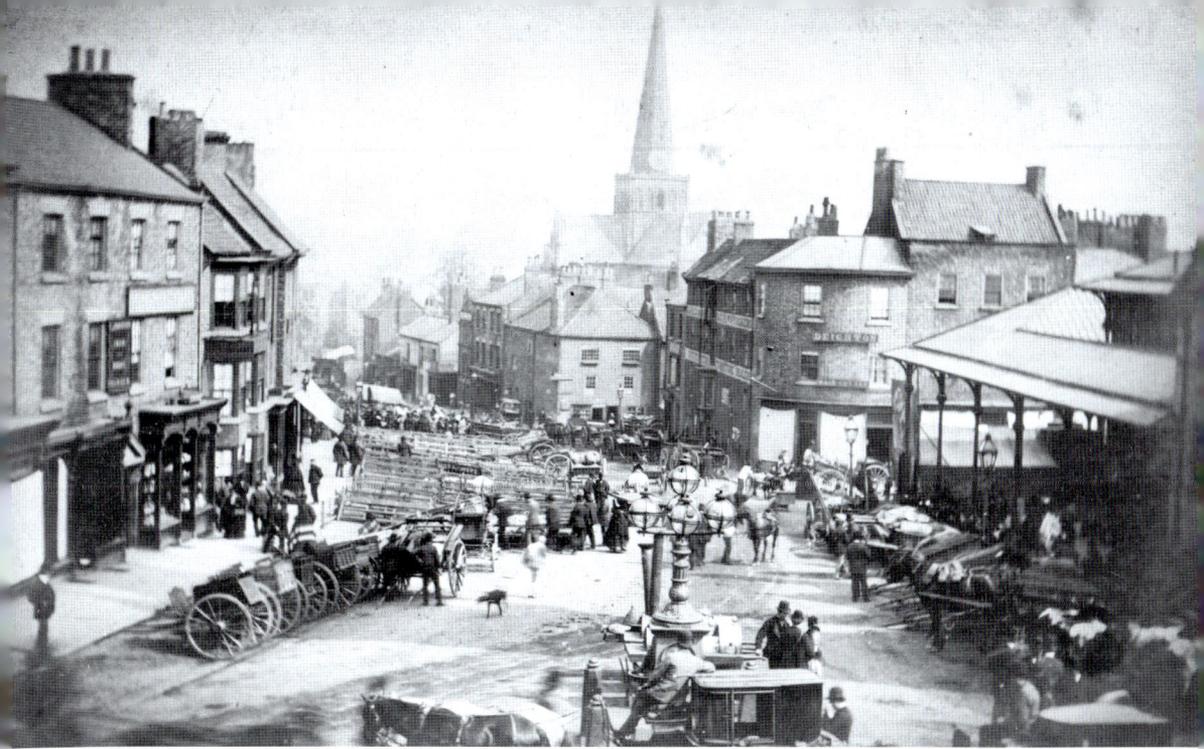

Tubwell Row, Darlington

Tubwell Row is an old street in an ancient market town. Named because of its public well (later covered with a pump), the Row was originally one of several Darlington 'Gates' or streets that led to the marketplace, the town's focus of activity. It was certainly a busy trading day when this photograph was taken around 1900. Carriages, carts and animal pens can be seen in an area first laid out by Bishop Pudsey of Durham in the late twelfth century. (© Crown copyright. Historic England Archive)

Modern View of Tubwell Row

Central Darlington, viewed along Tubwell Row in 2015, still follows its medieval street plan and draws the eye to the thirteenth-century spire of St Cuthbert's Church. Modern pedestrianisation has banished market day clutter but seem to have not unduly disturbed the Victorian covered market glimpsed on the right. Opened in 1864, it was built on the site of the old Town Hall and designed by Manchester architect Alfred Waterhouse. (© Historic England Archive)

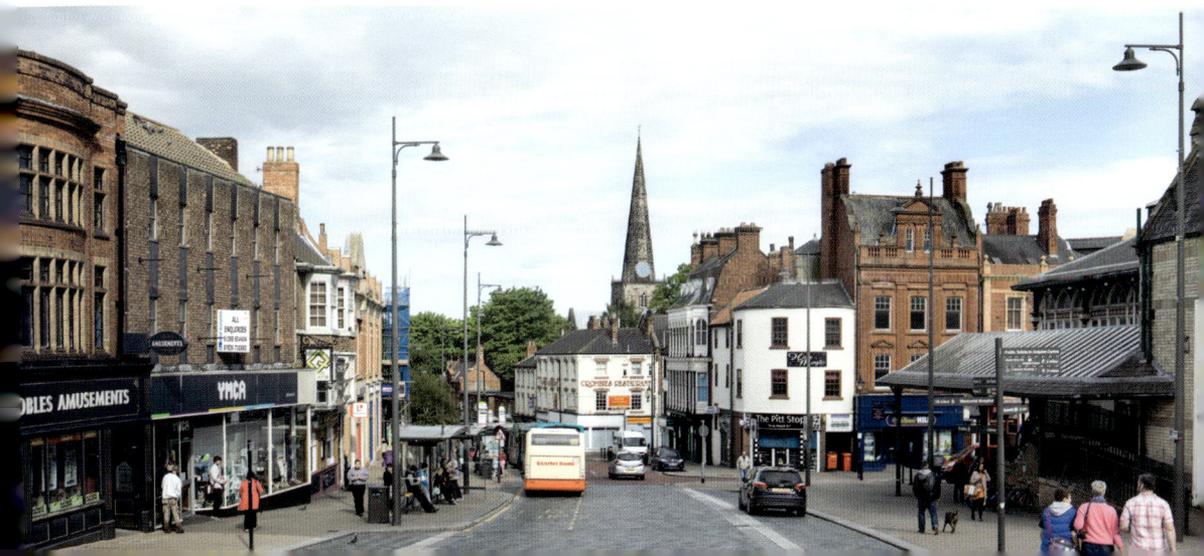

About the Archive

Many of the images in this volume come from the Historic England Archive, which holds over 12 million photographs, drawings, plans and documents covering England's archaeology, architecture, social and local history.

The photographic collections include prints from the earliest days of photography to today's high-resolution digital images. Subjects range from Neolithic flint mines and medieval churches to art deco cinemas and 1980s shopping centres. The collection is a vivid record both of buildings that are still part of everyday life – places of work, leisure and worship – and those lost long ago, surviving only in fragile prints or glass-plate negatives.

Six million aerial photographs offer a unique and fascinating view of the transformation of England's towns, cities, coast and countryside from 1919 onwards. Highlights include the pioneering photography of Aerofilms, and the comprehensive survey of England captured by the RAF after the Second World War.

Plans, drawings and reports provide further context and reconstruction artworks bring archaeological sites and historic buildings to life.

The collections are housed in a purpose-built environmentally controlled store in Swindon, which provides the best conditions to preserve archive items for future generations to enjoy. You can search our catalogue online, see and buy copies of our images, as well as visiting our public search room by appointment.

Find out more about us at HistoricEngland.org.uk/Photos
email: archive@historicengland.org.uk
tel.: 01793 414600

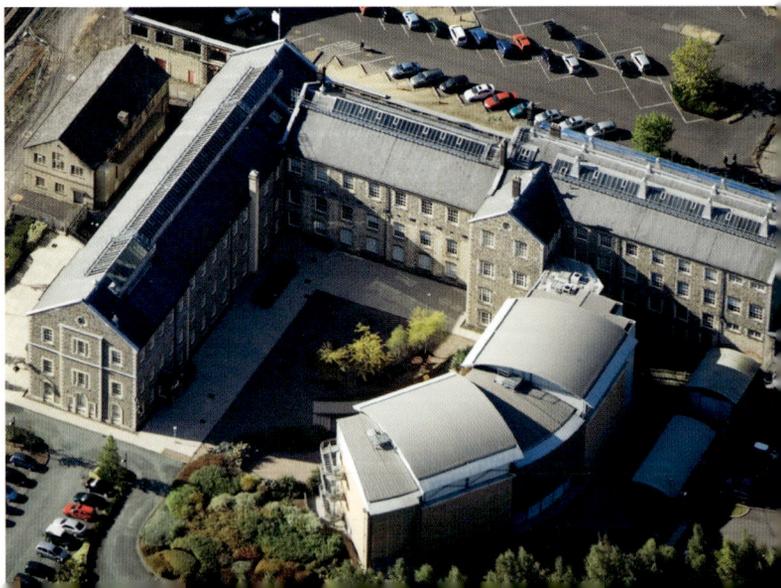

The Historic England offices and archive store in Swindon from the air, 2007.